Walker Evans at Work

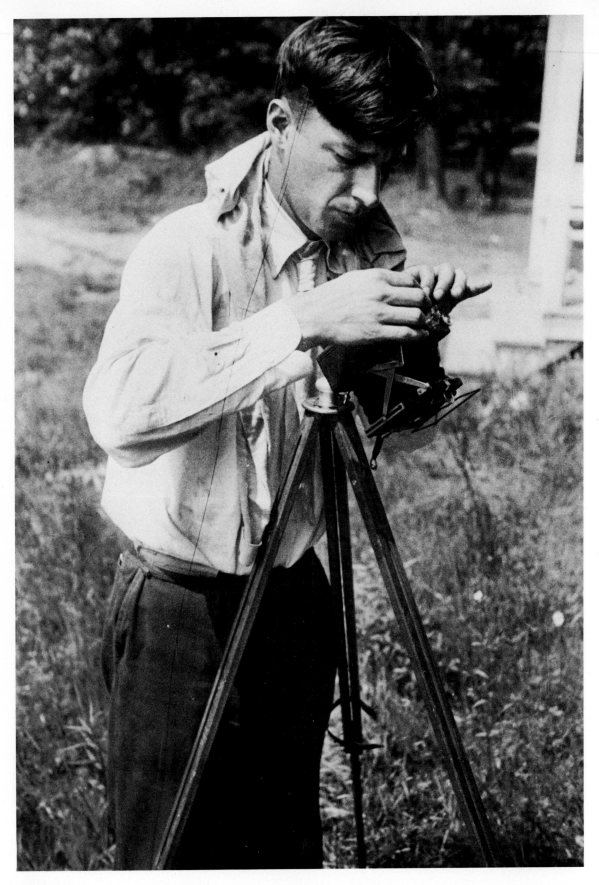

Walker Evans at work, ca. 1929. Photograph by Paul Grotz

Walker Evans at Work

745 Photographs together with Documents

Selected from Letters, Memoranda, Interviews, Notes

With an Essay by Jerry L. Thompson

Harper & Row, Publishers

New York, Cambridge, Philadelphia, San Francisco,

London, Mexico City, Sao Paulo, Sydney

FIRST EDITION

Library of Congress Cataloging in Publication Data

Evans, Walker, 1903-1975.
 Walker Evans at work.

 1. Photography, Documentary. 2. Photography, Artistic. 3. Evans, Walker, 1903-1975. I. Thompson, Jerry L. II. Title.

TR820.5.E89 1982	770'.92'4	79-1661
ISBN 0-06-011104-6		AACR2

82 83 84 85 86 10 9 8 7 6 5 4 3 2 1

Acknowledgments

In preparing this book, the Evans Estate has been fortunate in having the invaluable assistance of a number of Evans's friends and of several scholars. I would first like to thank Jerry Thompson for generously giving his time to writing so knowledgeably about Evans at work. He had rare firsthand experience, first as Evans's student and later as his assistant and friend, and he has done much to explain the tools and habits of a complex man.

I would also like to thank Lesley Baier for sharing her extensive research and, in particular, her unique information on Evans's *Fortune* career.

The Estate is further indebted to many private collectors, dealers, and institutions for making available material they own. Paul Grotz, Evans's close friend, allowed us to use freely his rare collection of early pictures of Evans at work. Harry Lunn and Ron Hill have permitted us to reproduce the dummy of a proposed book of subway portraits, and the enlarged detail of the "Havana Citizen." And the following people have opened their archives and collections for this project: Joe Buburger, Bill Christenberry, Arnold Crane, Robert Frank, David Herwaldt, Susan Kismaric and the Department of Photography of the Museum of Modern Art, Leslie Katz, June Leaf, Jerald Maddox and the Library of Congress, Hank O'Neal, Richard Sendor, Joel Snyder, and Alan Trachtenberg. Thanks are due to *Fortune* and to *Vogue* for allowing us to reproduce pages of Evans material they have published.

My deep appreciation goes to Amos Chan for organizing the photographic printing for this book. Chan, Robert Lisak, Sven Martson, Abelardo Morel, and Bryan Graham made all the prints included except those from the above collections.

I am grateful to Alvin Eisenman, Tom Strong, and Peter Levine, who assisted in the design and production. My wife, Dorothy Hill, also deserves a large measure of thanks for helping resolve a number of design problems and for her general endurance of this project. In selecting and sequencing the photographs, I had the help of a number of people to whom I am grateful; I especially benefited from the tireless work of Ed Grazda, who assisted in locating and assembling the material for a number of sequences.

The Evans Estate and this book owe their greatest debt to Frances Lindley, editor at Harper & Row. Four years ago she proposed the idea for this book about how Evans worked. Her deep understanding of the man and his work, along with her persistence and wisdom, have touched every part of this book.

John T. Hill Executor, the Estate of Walker Evans

Walker Evans at Work

Eugene Atget worked right through a period of utter decadence in photography. He was simply isolated, and his story is a little difficult to understand. Apparently he was oblivious to everything but the necessity of photographing Paris and its environs; but just what vision he carried in him of the monument he was leaving is not clear. It is possible to read into his photographs so many things he may never have formulated to himself. . . . His general note is lyrical understanding of the street, trained observation of it, special feeling for patina, eye for revealing detail, over all of which is thrown a poetry which is not "the poetry of the street" or "the poetry of Paris," but the projection of Atget's person.

Hound and Horn, *October-December 1931*

Walker Evans:
Some Notes on His Way of Working

A thorough, comprehensive study of Walker Evans's work and life has not yet been made. The photographs themselves, of course, are the richest, most fully developed expression of what Evans had to give to the world; these pictures are presented here in chronologically related groups, which frequently include examples of the many variant versions Evans almost always made when he photographed. Also, excerpts from notes, letters, and interviews appear along with the pictures.

These materials have been organized in the hope of showing something about how Walker Evans worked. The crucial decisions — the imaginative leaps — that lead to great work are mysterious, even miraculous, and difficult if not impossible to explain. Evans made a great many lesser decisions, however (as well as a number of lesser pictures), while engaged in the long labor that produced the miracles we have come to think of as his greatest pictures. He experimented extensively, and he never destroyed the evidence of his less fruitful efforts in an attempt to appear surer than he actually had been. He left behind in his negative collection many preliminary attempts, unused variants, and rejected failures. He moved from address to address a growing mass of papers which included lists of possible subjects, exposure records, requests for money, accounts of expenses, memos to colleagues, and multiple drafts of texts that were never used. Taken together, these humble data begin to suggest how Evans made his way through the world during his forty-five years as a working photographer.

Walker Evans made a few snapshots while he was traveling in Europe, but he began photographing regularly in New York in 1928, using a small hand-held camera which took roll film. Almost immediately, negatives from other cameras, bought or borrowed, began to appear in his files. By 1930 he had made negatives of the following sizes: 35 mm, $1^{5}/_{8}$ x $2^{1}/_{2}$, $2^{1}/_{4}$ x $3^{1}/_{4}$, $2^{1}/_{2}$ x $4^{1}/_{4}$, $3^{1}/_{4}$ x $4^{1}/_{4}$, 5 x 7, and $6^{1}/_{2}$ x $8^{1}/_{2}$ (glass and later film). The last two sizes were used in view cameras, cameras equipped with ground-glass viewing screens and designed for use on a tripod. The other sizes were used in cameras that could be hand held. At least one was a "vest pocket" tourist camera; it had a waist-level viewfinder and folded flat when not in use so that it could be easily carried. He used a borrowed Leica (the well-designed 35 mm "candid camera" used by Cartier-Bresson and others) as early as 1929.

Some of Evans's early pictures were observations of street life, views made quickly and in many instances without the subjects' knowledge. For such work a small camera was ideal. Evans was also drawn to other subject matter, however. He photographed Brooklyn Bridge with two small cameras; though he may have used a tripod to allow precise framing, he made no other allowance in technique for the size and difficulty of the subject. His approach might be characterized as impressionistic rather than descriptive. In 1930 he began to photograph nineteenth-century American houses, and a sustained interest in this subject required fuller powers of description than much of what he had attempted. He investigated this subject matter with a view camera in the systematic manner described by Lincoln Kirstein (p.00); in making these pictures he worked out the classic descriptive style, if not the full richness of meaning, that characterizes his later work.

This direct style did not appear suddenly, fully developed, nor is his straightforwardness as simple as it seems. There are many early examples of a direct approach — the picture of the black man in the Brooklyn doorway (p.22), for example — but in the same period (1928 – 30) Evans also made a considerable number of photographs which could be called abstractions. He had apparently seen avant-garde European photographs of the 1920s, and he made many — a great many — pictures of skyscrapers, shadow patterns, and still lifes which are dominated by bold geometric shapes. But after his course was set he tended to ignore his early experiments in abstraction, though he never threw them away.

Eventually Evans settled on a documentary style; he was perhaps encouraged in this by his literary interests (Flaubert was a favorite writer), by his reaction to what he thought of as the extreme artiness of artist-photographers such as Stieglitz (to whom he showed work), and by the stimulation of seeing a few direct photographs which moved him strongly. In later life he frequently mentioned

Strand's *Blind Woman* as a powerful stimulus, and he also acknowledged his interest in Ralph Steiner's work. By 1930 he had surely seen the work of Atget, whom he praised generously in a review published in 1931.

It would be an oversimplification to say that Evans learned to photograph with small roll-film cameras and then graduated to the view camera. Though he was attracted to the descriptive abilities of the larger camera, this instrument did not replace the small one. Rather, it was an addition to his arsenal, a kind of heavy artillery to use on large, intractable subject matter. He continued to use hand-held cameras regularly for the rest of his life. In Cuba, in 1932, he used one of his first roll-film cameras, to make unposed portraits (for which the conspicuous view camera on its tripod would have been unsuitable) and sometimes to make other versions of pictures made with his 6½ x 8½ view camera.

Evans's lifelong habit was to make several versions of each picture, often with different lenses or cameras. The reasons for this practice have to do with the photographer's many-leveled relationship to his world. A photographer responds to a world of things which he at once sees, experiences, and understands. When he is faced with stimulating subject matter, his immediate task is to make what sense he can of the components of seeing — camera distance, perspective, framing, light, and gesture, all of which may be telling him important, perhaps contradictory, things at the same time. In addition, he is bedeviled by connections his mind is making between what he sees and what he knows — what he has read and lived, pictures he has seen, how he was raised, and a thousand other things. To be a good artist means to devise a personal strategy for reconciling the elements of this rich assault.

Evans's own strategy may have derived as much from temperament and habit as from reflection and conscious choice. It is impossible to say what went on in his mind, but his work shows he frequently found that more than one exciting picture could be made during a single encounter with a subject. In some instances, more than one view of a scene must have continued to interest him. Two middle-distance views of Belle Grove plantation made in 1935 — one with a dead stump in the foreground, one with a young sapling in about the same position in the frame — were printed and exhibited by Evans in later life.

At other times, many views were probably made as a sort of thorough search for the best view, one that Evans could not have predicted but was able to select afterward. Often he seems to have been after the least contrived, most straightforward view of a situation, which would also reveal most fully the significance of that situation as he understood it. He was rarely satisfied by a single attempt at this ambitious goal: he worked hard to make pictures that show deceptively simple facts.

Evans began to photograph regularly with an 8 x 10 view camera in 1933. He had made negatives of this large size as early as 1931 (in Saratoga Springs and of the Westchester farmhouse with tree and auto in front), but he seems not to have used this negative size consistently until two years later. Perhaps his early attempts had been made with a borrowed camera, one not available to him for use on his trips to Cuba and Tahiti. At any rate, he apparently acquired an 8 x 10 outfit of his own in 1933, for he abandoned the smaller-sized view cameras he had been using and began experimenting with lenses of various focal lengths on his 8 x 10 camera.

Choosing a lens for a particular picture is an important decision for a photographer who uses a view camera, because the focal length of the lens is intimately related to his choice of camera position. Where the photographer decides to place his camera, in turn, largely determines how his picture understands its subject. A photographer who decides to photograph a building, for example, has many options. He can stand back and let the structure float in a larger frame so that it is overwhelmed or contradicted by its surroundings, or he can move up and photograph the building head-on, so that the design of the facade fills the whole frame of the picture, seemingly with its own energy.

The several versions of the Westchester farmhouse with auto and tree in front (page 56) provide one of the earliest examples of Evans's experiments with camera position. In each version of this picture, the house facade, the car, and the tree shift their positions slightly in relation to each other and to the frame of the picture. The photographer is working like a writer who, having found a group of words or images he wants to use, is experimenting with slightly different ways of combining them.

Evans photographed many subjects from different

distances and angles, and with different lenses. His 8 x 10 negatives from 1934–36 show that he did not explore camera position, focal length, perspective, etc., in a studied, theoretical way; these considerations interested him only as means to an end. He seems to have worked in episodes during which he would try a number of promising approaches to a subject that attracted him. Some of these episodes must have been periods of considerable excitement; shadows in sunlit pictures often show that a number of 8 x 10 negatives — even a dozen or more — were exposed within a fairly short space of time. These prolific experiments did not go undigested, however.

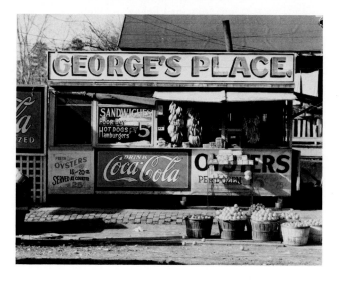

Evans was a critical editor of his own pictures, and he gradually came to prefer some possibilities over others. These preferences, elaborated in many hundreds of attempts, became the elements of what we recognize as his straightforward style.

As long as he continued to use a view camera, Evans chose to rely on a lens that allowed him a large measure of versatility — a triple convertible. A triple convertible is a lens with two component elements that can be used separately. With the components combined, the lens has a normal focal length. One of the elements used alone acts as a long-focus lens; the other element is a lens of still longer focus.

Throughout the mid-1930s Evans occasionally used more than one focal length on the same scene — in his views of Atlanta shacks, for example, and in the views of sidewalk scenes made in Vicksburg (page 140). He used the normal as well as the two longer focal lengths, but in 1935 and 1936 he was consistently making pictures that depend on the compression of depth and the flatness of perspective characteristic of a long lens. According to his Resettlement Administration field notes, Evans on November 8, 1935, made a series of long views in Bethlehem, Pennsylvania, beginning with views of a graveyard with steel mills behind (including the view with a large cross in the left foreground), going on to Joe's Auto Graveyard, and ending with views of Easton across the Lehigh River. Every version of every picture was made with the longest element (69 cm; a normal lens for an 8 x 10 negative is about 30 cm) of his triple convertible lens.

In at least two of the pictures that survive from that day, the nearer and farther objects are purposefully related because of the flattened perspective of the lens. If either of these views had been attempted with a normal lens, the near objects would loom large, threatening the equation between things near and far on which these pictures depend. With a normal lens, for example, the view of Joe's Auto Graveyard would have been a different picture — one of junked cars with hills far behind, if the camera had been placed close to the cars, or one of tiny wrecked cars between small, far-off hills and a long, prominent foreground, if the camera had been placed farther back.

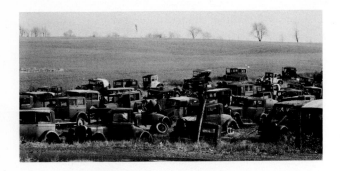

Either possibility might have led to interesting results, but Evans did not explore them that day. He chose to make the picture with the flat perspective of a long lens so that the mass of junked cars, seen from a distance and foreshortened, fits into the hilly countryside.

The view that results is a mock landscape. The overall form is like that of many other views which could be (and had been) made of rolling hill country: a strip of sky sits over a row of distant hills which in turn is over several layers of foreground interest. In this view, however, one of the layers of the composition is not a river or a band of dark vegetation but a pile of junked cars. The autos appear in the landscape as a foolish desecration; the natural landscape persists, but as a distant, besieged ideal. Even the forms and conventions of the landscape view are questioned here — are they quite adequate for the needs of the present day? The picture does not present a simple complaint at the encroachment of the automobile; rather, it describes, with considerable wit and penetration, a fine manifestation of the entangled and contradictory energies that drive American culture.

Like many of the other pictures published in *American Photographs*, this picture is not a document but what Evans carefully called "documentary style," deliberately wrought visual poetry disguised as plain prosaic fact. By 1935 Evans understood this distinction well, and he also understood the possibilities offered him by the long lens. He had found a contemplative, distanced perspective that perfectly suited his needs at the time. The pictures he made with long lenses show the world compacted, held at arm's length, flattened to be read like a page of literature, full of irony and delicate meaning.

While Evans was refining his photographic skills, he was also busy trying to make his living as a commercial photographer. He tried portraits, photographs of painting and sculpture, advertising photography, and photojournalism (his first job for *Fortune* was done in 1934). He had some early recognition as an artist — a show at the Museum of Modern Art in 1933, as well as several shows in private galleries — which he attempted to turn to his financial advantage. A letter to his friend Hanns Skolle in 1929 reports the sale of a picture to a small magazine (*The Alhambra*) for the sum of twenty-five dollars; a letter to Skolle a year later announces his intention to "publish some photographs in order to become known and make someone exhibit me and sell prints and make money." Evans published photographs in several of the small art magazines of the period, and he seems to have used his growing reputation to get himself hired to make photographs for books. In 1932 he went to Cuba to make photographs for *The Crime of Cuba*, and in early 1935 he traveled in the South to make pictures for a book on plantations which eventually appeared without his photographs. Being paid to travel and make photographs appealed to Evans more than other kinds of work he had tried, and he continued to find this kind of employment for the rest of his life.

By late 1935 Evans had gotten a job with the Resettlement (later the Farm Security) Administration — he was hired as an "information specialist," and expected to document the plight of the rural poor and the New Deal's achievements on their behalf — and his success at making this job serve his needs as an artist is well known. The administration required Evans to keep field notes, which show three series of negative numbers. All 8 x 10 negatives were numbered with the prefix *D*, for Deardorff, the camera he had on loan from the government. He used it with a Zeiss Protar lens, a triple convertible whose two elements had focal lengths of 48 cm and 69 cm when used separately. His notes also record exposures made with a 13-inch lens. The normal focal length of the Protar would have been about 29 cm — closer to 12 than to 13 inches. It is not clear whether Evans used another lens as his normal lens, or perhaps mistakenly got into the habit of thinking of 13 as the correct expression in inches of the focal length of his combined Protar.

Evans's 4 x 5 negative numbers were preceded by the prefix *G*, for Graflex Speed Graphic. This was a press camera, which had a viewfinder and rangefinder as well as a ground-glass viewing screen. Consequently it could be used on a tripod or be hand held. Eventually Evans used this camera with two lenses, a 13.5 cm Zeiss Tessar and a 7 in./14 in. double Protar, but his field notes do not record whether he used either of these lenses for the small amount of work he did on 4 x 5 film for the Resettlement Administration.

The third series of negatives had the prefix *L*, for Leica. It would be difficult to say with any certainty to which of the many Leicas Evans owned or borrowed the *L* referred, but he used this camera extensively in his work for the government, and he seems at this time to have preferred the normal (5 cm) lens.

In Evans's work of 1935 and 1936, the 8 x 10 pictures dominate, with the stunning exception of the pictures which became part of *Let Us Now Praise Famous Men*. These Leica snapshots (as Evans often called pictures made with that 35 mm camera) show a vision fully developed, different in form but complementary in content to the large camera portraits and views. The view-camera pictures tend to isolate and examine pieces of a world; building facades, composed faces, and interior details appear in these pictures, singled out and scrutinized by an intelligence that sometimes seems almost outside time. The 35 mm pictures show the same world, but usually from a different point of view — actors, scenery, and props are blended as they are in the flux of everyday life. These pictures show the farm families singing hymns, grooming themselves (perhaps for the posed portraits about to be made), taking care of each other, even flirting with the photographer. In one of these pictures (p. 124), several different gestures involving upraised arms appear in the same frame with a tilted weathered roof support (which is also holding up a leaning figure with a bowed head) and the heavy folds of coarse, sacklike shifts. The photographer is close to — almost a part of — the group on the porch, and the picture is immediate and momentary, a collection of fragile diagonals caught in an extremely temporary balance. In pictures like this, intimacy allows a kind of close observation that is different from but no less precise than the detached perusal of the

large camera views. Evans's greatest success in the work of this time came from moving freely from one camera to another. Possibly he was working at such a pitch that he readily found material for whatever camera he found himself using.

Most of the technical information that survives from the 1930s has to do with 8 x 10 negatives, probably because each negative required a separate storage envelope, which supplied a convenient place for notes. Much of this information is deducible from the pictures: He usually used small lens apertures, stopping down to $f/45$ or even "limit" aperture to keep as much of the picture as possible in sharp focus; he frequently used a *G* filter to emphasize clouds; he often used the shortest exposure time possible under the circumstances to minimize movement. The shortest possible time was not always very short, however. An outdoor exposure on a dull day might need a full second or more, and photographs of indoor subjects sometimes took much longer. One of the Saratoga Springs hotel interiors (p. 60) shows a running clock, the minute hand of which is blurred through nine minutes. In sunlight, records of exposures of $1/5$ second or even shorter at $f/45$ are not uncommon. Notes on negative envelopes show he often used vigorous developers — D-72 (Dektol) diluted 1:1 in some cases — to get negatives of sufficient density in short exposures. Sometimes he used a flashbulb in order to be able to use short exposures, and small aperture settings when making close portraits. John Szarkowski has pointed out that some of the Alabama tenant farmers were photographed both with and without fill-in flash.

Most of Evans's 8 x 10 negatives yield fine prints with a full tonal scale when printed carefully, and many of the negative envelopes contain detailed printing instructions in Evans's own hand. Though he appreciated a good print from one of his negatives, he was suspicious of print quality as an end in itself. He maintained that the print should be good enough to make a clear statement, and he sometimes cautioned his assistants against wasting printing paper in pursuit of a perfect print. The most obvious defects noticeable in some of his pictures — light lines through the skies in particular — are not due to careless development but rather are a result of improper storage conditions. There are some marks resulting from

the metal hangers used to develop sheet film in tanks, but these are near the picture edges and were frequently cropped out.

Evans printed his 8 x 10 negatives mostly by contact — same size, with the negative pressed tightly against the printing paper. This technique results in prints of the greatest clarity and minimizes such defects as graininess of the negative and the limited resolving power of the simple long-focus lenses he often used. He frequently cropped his pictures, sometimes by cutting the negative. He never owned an 8 x 10 enlarger, but he had one that took 5 x 7 negatives, and occasionally he enlarged a portion cut from an 8 x 10 negative. The figure in front of the Cherokee Auto Parts store was cut from an extra negative and enlarged, and two of the three negatives he made of the Savannah penny picture studio window were cut down in an attempt to find the best 5 x 7 piece to enlarge. Fortunately, the third negative was in the files of the Farm Security Administration in Washington, where it still safely rests.

By 1940 Evans's working habits had changed considerably. He had left the Farm Security Administration and given back his Deardorff outfit. He got an 8 x 10 Korona and a Turner-Reich triple convertible lens, but he used it little. He used the 4 x 5 Speed Graphic more, and he also used 35 mm cameras. In 1941 he got the first of his many Rolleiflex 2¼ x 2¼ twin-lens reflex cameras. These cameras offered ground-glass viewing and lent themselves to work on a tripod, but they were small enough to be hand held easily. The negative was square, on roll film, but big enough to allow an enlargement that could be cropped into any shape. The lens was not movable, so the camera was not so well suited to architectural subjects as a view camera, but it was easier to carry, and he could stand back, hold the camera level, and crop out the unwanted foreground when he photographed buildings. Or he could correct parallel lines while printing; he owned a tilting support for enlarging easels, designed to make this operation possible. Evans eventually owned as many as six of these cameras at one time; they were the cameras he used most during the next thirty years.

With a few exceptions, Evans made no additions to his working technique between 1940 and 1970. In general,

his way of working was an adaptation, a kind of streamlining of the procedures he developed so richly in the 1930s. His subject matter for the most part did not greatly change either, and he continued to photograph it in his straightforward way, only with small cameras instead of a view camera. By 1945 Evans was on the staff of *Fortune* magazine. His work there has been most fully described by Lesley K. Baier, whose research and conversations with Evans's colleagues have allowed her to construct a detailed account of his methods:

" Walker Evans's work from 1945 to 1965 as *Fortune's* only staff photographer spans almost half his photographic career and constitutes the most extensive body of work he produced. In that twenty-one year period, the magazine published 372 of his photographs — less than one-fifth of his total *Fortune* production — as well as twenty-six lithographed postcards from his turn-of-the-century American postcard collection. Prior to that, between 1934 and 1941, forty-four of his photographs commissioned on a freelance basis, had also appeared in *Fortune* articles. . . . His most famous photographs commissioned by *Fortune*, although never used in the magazine, were the tenant farmer series later published in *Let Us Now Praise Famous Men*.

" The majority of Evans's portfolios were presented as artistic features and were not intended to convey factual information. He was allowed almost complete artistic license in his selection of subjects as well as the ultimate appearance of his portfolios and the texts he wrote for them. These texts, used almost exclusively with his portfolios after 1950, are an integral part of his *Fortune* work. The specific facts that he occasionally incorporated into them were gathered by *Fortune* staff researchers. Evans's own preparatory research usually consisted of brief glances through related books in order to get a sense of the general nature, rather than the specific character, of his subject.

" Editing his portfolios was as important to Evans as actually taking the photographs. He ordinarily prepared his own layouts, although after 1954 he worked on them with Ronald Campbell, a member of *Fortune's* art department. Evans's own layout method was neither

economical nor particularly well organized. He at first wanted each print full-page but was forced to compromise because the magazine format did not lend itself to that arrangement, and because carefully enforced page restrictions severely limited the number of images he could include. Layouts at *Fortune* were done with photostats. Instead of restricting his photostat order to carefully estimated needs, Evans would initially order 'thirty of everything' so as to have every conceivable size of every photograph immediately available.

"Although he did very little of his own printing there, Evans did specify image-size and cropping. Not trusting the printers to follow his instructions, however, he occasionally trimmed his negatives to the desired image with scissors or glass and a blade. This habit created far greater problems for the printers than the one Evans sought to avoid. His cut edges rarely met at right angles, and the printers had to crop the photograph further to straighten it. In addition, one-eighth inch was lost around the edges of each page when *Fortune* was bound and cut. Full-page illustrations were therefore bled to avoid the possibility of a fine white line remaining along the finished border. When Evans trimmed his negatives, he left no leeway for this bleed loss. Throughout his association with *Fortune*, he completely disregarded the practical mechanics of large-scale magazine production. Indeed, it was his refusal to accommodate his methods to the needs of the magazine, not his photographs and texts, that often led to problems with his editors."

Evans had been from the beginning interested in the cumulative meaning of a group of photographs. For twenty years he used *Fortune* as his forum, regularly presenting a small group of pictures centered around an idea. These ideas often were efforts to extend the brilliant definition begun in *American Photographs*. Each essay attempts to examine in detail some particular aspect of the American phenomenon he had dealt with head-on, and as a whole, in that book.

Evans's reliance on smaller cameras simplified the business of traveling as a respectable professional who might photograph corporate presidents as well as assembly-line workers. And on the printed page, the difference between an 8 x 10 contact print and an enlargement from a 2¼ x 2¼ negative would matter little. Portability became an increasingly important requirement for his personal equipment as well. His professional work occupied a good deal of time, and personal work was done on working trips, on social visits, and sometimes on lunch hours. Evans had always used a hand-held camera, even at the height of his enthusiasm for the large view camera, but in these years carrying a small camera became a habit which led him to new kinds of observation. He still sometimes made long views (like the epic vistas he made expeditions to seek in 1935), but in addition he sought the lyric observations of a cultivated eye. He continued to photograph architecture and people, but he might also be drawn to a trash can or a bit of rubbish in the gutter. He found the curious, the out-of-the-way, and the whimsical, and he made photographs that were not in the least at odds with his earlier work. Indeed, the freedom allowed by the small camera enabled him to discover his subject in increasingly unlikely places.

Frequently these discoveries became as focused, and as hotly pursued, as any work of his career. The unposed subway portraits made in 1938 and 1941 with a 35 mm camera involved a technique as highly developed, in its own way, as the long-lens views of 1935 and 1936. It became clear to Evans that in order to make the pictures he wanted, he needed unhampered freedom to select his subjects, to remain unobserved so as not to affect their actions, and to arrest those actions when he chose. He developed a way of working that sacrificed all other considerations to these needs. Camera position, so carefully chosen in earlier work, was determined by the width of the subway car, the distance of the seat opposite. Framing decisions were ignored; it was more important to keep the camera hidden, so he chose not to use the viewfinder. He felt he needed a shutter speed of ¹⁄₅₀ second to avoid blurs, so he accepted the difficulty of working with negatives so thin they record scarcely more than highlights. This technique was totally different from the controlled descriptive technique used to photograph the Savannah penny picture display a few years earlier, but his subject was the same. He was approaching it from a different angle — from the private, rather than the public side, and as a different man perhaps, but with no less intensity of interest and rigor of observation.

Evans developed, or rather revived and refined, another way of working in 1955 when he made studio photographs of small hand tools for the *Fortune* essay "Beauties of the Common Tool." He had used a view camera in the studio before, to make still lifes and to photograph several hundred pieces of African sculpture; most of his work, however, had been done in the rooms, streets, and fields of the everyday world. Even so, he decided to photograph these tools out of their everyday context. His purpose was to see them as efficient form, as objects useful but unselfconsciously beautiful at the same time. He avoided strong directional light, which, while it might emphasize the broad outlines of plastic form, might obscure the identity of the objects and introduce potentially confusing shadows. He fixed the tools above a plain background and placed the camera squarely above each tool. In several instances he had the backgrounds retouched to eliminate all traces of shadows. The resulting pictures are purely about the tools as *things*, and not about their temporary circumstances of light and place. Again Evans's subject was a familiar one — he had earlier photographed many hardware store window displays — but examined from a different point of view, and with a different photographic approach.

Evans continued to publish portfolios of photographs in *Fortune* until he retired in 1965. From then on he lived most of the time in his house in Old Lyme, Connecticut. After a successful 1964 lecture on the subject of postcards (a lifelong interest) at Yale University, he began to teach photography there. His courses attracted interested undergraduates as well as more specialized graduate students in the School of Art, and his teaching sometimes took the form of week-long field trips to areas where he wanted to work.

Throughout the 1960s and early 1970s, Evans continued to respond in regular fits of intensity to what he called his "subject." Occasionally he would travel by car, often with a younger companion who helped with the gear, to a place he knew would be good for him: Nova Scotia, Maine, Virginia's Eastern Shore, the backwoods of New Hampshire — some area that had not greatly suffered from prosperity and development. He tended to avoid the territory he had worked over in the 1930s.

At this time his equipment was a set of five, and later six, Rolleiflexes — two with normal lenses, two with wide-angle lenses, and two with telephoto lenses — and two Leicas, one with a normal and one with a 35 mm wide-angle lens. One of the Leicas, and maybe one or two of the Rolleiflexes, might be loaded with color film. He and his assistant would drive toward some known or suspected goal (perhaps he had been tipped off by a friend or student), stopping whenever something good presented itself. Evans would call for a stop, get out, and assemble his equipment on the hood or tailgate of the car. Then he would walk out into the field (as it often was), approaching, circling, and photographing the object that had attracted him. He might return for a freshly loaded camera or a cup of tea from a thermos, and then set out again. By the early 1970s his appearance and habits gave ample evidence of advancing age, but these working trips (as he called them) were not nostalgic reenactments of the old days. He was still pursuing a subject, and he was capable of intense (if brief) periods of excitement over a good find. During these episodes, his usual polite, almost reticent manner became ferocious: when stimulated, he would stop at nothing to get at a good manifestation of his subject.

By this time he left darkroom work to others: assistants, friends, or sometimes a highly regarded commercial laboratory. He had contact sheets made of all his negatives and went over them with considerable care, marking the pictures he wanted and indicating cropping, when needed. Then he would arrange to have prints made — in his own darkroom, if possible, so he could watch the work progress.

By 1971 there was a good chance that the subject Evans chose would be some kind of sign. Signs had always been part of his subject, but by 1971 they had become almost his artistic obsession. Frequently on his excursions he would photograph a sign and then remove it, if possible, and take it with him. Often he would photograph the sign again at home, and on one occasion he exhibited photographs of signs and the signs themselves side by side. Sometimes he would take the sign and not bother to photograph it at all. It was as if he felt that his role all along had been that of connoisseur, one who pointed out the things of true importance. The photograph had always been his way of making clear exactly what it was that had significance; perhaps he thought that at his age he would

dispense with the bother of technique altogether and allow himself the pleasures of working with the things themselves. He would have taken objects larger than signs, if he had had the means; he once bought the entire contents of a barn sale and had it delivered to the nearby yard of a friend.

Evans did continue to photograph, however, almost to the end of his life. He developed an interest in the Polaroid SX-70, partly because it took color pictures and partly because it gave instant results. It was not so much that he wanted to see pictures as he worked — he made many variations as before, and looked at the pictures later — but he liked being able to edit (and sign) his day's work at the end of the day, without waiting to have it developed and printed. Also he liked the camera's simplicity; he said several times that so streamlined a process put all responsibility on the mind and eye, leaving nothing to be added by technique.

He carried this camera with him on his daily outings, making hundreds of pictures of signs, bits of litter, and the faces of his friends and students. This work was ended in late 1974 by a fall which broke his collarbone and left him unable to hold the camera.

In 1972, while Evans was artist in residence at Dartmouth College, a student asked him which camera he had used to make one of his pictures, which was on display. After a pause Evans said he rather resented the question, that it was like asking a writer what typewriter he used. His clear implication was that the tool mattered little, that the artist's intelligence and skill were everything. While this is true, it may also have been true that Evans was unable to remember which of the many cameras he had owned had been used to make that picture. At the time of his death in 1975 he owned five Polaroids, three Leicas with lenses ranging from 21 mm to 50 mm, a Nikon with two lenses, a Contax, a Miranda, one Master Reflex (2¼ x 2¼), six Rolleiflexes, a 4 x 5 Speed Graphic with two lenses, a 5 x 7 view camera with a Wollensak triple convertible, an 8 x 10 Korona view camera with a triple convertible, and a dozen antique cameras of various sizes.

Amenia, N.Y. Jerry L. Thompson

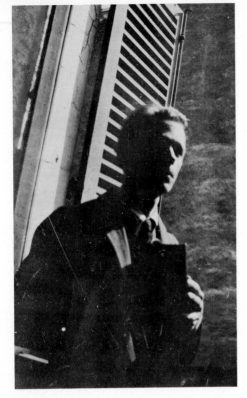

Self-portrait, September 1926

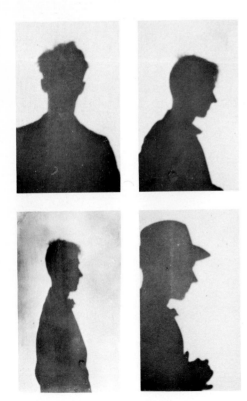

Silhouette self-portraits, January 1927

New York, Apr. 6 [1926] noon, RMSP *Orduna*

Cherbourg, Apr. 16, 7 p.m.

Paris, Apr. 17

 Hotel Cambon

 Hotel Fleurus, Apr. 21

Versailles, May 1

Marseille, Hotel Terminus

 about July 1

Cannes, Maden Hotel, Rue Serbes

 about 2 July

Juan les Pins, chez Alliaume

Villa Myosotis, about 15 July

Paris, 5 Rue de la Santé, 1 Aug.

Deauville ⎫

Dinard ⎬ Sept.

Douamenez ⎭

5 Rue de la Santé, Mme Thuillier

 Nov. 2–3

Marseille, Jan. 3 [1927]

 Aix en Provence

Villefranche, Hotel Welcome, Jan. 4

Juan les Pins, Villa Choupette, Jan. 15

Juan les Pins, Hotel des Fleurs, 24 Mar.

S.S. *Biancamano*, sailing from Villefranche, 4 April at

 midnight

Genoa, Apr. 5, 6 a.m.

Arr. Naples, 6 Apr., 6:30 a.m.

 Pensione Marcini Partinope

Lv. Naples nr. midnight Apr. 12

Rome, 6 a.m. Apr. 13 Wed.

Lv. Rome 2:30 a.m. Apr. 13

Florence, 8 p.m. Wed. Apr. 13

 Pens. Constantin, Via Solferino

Lv. Florence midnight Fri. 22 Apr.

 Change Pisa, arr. Genoa 22 Apr., 6 a.m.

Genoa, 7:30 a.m. Bordigliera, Ventimiglia

Ventimiglia, 2:30–5:10 p.m. &

 arr. Juan 8 p.m. Sat. 23 Apr.

Lv. Paris 10 Mai, 9:35 a.m.

Lv. Cherbourg 5:15 p.m., 10 Mai

Arr. N.Y. 11:45 a.m., 16 May

Pages in travel diary

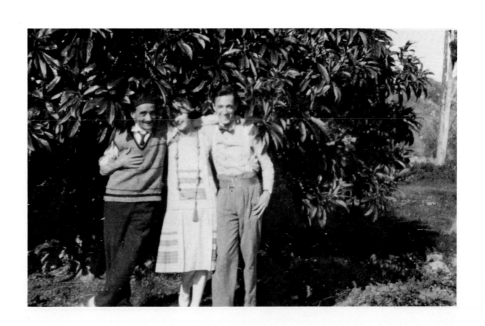

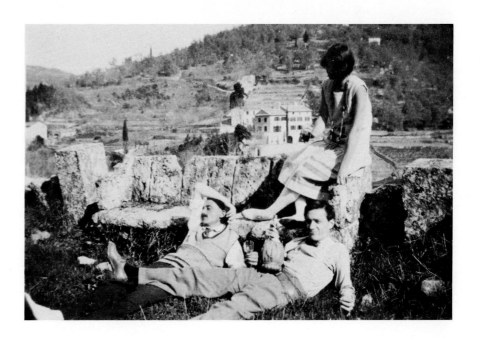

Evans in France, 1926–1927

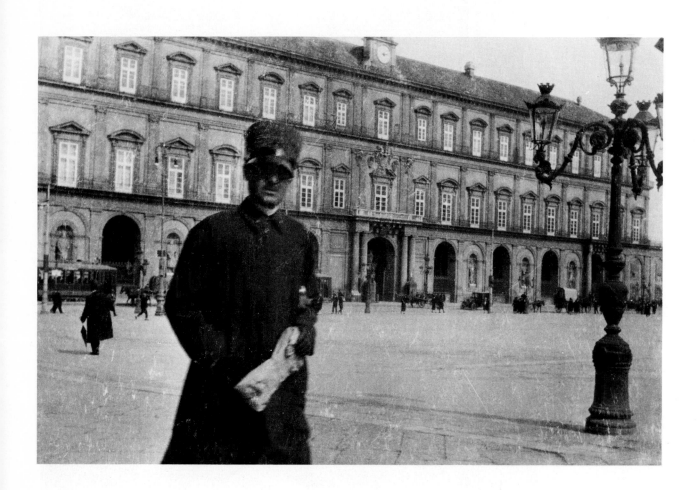

I had a vest-pocket camera [in Paris] and I still have
about three snapshots that I made, and they're quite
characteristic. They're documentary scenes.

Tape: 2/1/73

European snapshots, 1926–1927

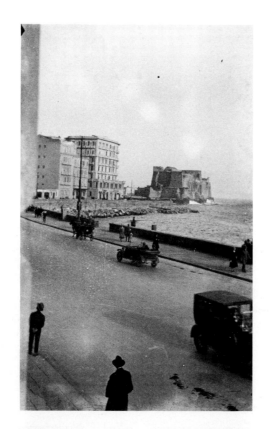

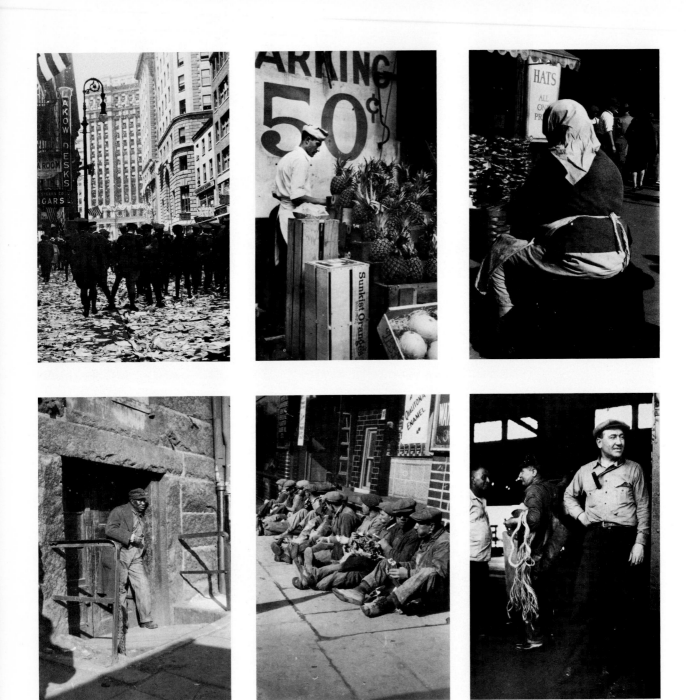

New York City, 1928–1929. 2¹/₂ x 4¹/₄ roll film negatives;
facing page, Evans's cropping and enlargement

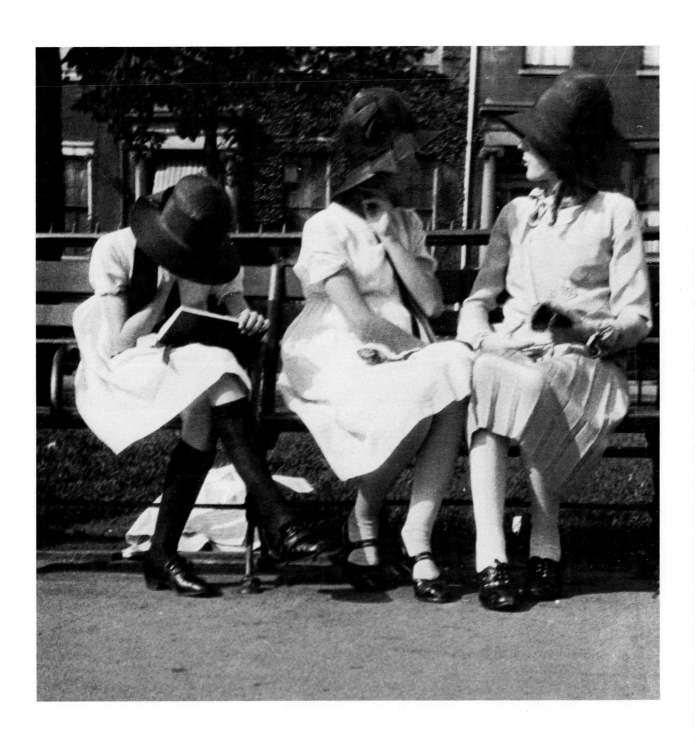

I came across that picture of Strand's blind woman and that really bowled me over. But I'd already been in that, and wanted to do that. That's a very powerful picture. I saw it in the New York Public Library files of *Camera Work*. That's the stuff, that's the thing to do. Now it seems automatic even, but it was quite a powerful picture. It charged me up.

Letter to Hanns Skolle, 6/28/29

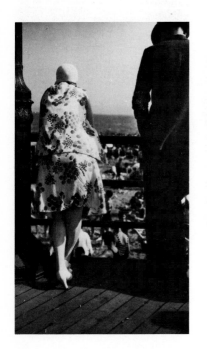 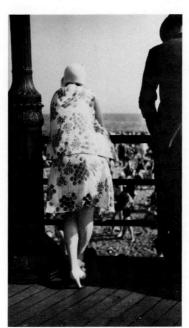

Coney Island, New York, 1928 or 1929.
2½ x 4¼ roll film negatives

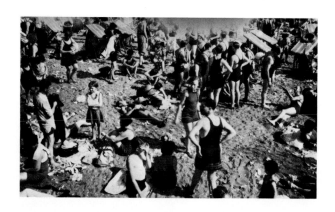

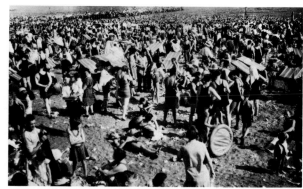

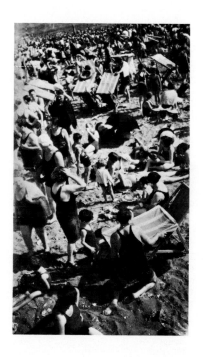

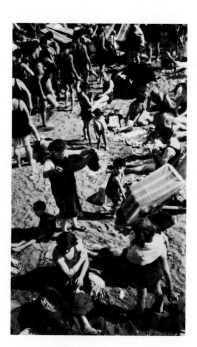

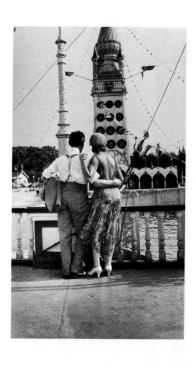

New York City, 1928–1929.
$1^{5}/_{8} \times 2^{1}/_{2}$ and $2^{1}/_{2} \times 4^{1}/_{4}$ roll film negatives

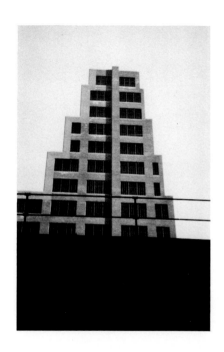
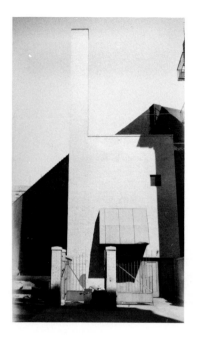
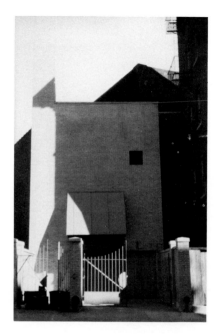
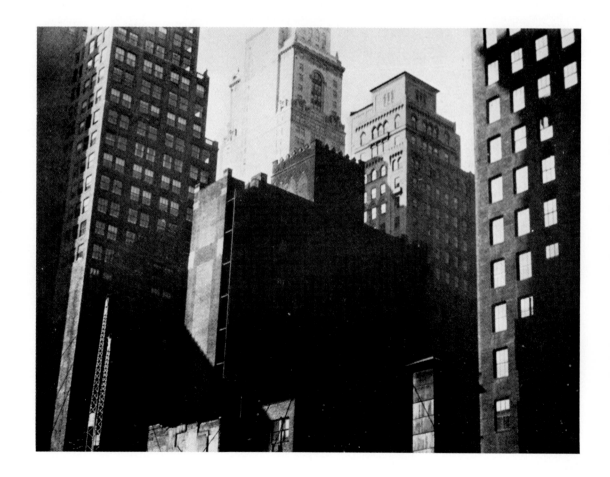

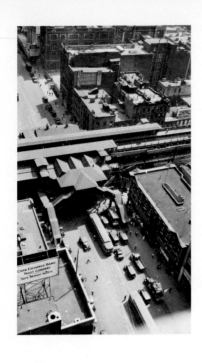

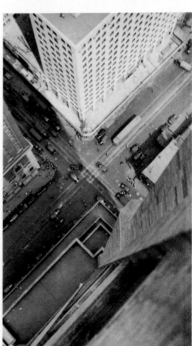

New York City, 1928 or 1929.
2¹/₂ x 4¹/₄ roll film negatives

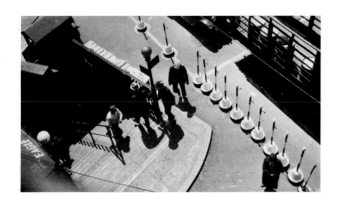

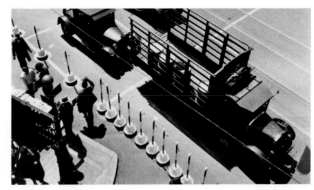

"Evans is one of the objectively recording photographers, these glorified reporters supremely indifferent to the technical side of their trade, who go to Nature in all singleness of heart and armed with a Kodak. He can be compared to Atget, the French photographic primitive who made thousands of plates of the Paris streets. . . . To both Evans and Atget 'life is beautiful,' but Atget's vision of life was full of horse buggies, headless dressmakers' dummies, and corset shop windows; whereas Evans understands life in terms of steel girders, luminous signs and Coney Island bathers."

M. F. Agha, Introduction to John Becker Gallery exhibition catalogue, 1931

New York City, 1928 or 1929.
2¹/₂ x 4¹/₄ roll film negatives

New York City, 1928–1929. "Broadway Composition,"
probably 35mm negatives

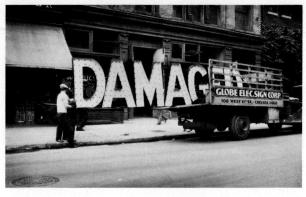

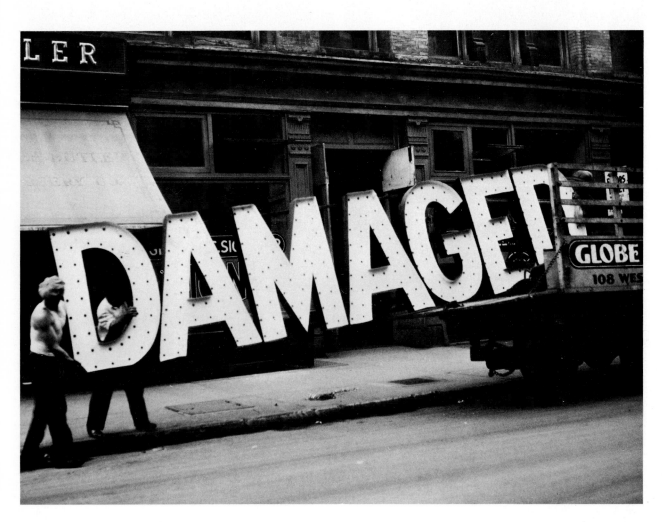

New York, 1928 or 1929. 2^1/$_2$ x 4^1/$_4$ roll film negatives

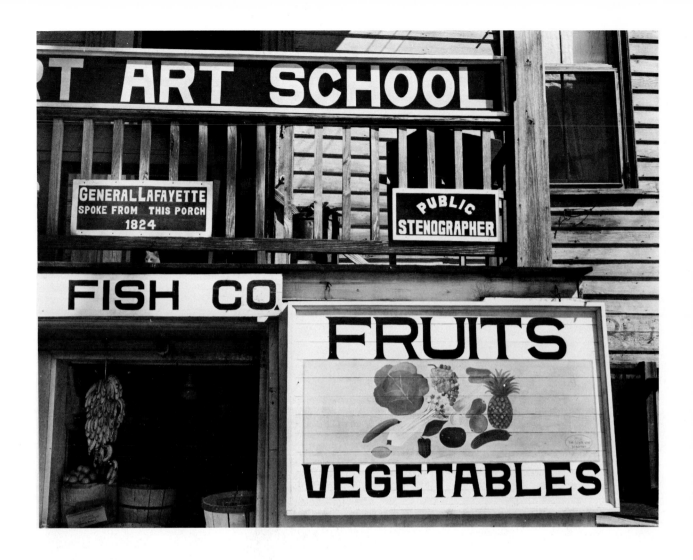

I can show wit and humor in a photograph and have it missed now because nobody is in a frame of mind to laugh or enjoy wit.

Tape: Katz/Evans interview for Art in America, *April 1971*

South Carolina, 1936. 8 x 10 negative

Coney Island, New York, 1928 or 1929.
2¹/₂ x 4¹/₄ roll film negatives

Coney Island, New York, 1928 or 1929.
2¹/₂ x 4¹/₄ roll film negatives

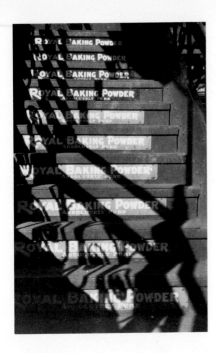
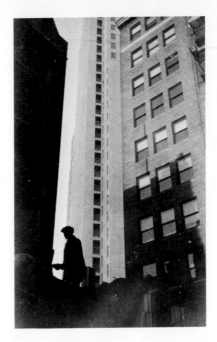
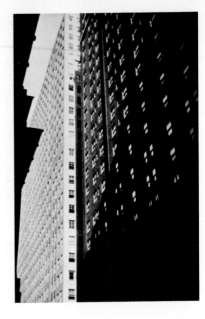

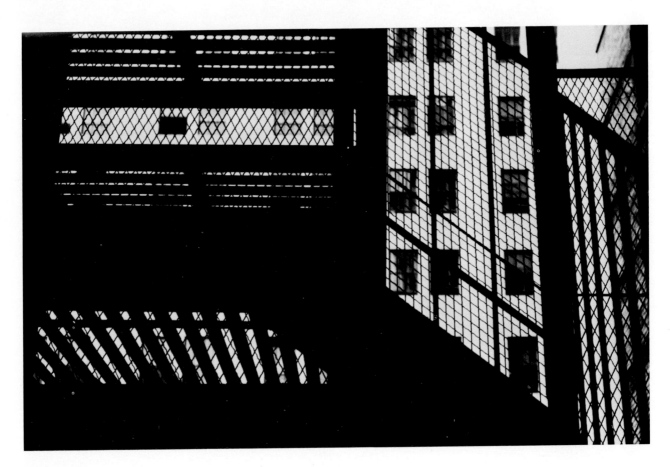

New York City, 1928–1929.
1⁵/₈ x 2¹/₂ and 2¹/₂ x 4¹/₄ roll film negatives
Cf. page 213.

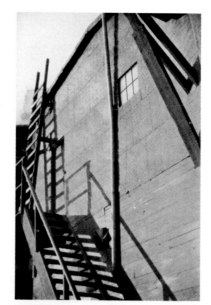

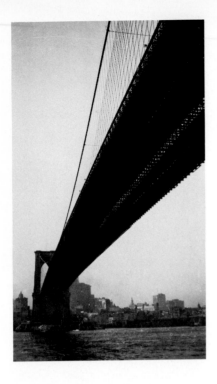
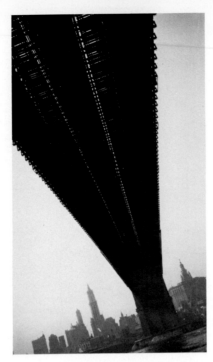
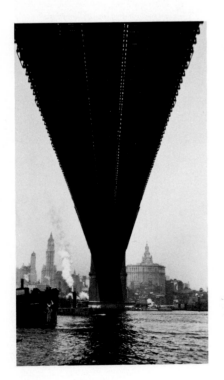
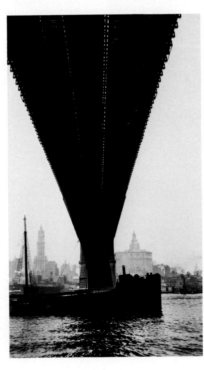
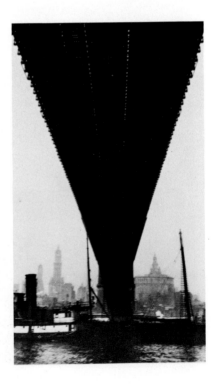

Brooklyn Bridge, 1929.
2^1/$_2$ x 4^1/$_4$ roll film negatives , except
upper right, facing page, 1^5/$_8$ x 2^1/$_2$

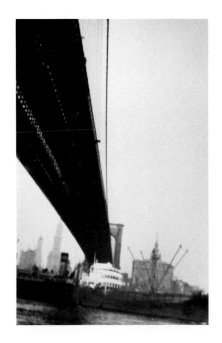
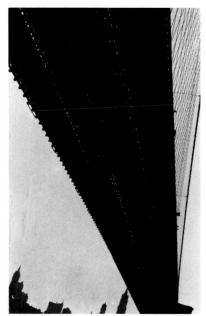
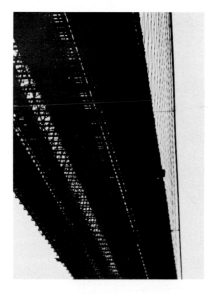
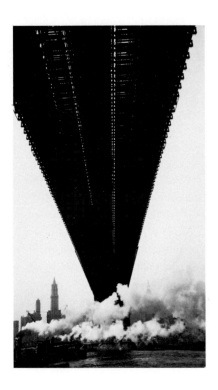
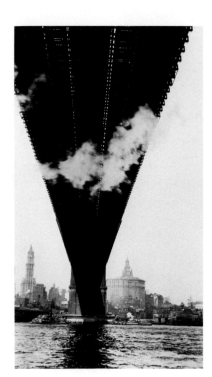
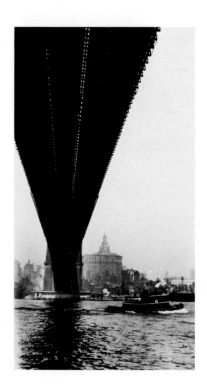

41

 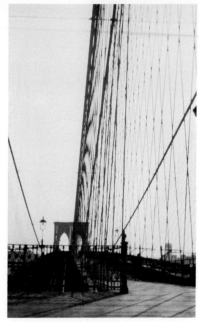 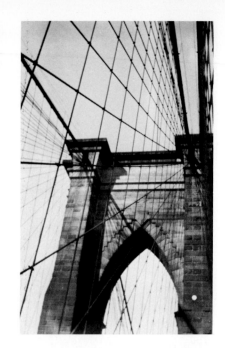

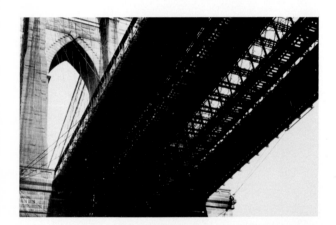

Some of them [early photographs] are romantic in a way that I would repudiate now. Even some of those Brooklyn Bridge things — I wouldn't photograph them that way now. I developed a much straighter technique later on. But in 1928, '29 and '30 I was apt to do something I now consider romantic and would reject. I hadn't learned to be more straight about things. . . .

Katz/Evans interview

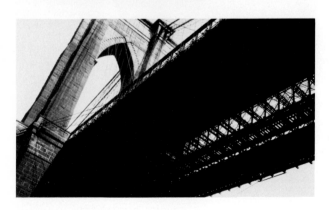

"By the way, will you see that the middle photograph (the one of the barges and tug) goes between the 'Cutty Sark' Section and the 'Hatteras' Section. That is the 'center' of the book, both physically and symbolically. Evans is very anxious, as am I, that no ruling or printing appear on the pages devoted to the reproductions — which is probably your intention anyway."

Hart Crane letter to Caresse Crosby
December 26, 1929

Brooklyn Bridge, 1929.
1⅝ x 2½ and 2½ x 4¼ roll film negatives

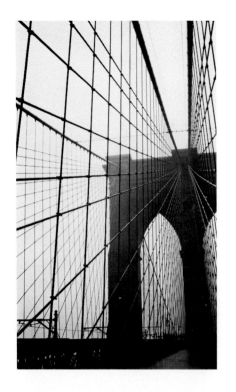
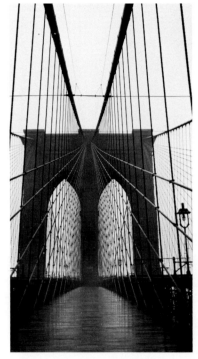
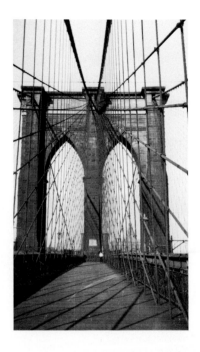
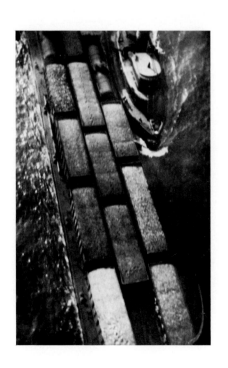

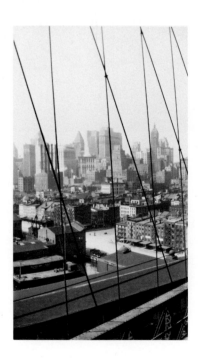

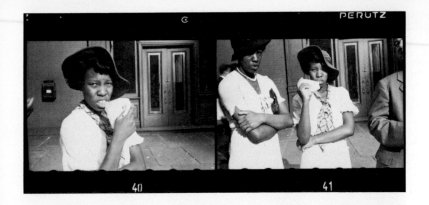

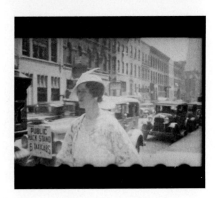
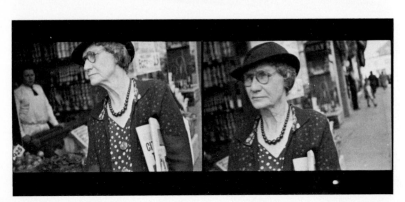

That photo I sent you was made with Grotz' little Leica camera, using a special close-grain film imported from Germany at a stiff price, but allowing enlargement to huge proportions if desired. We have thrown that one up to almost life size.

To Skolle, 6/24/29

As a matter of fact, I had a few, sort of prescient, flashes – unconscious flashes – and they led me on. I found that what I wanted to do was get a type in the street, for example, and grab a very natural snapshot of a fellow on the waterfront, or a stenographer at lunch, and things like that. That was a very good vein. I still mine that vein . . . I could have done newsreel photography, and there was a lot more of it in those days. . . . That was documentary photography with a vengeance, and wonderful.

Katz/Evans interview

New York City, 1929–1930. 35mm negatives

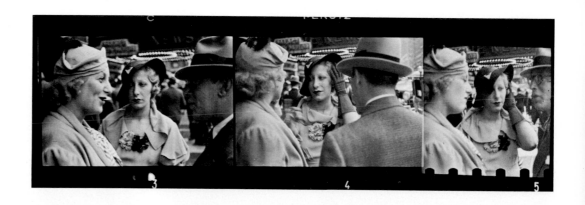

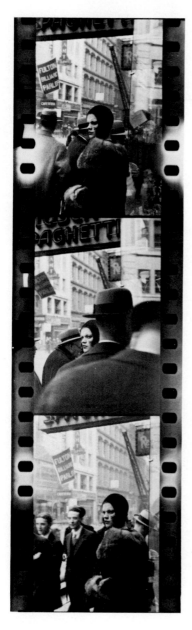

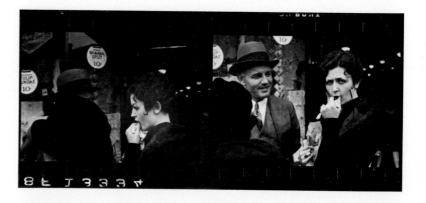

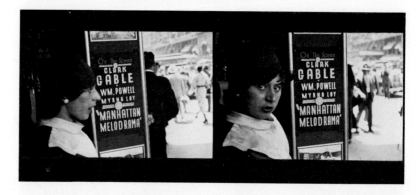

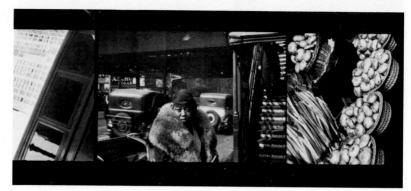

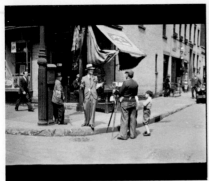
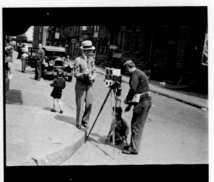
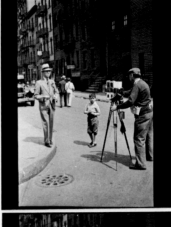
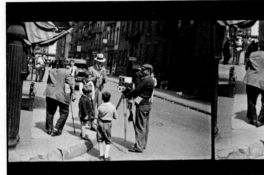
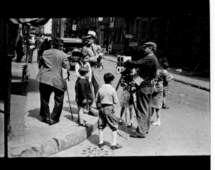
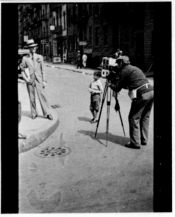

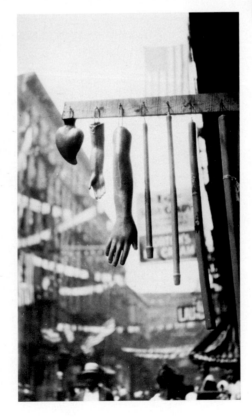

New York City and Westchester County, 1929–1930.
35mm negatives, except lower right, 2¹/₂ x 4¹/₄ negative

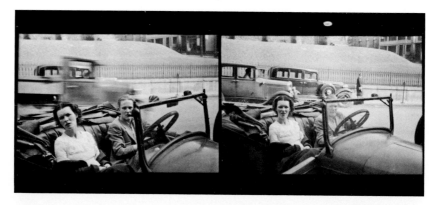

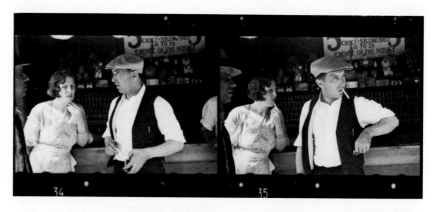

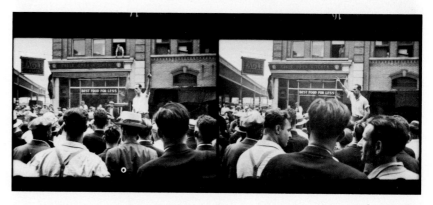

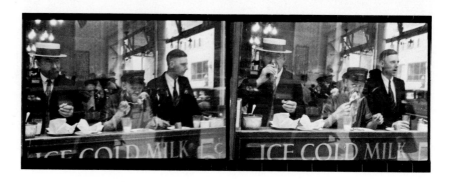

You will remember, we made two portraits of you in Darien (with the view-camera). The one I sent you was the only success. I think it is damned good; like it better and better. I see that it takes a born actor to pose for camera portraits. Apparently you are one, since I have always had good results with your head.

To Skolle, 2/25/30

1929–1930. 4 x 5, 5 x 7, and 6¹/₂ x 8¹/₂ negatives
This page; Paul Grotz, Ben Shahn, Berenice Abbott
Facing page; Jane Evans Brewer, Hanns Skolle,
Hart Crane, Lincoln Kirstein

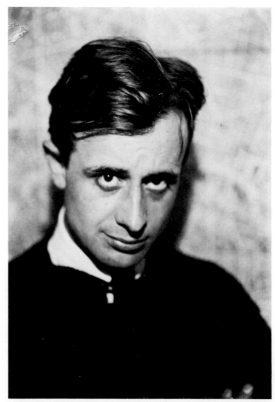

Augmented the series of Victorian architecture photos with a rather better series, during a second trip to Boston. . . . Ralph Steiner, the photographer, has turned out to be most generous, and has offered to teach me photography. . . . I will let him work on me as much as he likes. He has made some of the best street snapshots of people I have seen, but doesn't show them. People greeting one another, showing off, et cet. . . .

To Skolle, 7/4/31

"In order to force details into their firmest relief, he could only work in brilliant sunlight, and the sun had to be on the correct side of the street. Often many trips to the same house were necessary to avoid shadows cast by trees or other houses; only the spring and fall were favorable seasons. . . .

"These houses were found by searching in an automobile, with the photographic equipment in the rumble, wherever Evans chanced to be for a sufficient length of time . . . metropolitan Boston, the North Shore of Massachusetts, Cape Cod, Martha's Vineyard, Northampton, Mass., Greenfield, Saratoga Springs . . ."

Lincoln Kirstein, Museum of Modern Art Bulletin, *December 1933*

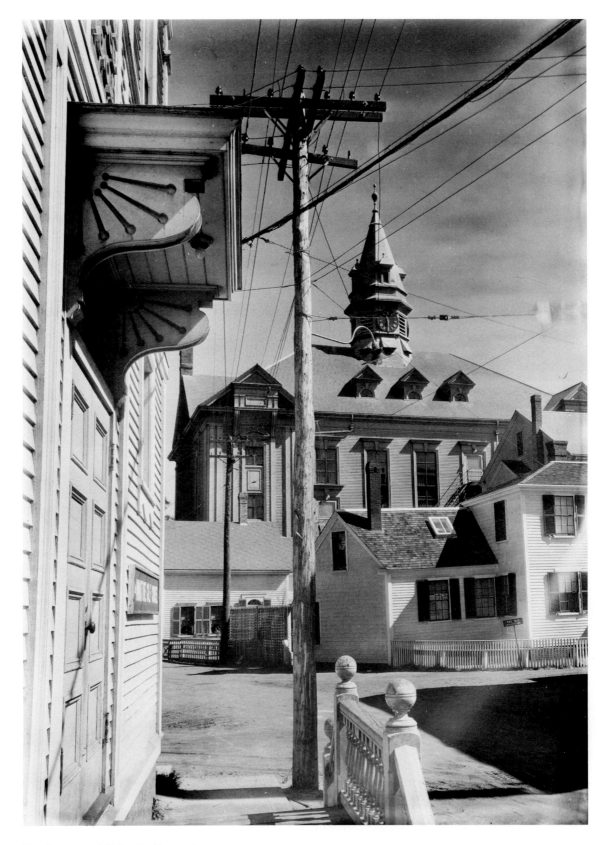

Provincetown, 1931. 5 x 7 negative

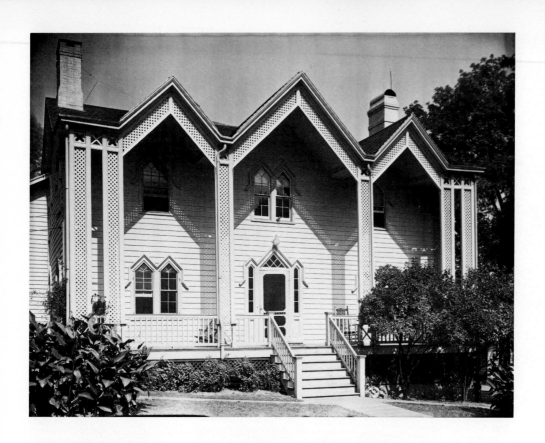

Victorian architecture, 1930–1931.
5 x 7 and 6¹/₂ x 8¹/₂ negatives, except lower photograph,
this page, which is 8 x 10

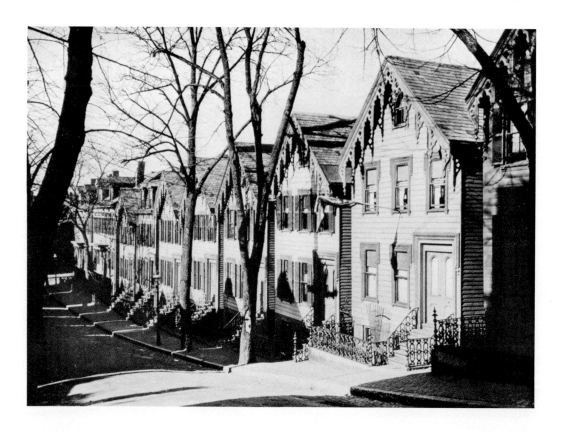

53

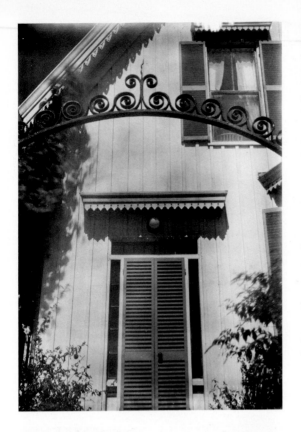
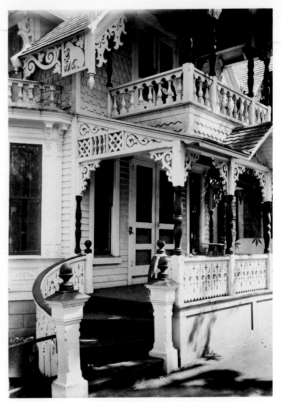
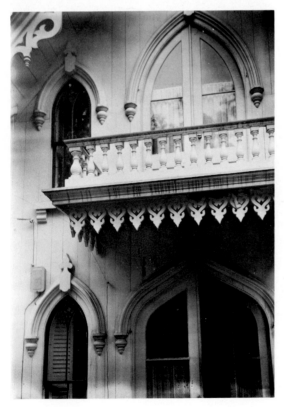
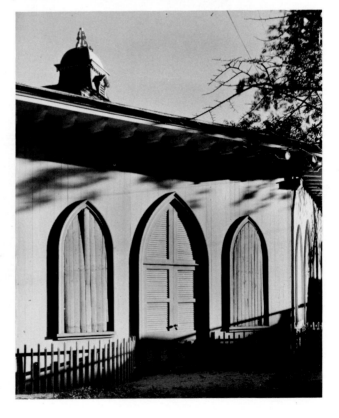

Victorian architecture, 1930–1931.
5 x 7 and 6¹/₂ x 8¹/₂ negatives, except upper photograph,
facing page, which is 5 x 7 fragment of 8 x 10 negative

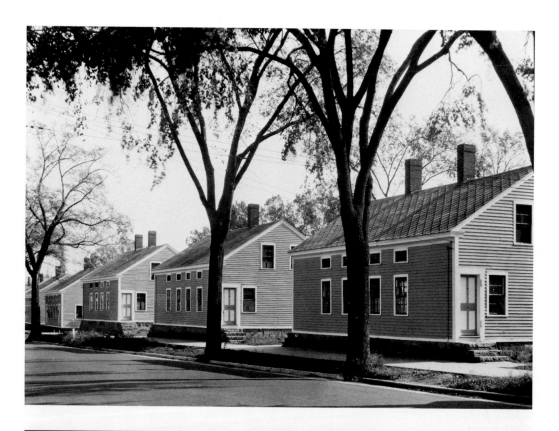

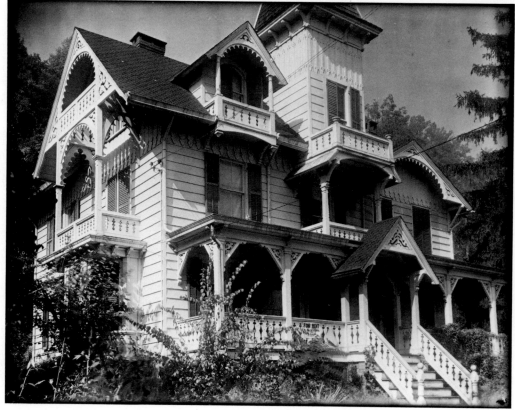

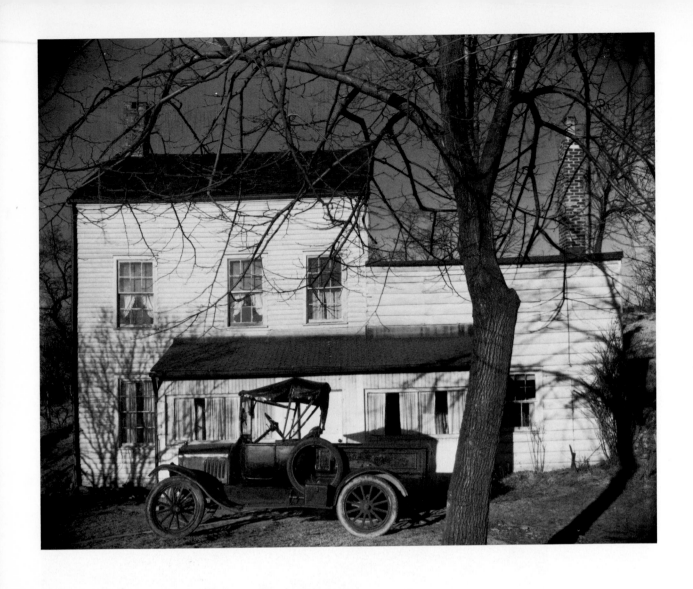

Westchester County, 1931. 8 x 10 negatives, except bottom,
facing page, which is a fragment cut from an 8 x 10 negative

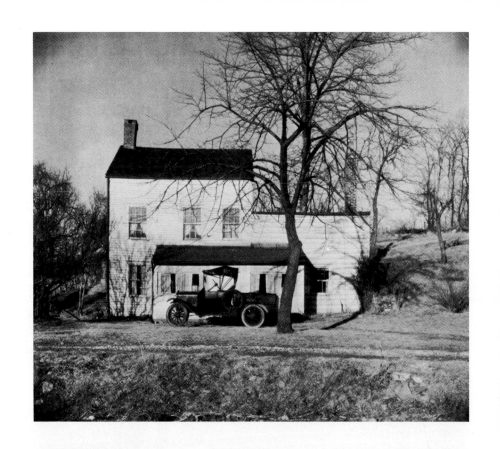

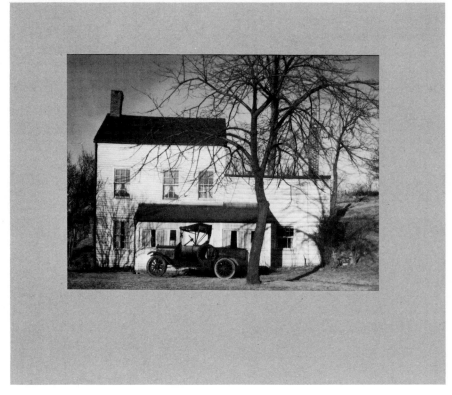

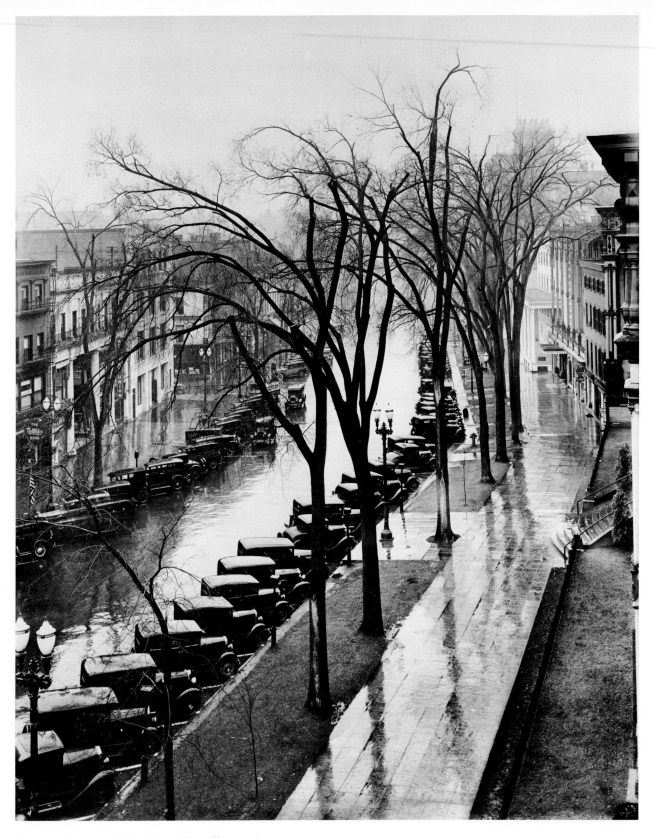

Saratoga Springs, 1930, 1931. 6^1/$_2$ x 8^1/$_2$ negatives
except lower two, facing page, which are 5 x 7

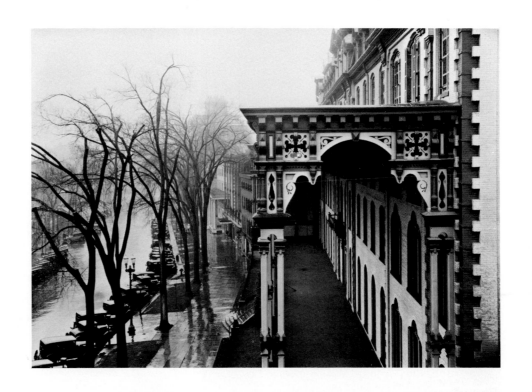

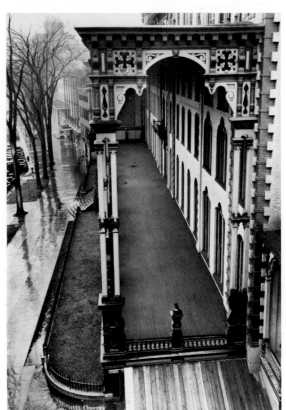

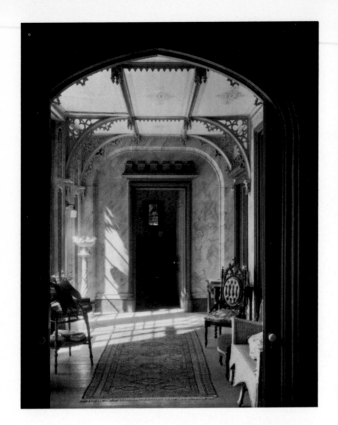

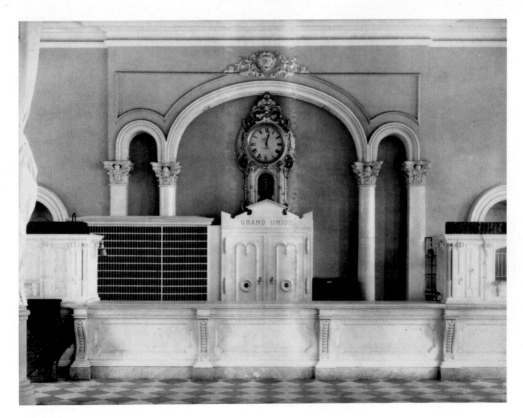

*Saratoga Springs, 1931. 6¹/₂ x 8¹/₂ negatives except
top left this page, which is 8 x 10*

Saratoga Springs, 1931. 6¹/₂ x 8¹/₂ negatives

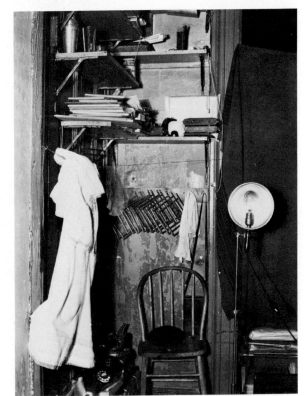

*Evans's workrooms, 1930–1940. Top photograph facing
page by Paul Grotz*

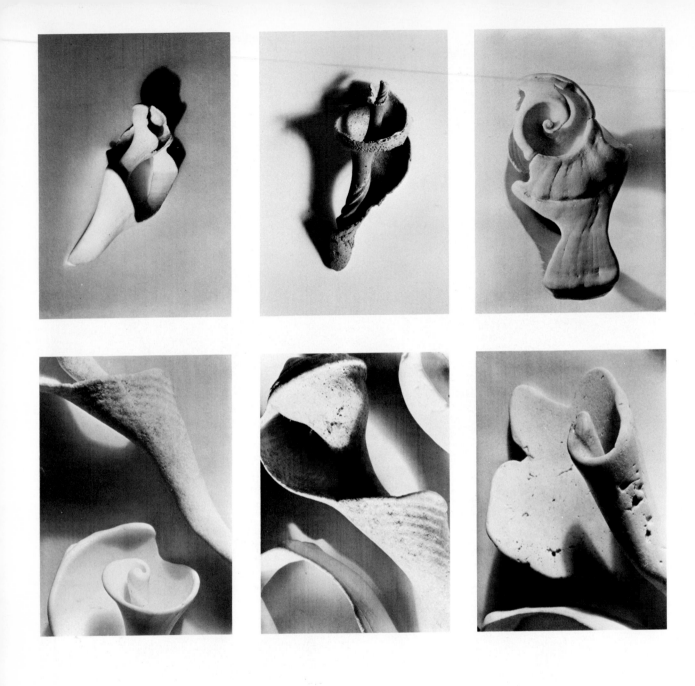

Private commission, ca. 1934. 5 x 7 negatives

Cape Cod and Martha's Vineyard, 1930, 1931.
5 x 7 and 6¹/₂ x 8¹/₂ negatives

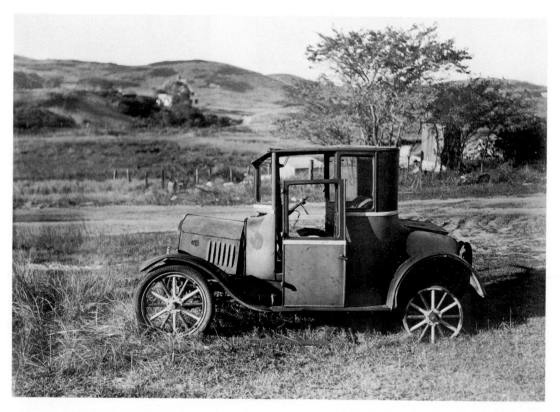

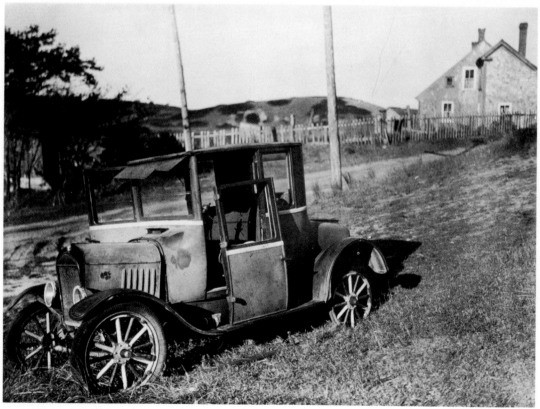

*I think I incorporated Flaubert's method almost
unconsciously, but anyway I used it in two ways; both his
realism, or naturalism, and his objectivity of treatment.
The non-appearance of author. The non-subjectivity.
That is literally applicable to the way I want to use
a camera and do.*

 Katz/Evans interview

*Is it too late to arrange an exhibition for me this season?
I could have about thirty prints out there in a month's time.
Need money it might bring in. Would charge ten or fifteen
dollars a print. Or anything appropriate!*

 To Skolle, 3/11/1930

*I am going to publish some photographs in order to become
known and make someone exhibit me and sell prints and
make money and take leave of certain malaise.*

 To Skolle, 6/9/1930

Truro, Mass., 1930, 1931. 6¹/₂ x 8¹/₂ negatives

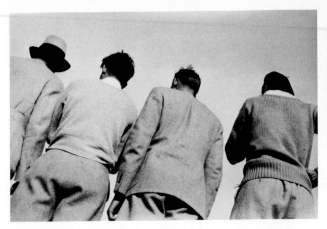

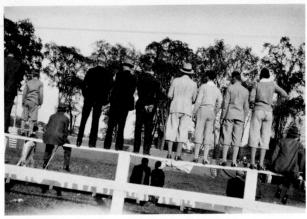

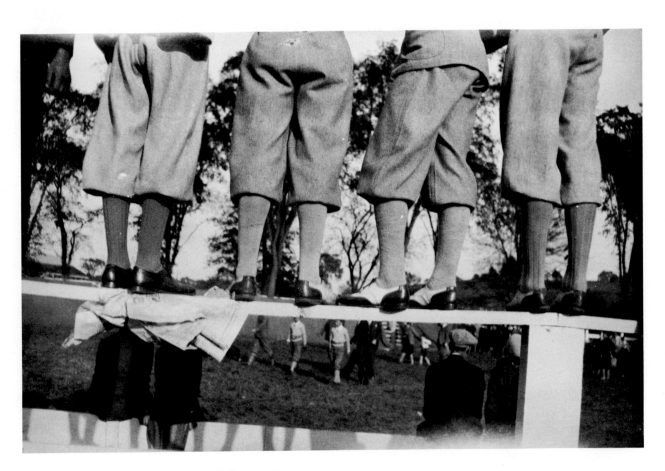

Spectator sport, ca. 1929. $2^1/_2$ x $4^1/_4$ roll film negatives

New York City, 1929. 2¹/₂ x 4¹/₄ roll film negative.
Walker Evans at work, 1929, photograph by Paul Grotz

The Cressida is 170 ft. topsail schooner, steel hull, Diesel power, German built 1927, chartered from owner for four months cruise in Southern Pacific. . . . Average speed 11 knots. Library of George Moore, Beerbohm, Boswell, Conrad, Alice in Wonderland, Schopenhauer, Hardy, Ring Lardner, Dostoyevski, Andre Gide, Apuleius, Willa Cather, Samuel Butler, Hamsun, Shakespeare. Four tiled bathrooms, no official sexlife.

To Skolle, 1/1/32

I will send some pictures of the South Seas which by the way are nothing much I mean the pictures as well as the South Seas. Romantic journalism, the beautiful tropic isles, etc., but not up to my usual great work.

To Skolle, 5/19/32

I am beginning to understand what sort of a period we are living in. Now I am thrown on my own resources (which thank heaven are something at present, through photography). There is nothing to be done but go after money by the nearest means to hand. For instance I have "contacts" and "leads." People in such bastard trades as advertising, publicity, etc. have sometimes heard of me because I have given two exhibitions of photos. So I may get a job. I may make photo murals for Bloomingdale's store or I may make theatrical posters for Roxy's theatre. As they want them, of course; not my way. Also I brought back some few thousand feet of film from this South Sea trip, through which I may break into something. The film by the way is good in spots. That is, there are a few irrelevant shots that are beautiful and exciting in themselves. . . . If I can sell the whole works to movie people, I will, of course. If not, I'll try to make something short and original and then show it to the Guggenheim Foundation or Otto Kahn or anyone else who might help me go on and make some more. Movies, as you know, are very expensive. The materials for this one I made came to $1,000, paid for by the people who took me along. . . . Movies are more difficult than I realized. I seem to be able to get striking individual pictures but have difficulty in composing any significant sequence. Hard to dramatize my subjects. The technique is not especially difficult. Out there I depended a lot on color filters and telephoto lenses. I was really surprised the stuff came out into well-taken pictures, have learned from this little experience that results *can* be gotten anyway, by my own hand. The thing is, I went in fear and trembling because I knew next to nothing about how to operate my machinery, and couldn't tell what I was getting until we got back to New York. . . .

To Skolle, 5/19/32

Tahiti, 1932 . 6^1/$_2$ x 8^1/$_2$ negative

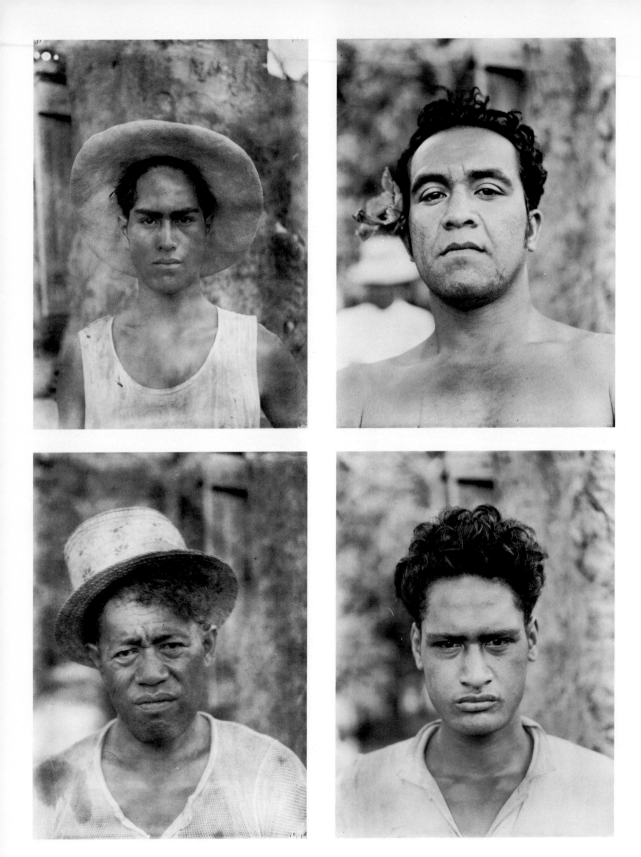

Tahiti, 1932 . 6¹/₂ x 8¹/₂ negatives
except 2¹/₂ x 4¹/₄ roll film negative, bottom, facing page

76

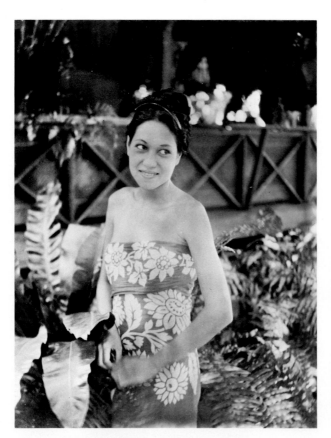

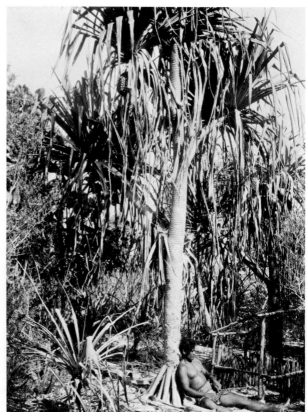

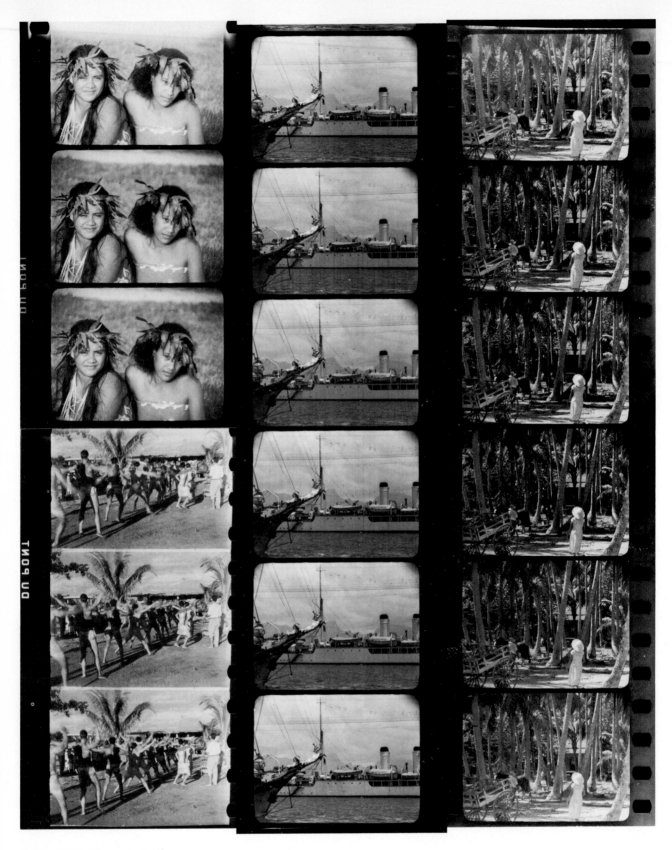

Tahiti, 1932 . 35mm movie film

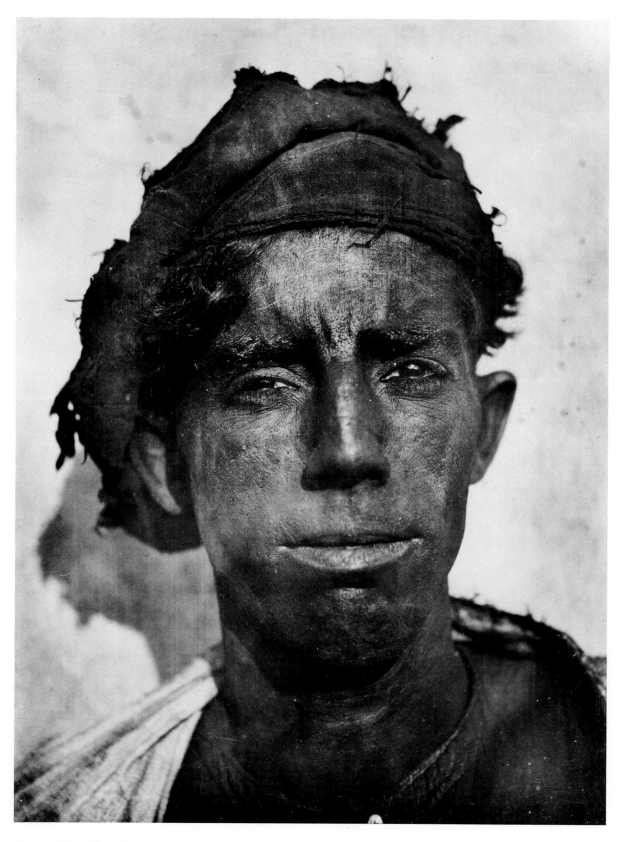

Cuba, 1932. $6^{1}/_{2} \times 8^{1}/_{2}$ negative

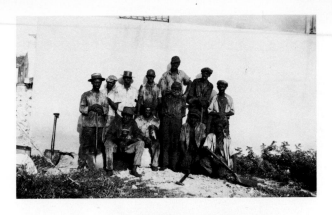

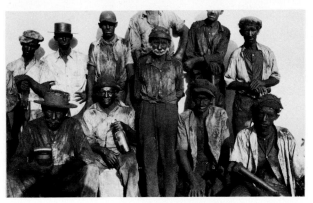

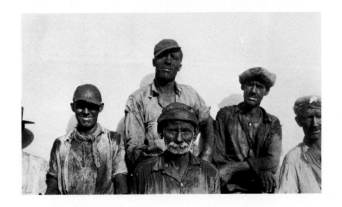

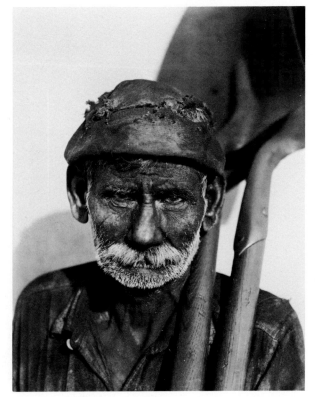

Cuba, 1932 . 6¹/₂ x 8¹/₂ negatives
except left column, above, which are 2¹/₂ x 4¹/₄ roll film

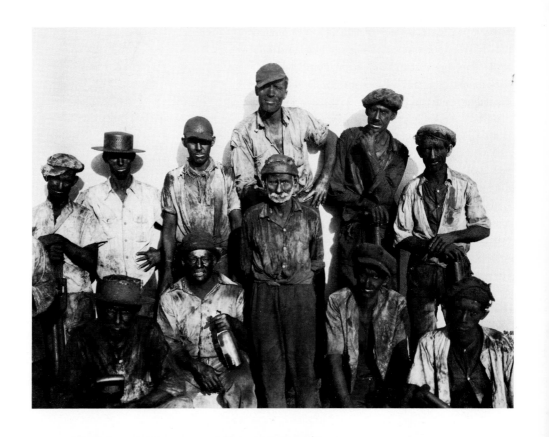

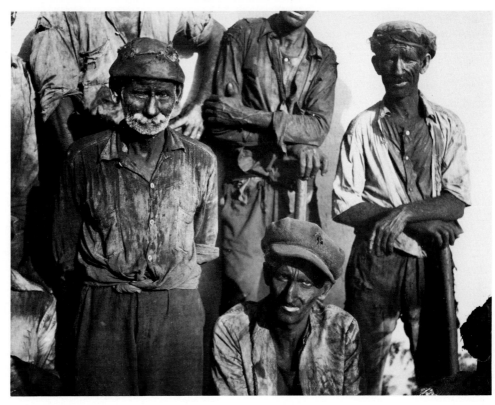

It was a job. It was commissioned. You must remember that this was a time when anyone would do anything for work. This was a job of a publishing house publishing a book about Cuba, and a friend arranged that I should do the photography. So I grabbed it. I did make some conditions. I said I wanted to be left alone. I wanted nothing to do with the book. I'm not illustrating a book. I'd like to just go down there and make some pictures but don't tell me what to do. So I never read the book. But I did land in Havana in the midst of the revolution, and Batista was taking over, and I had a few letters to newspapermen, which turned out to be lucky because it brought me to Hemingway. So I met him. I had a wonderful time with Hemingway. Drinking every night. He was at loose ends . . . and he needed a drinking companion, and I filled that role for two weeks. . . . I think I was only down there for two weeks, and then I added a week on Hemingway's generosity. As a matter of fact, I said to him I'm going home — because I had a return ticket and I ran out of money — and he said stay around for another week, and I'll pay for it, and he did.

Tape: Boston interview, 8/4/71

("How long had you been shooting seriously when this job came — were you quite sure of your direction or did that come later?")

I was pretty sure then, yes. I was sure that I was working in the documentary style. Yes, and I was doing social history, broadly speaking.

Boston interview

Those people [the dockworkers] have no self-pity. They're just as happy as you are, really.

Interview, Yale Alumni Magazine, *February 1974*

Cuba, 1932. 6¹/₂ x 8¹/₂ negatives

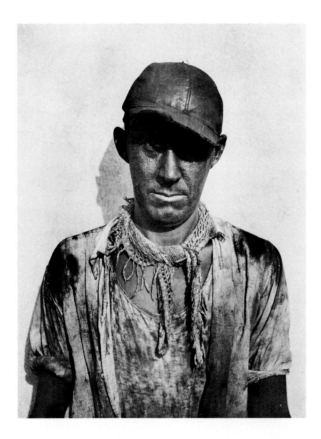

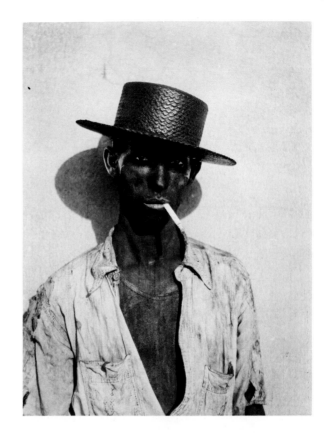

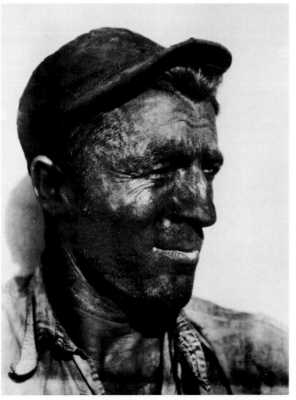

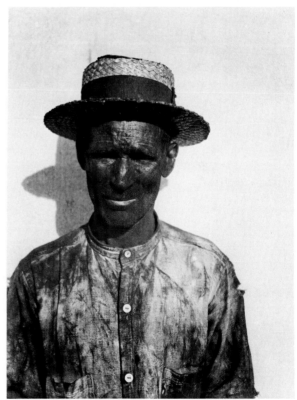

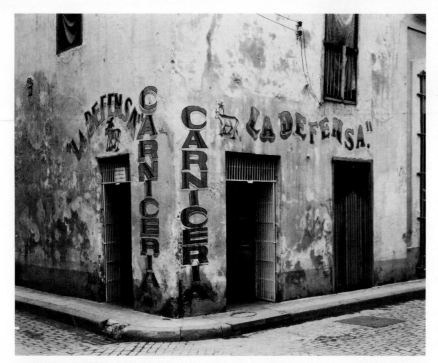

Cuba, 1932. 2¹/₂ x 4¹/₄ roll film negatives
except left column, above, which are 6¹/₂ x 8¹/₂

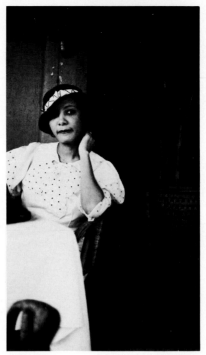
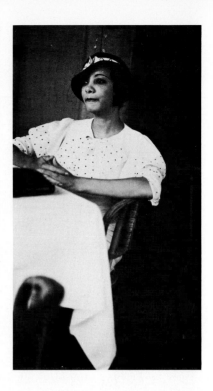
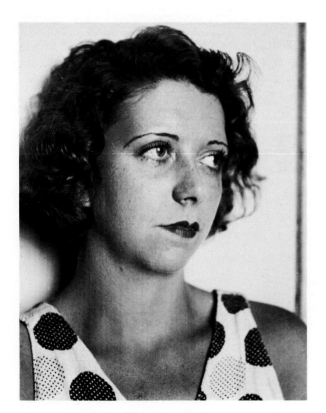
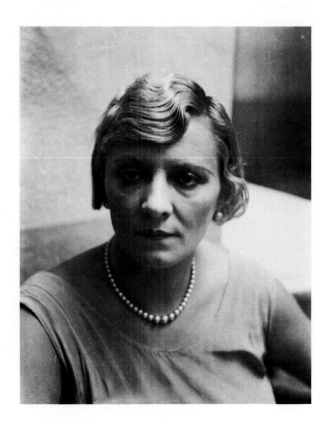

Cuba, 1932 . 2¹/₂ x 4¹/₄ negatives, top this page
and top left, facing page; other negatives 6¹/₂ x 8¹/₂

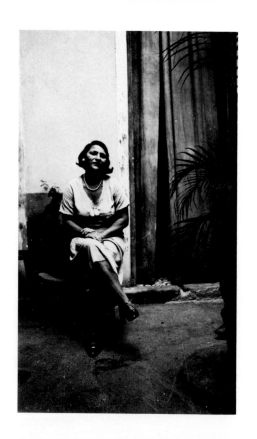

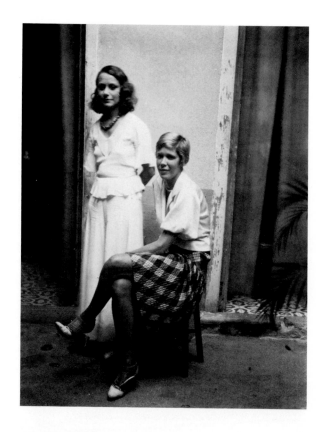

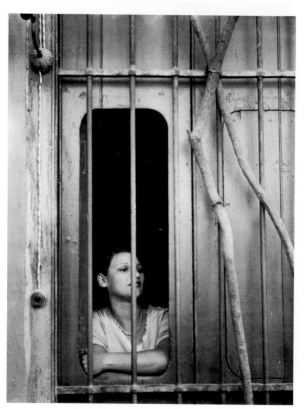

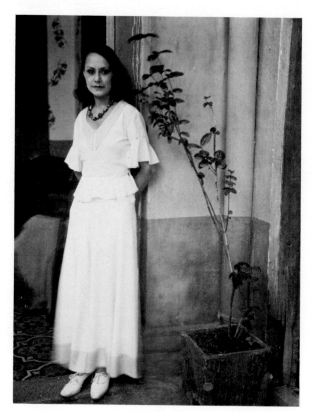

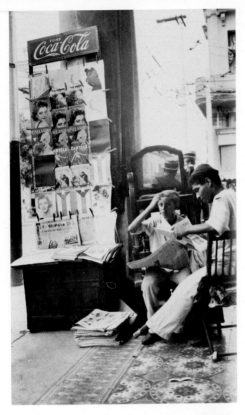

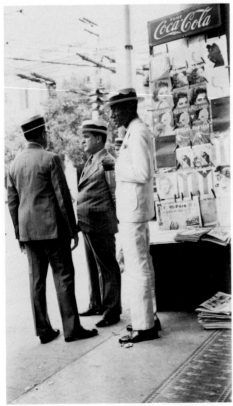

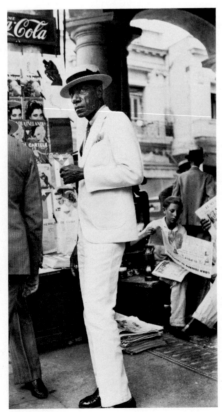

Cuba, 1932. Havana citizen. 2¹/₂ x 4¹/₄ roll film negatives;
facing page, Evans's cropping and enlargement

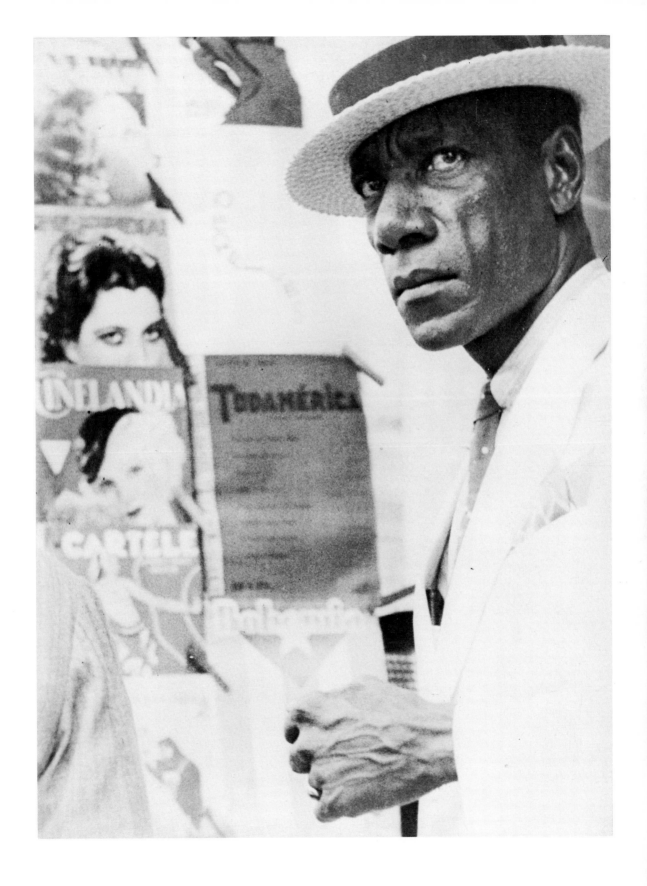

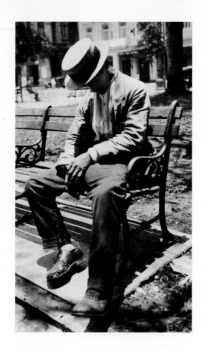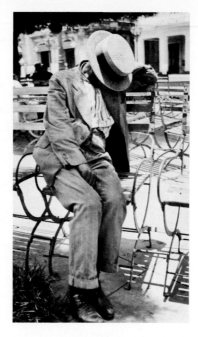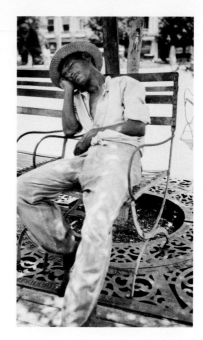

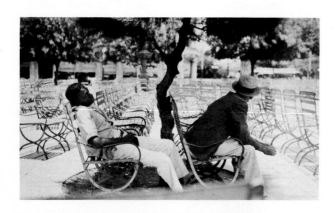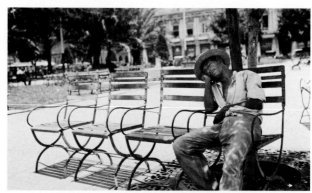

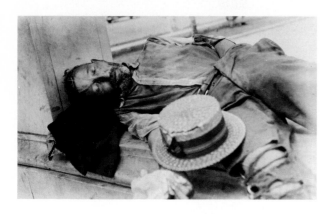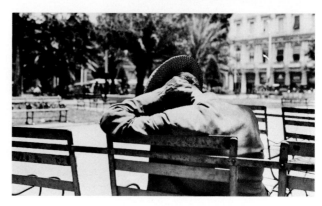

Cuba, 1932 . 2¹/₂ x 4¹/₄ roll film negatives

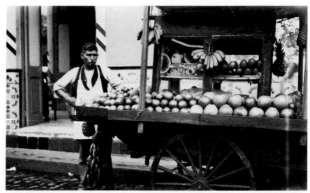
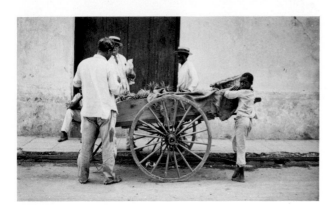
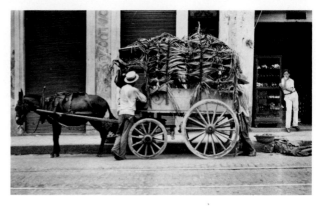

Cuba, 1932. 2¹/₂ x 4¹/₄ roll film negatives

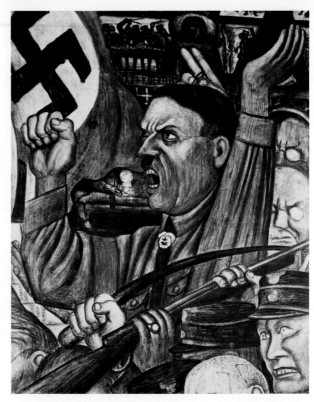

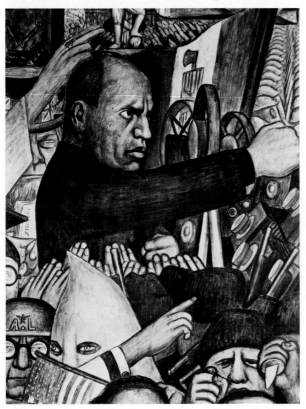

New York City, 1933. Diego Rivera murals 8 x 10 negatives,
facing page, 5 x 7 negatives

Shahn is working with Rivera on a mural (fresco) in Radio City, and that *is* exciting. I go up often and watch the procedure.

To Skolle, 4/20/33

. . . the work I have been doing for cash wouldn't interest you any more than it does me. At the moment, though, there is a lot of 50 copies to be made for the Downtown Gallery, of American folk paintings and objects, and that job not so bad. I have done some more things around Ossining, which grows better and better as a subject for camera.

. . . I could support myself copying paintings I think but don't relish the work.

To Skolle, 4/20/33

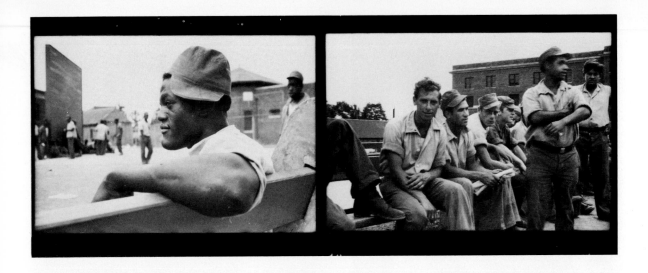

Heading South, 1934. 35mm negatives

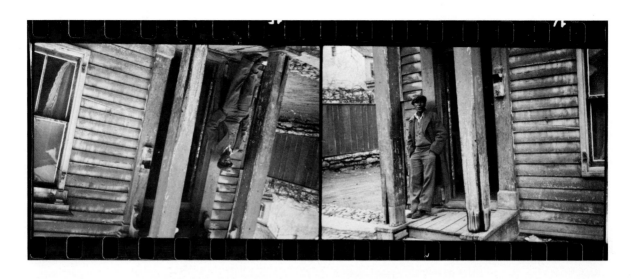

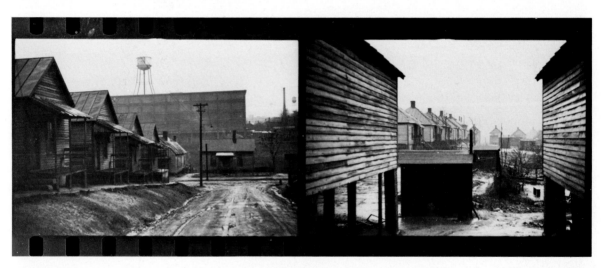

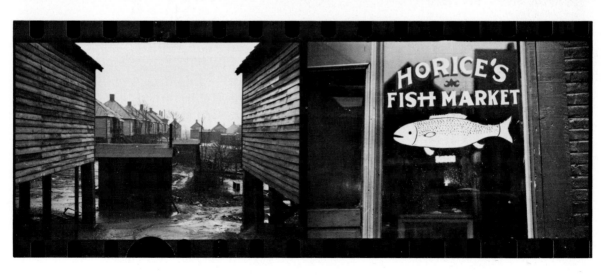

Island Inn
Hobe Sound, Florida

Dear Ernestine,

I was in a bad temper. I'll answer your letter now that the climate is agreeable and the food served regularly.

What do I want to do? Where did the conversations with the publishers end? I know now is the time for picture books. An American city is the best, Pittsburgh better than Washington. I know more about such a place. I would want to visit several besides Pittsburgh before deciding. Something perhaps smaller. Toledo, Ohio, maybe. Then I'm not sure a book of photos should be identified locally. American city is what I'm after. So might use several, keeping things typical. The right things can be found in Pittsburgh, Toledo, Detroit (a lot in Detroit, I want to get in some dirty cracks, Detroit's full of chances). Chicago business stuff, probably nothing of New York, but Philadelphia suburbs are smug and endless:

People, all classes, surrounded by bunches of the new down-and-out.

Automobiles and the automobile landscape.

Architecture, American urban taste, commerce, small scale, large scale, the city street atmosphere, the street smell, the hateful stuff, women's clubs, fake culture, bad education, religion in decay.

The movies.

Evidence of what the people of the city read, eat, see for amusement, do for relaxation and not get it.

Sex.

Advertising.

A lot else, you see what I mean.

Florida is ghastly and very pleasant where I am, away from the cheap part. One feels good, naturally, coming out of New York winter. This island a millionaire's paradise and I'd like to be a millionaire as you know. A few weeks I'll get hopping too, to earn some money. I motored down, Carolina & Georgia, a revelation. Have to do something about that too.

Did you see Hopkins? I stopped nowhere but will call on Peterkin on the way back.

May go to Cuba to say hello.

You ought to see West Palm Beach and die. There is among other things a walkathon, if you know what that is, going on at present. Oh, the Florida whites! Even Negroes bad in Fla. Me I play tennis and drink iced tea in grateful seclusion.

Unfinished letter to Ernestine Evans, February 1934

At the moment I am in Florida on a still picture job. . . . Nothing interesting, but warmth and temporary security damned welcome. . . . I have become interested in South Carolina and Georgia; and we may start on that.

Letter to Jay Leyda, 2/21/34, Hobe Sound

I'm just back, spent some time in South Carolina on the way up from Florida. Almost broke — but couple of jobs in sight and I have a car and a swell Graflex 4 x 5 camera with excellent lens.

To Leyda, 3/27/34, New York

Florida, 1934. 4 x 5 negatives

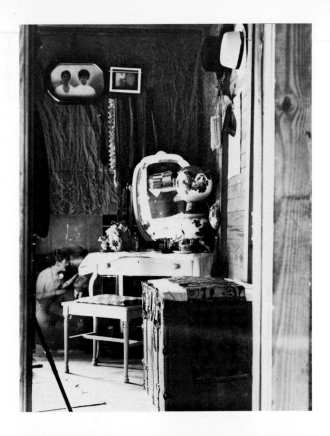

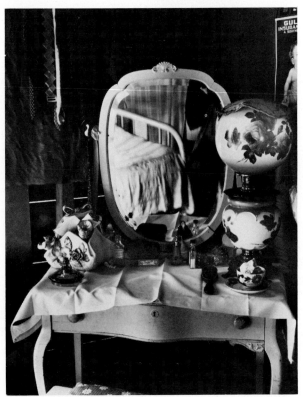

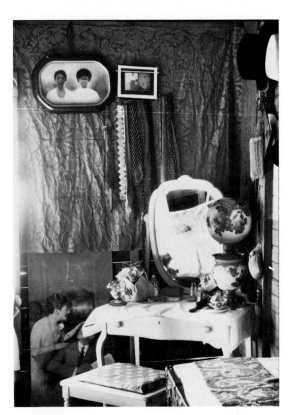

Florida, 1933. 4 x 5 negative, top;
lower left, 8 x 10 negative;
lower right, 5 x 7 fragment cut from negative, facing page

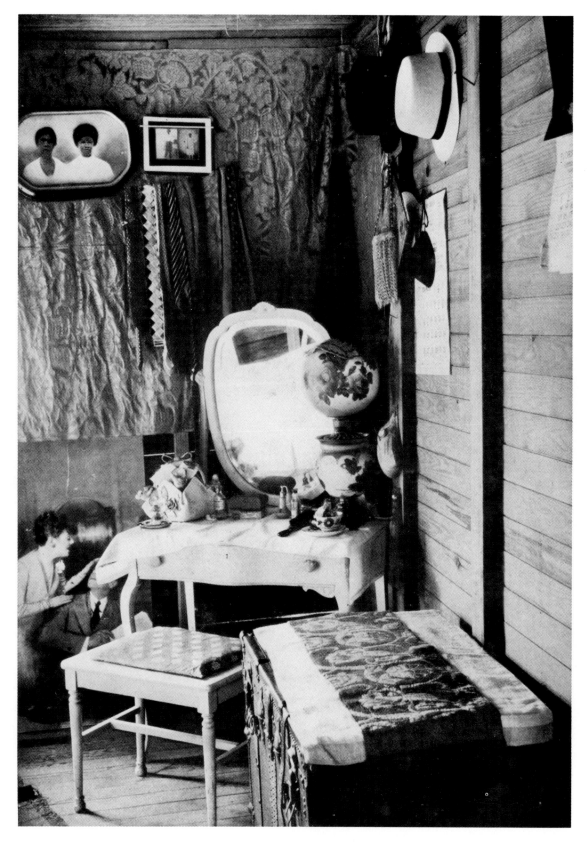

8 x 10 negative with cropping as it appeared in American Photographs

Florida, 1934. 4 x 5 negatives
except bottom, facing page, which is 8 x 10

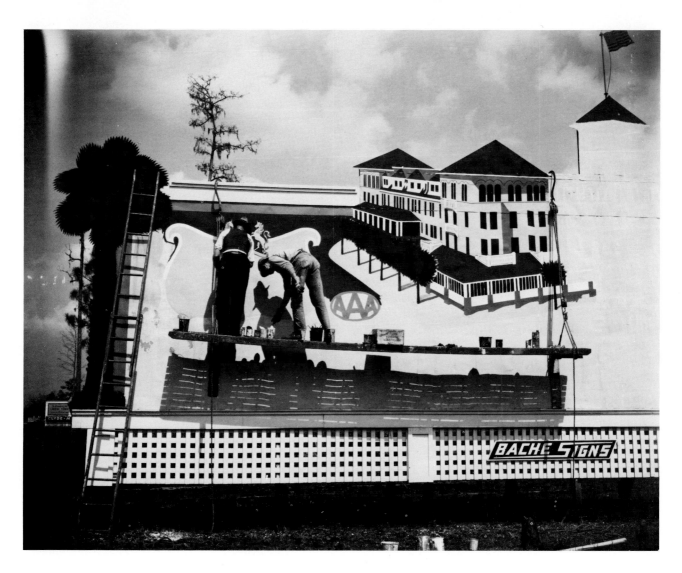

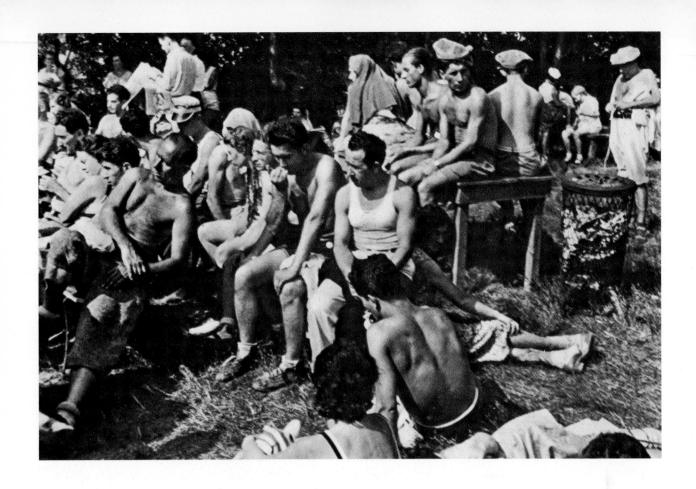

Communist summer camp,
from "The Communist Party," Fortune, September 1934

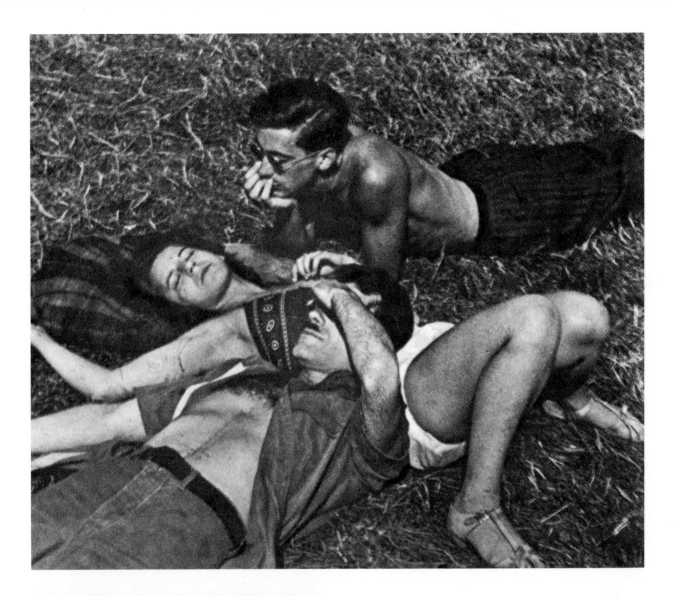

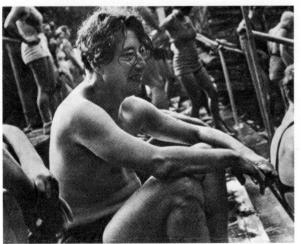

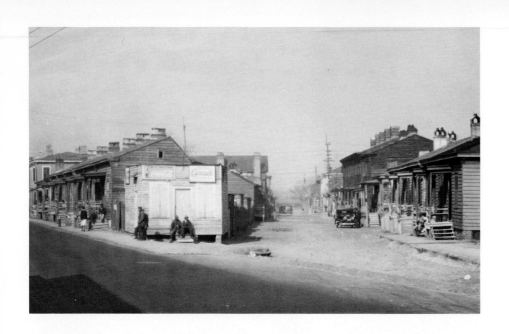

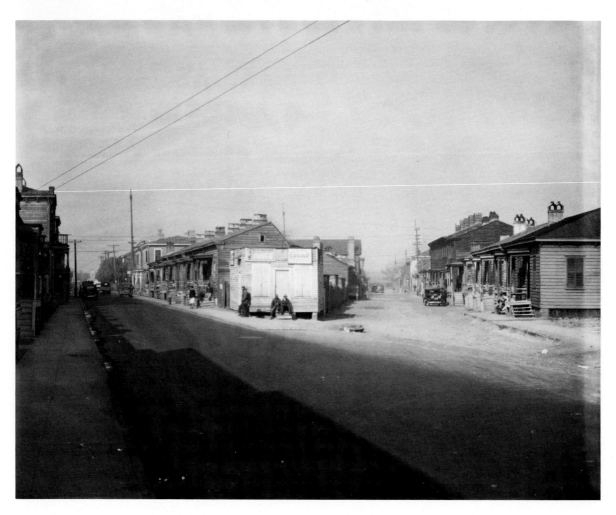

Savannah, 1935. 8 x 10 negative. Full frame (bottom)
was never published or exhibited by Evans.

the trades
the backyards of N. Y.
Harlem
bartenders
interiors of all sorts
 to be filed and classified

Notes on organization of a
photo unit in WPA here
————————————————

Personnel:
 Secretary to chief
 File clerk
 Routine photographers
 ~~Creative~~ Project photographers
Projects:
 New York society in the 1930's
 1 national groups
 2 types of the time (b & wh)
 3 children in streets
 4 chalk drawings
 5 air views of the city
 6 subway
 7 ship reporter
 (This project get police cards)

 the art audience at galleries
 people at bars
 set of movie ticket takers
 set of newsstand dealers
 set of shop windows
 the props of upper class set
 public schools faces and life

*Handwritten notes on the reverse of a Bank of the
Manhattan Company blank check, New York, 1934-1935*

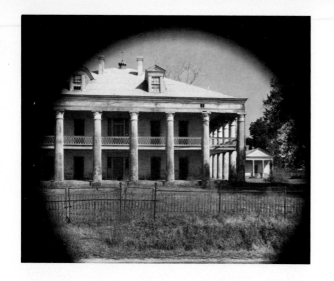
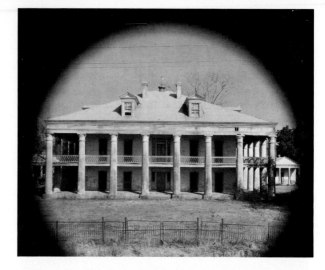
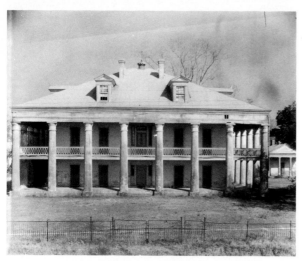
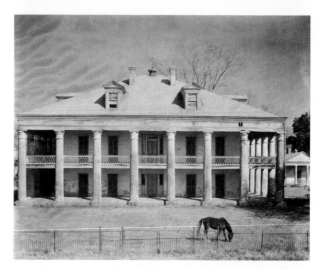
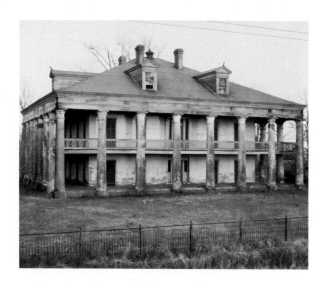
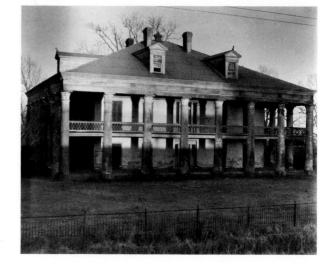

Louisiana, Uncle Sam Plantation, 1935.
8 x 10 negatives

 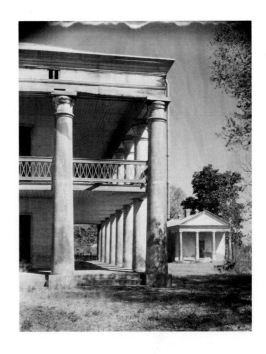

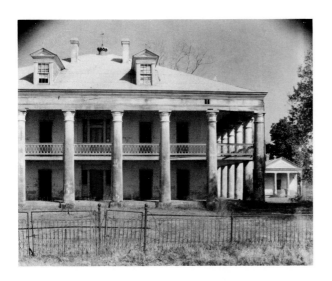 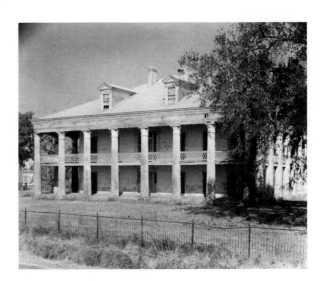

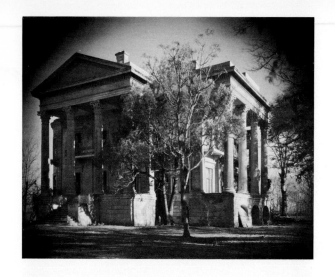

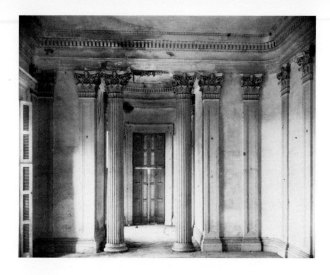

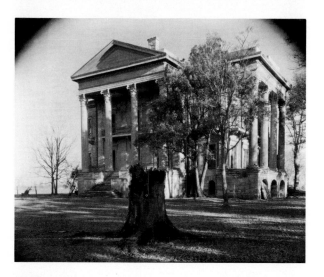

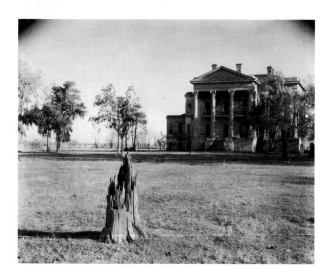

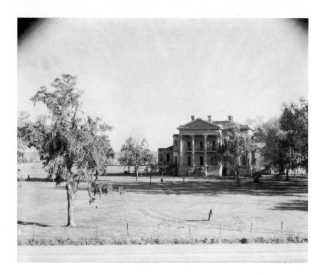

Louisiana, Belle Grove Plantation, 1935.
8 x 10 negatives this page; facing page 4 x 5

110

car

recorder, recorder records
letters & official entree
consultant job classifying,
 preparing exhibition &
 analyzing with assistance
collection intact (prints only)
all rights retained by me
photo supplies, films, paper, etc.
cameras
assistants (in Washington only)
guarantee of one-man performance
 car
 recorder

Will give

1 complete set prints and
word records

under what circumstances you could lend me various
supports such as use of certain equipment in exchange for
the outright gift on my part of complete collection of year's
work (prints only) in America together with analysis,
classification and possibly report

never under any circumstances asked to do anything more
than these things. Mean never make photographic
statements for the government or do photographic chores
for gov or anyone in gov, no matter how powerful — this is
pure record not propaganda. The value and, if you like,
even the propaganda value for the government lies in the
record itself which in the long run will prove an intelligent
and farsighted thing to have done. NO POLITICS whatever

Handwritten draft memorandum re Resettlement
Administration job, Spring 1935

20 Bethune Street, New York
August 17, 1935

Mr. John Carter
Resettlement Administration, Division of Information
Room 221, Administration Building
United States Department of Agriculture
Washington, D.C.

Dear Mr. Carter,

To the details which require your attention I hesitate
to add the explanation of a possible error I have made in
sending to Washington a set of photo negatives just as I
was in the midst of making prints from them, at the
request of Mr. Laurentz, for Miss Orr to take to a regional
conference in Chicago. If, however, my action has
interfered with any of the plans of the Information Division
to the extent that you would like to have the details of its
occurrence, I should be glad to go into the matter.

I am grateful to know by your letter of August 1 that
my work has seemed of value. It is unfortunate for me that
I have been so fully occupied in completing the work I am
doing here for the Museum of Modern Art, which I think I
mentioned to you at our first meeting, that I have not been
able to proceed with the series of pictures I have begun for
the Information Division, as I am exceedingly interested
in the undertaking, which seems to me to have enormous
possibilities, of precisely the sort that interest me. In
passing, I hope you will agree with me that the only really
satisfactory prints of a careful photographer's negative
must be made by the original photographer; and that you
will appreciate a certain craftsman's concern on my part
over the quality of prints from my negatives. What future
work is done by me I shall certainly arrange so as to allow
myself time to make all the necessary prints. On the next
possible occasion, if you are interested, I should like to
discuss this and other matters with you. I learned from Mr.
Stryker in a telephone conversation that he will be in New
York this week, and I expect to have a talk with him.

Please be good enough to excuse the length and,
possibly, the egotism of this letter. They have seemed
unavoidable.

Yours very sincerely,
Walker Evans

RESETTLEMENT ADMINISTRATION

WASHINGTON. D. C.

September 16, 1935
Mr. Walker Evans
Division of Information

Dear Sir:

You are hereby notified that you have been appointed to the position of *Assistant Specialist in Information, CAF-7,* in the *Division of Information of the Resettlement Administration,* at a salary of $ *7 .22 per d .was* , effective *September 24, 1935* .

October 9, 1935

TO: Miss McKinney, Division of Information
 Room 221
FROM: Roy R. Stryker
 Division of Information
RE: Walker Evans

Mr. Walker Evans has agreed to join our staff on a permanent basis. It will be necessary in order to hold him to increase his salary to $3000. I talked this over with Mr. Carter and he agrees that this should be done. I have also taken the matter up with Mr. Courts Ron of the Personnel Division and it has met with his approval. Mr. Evans' title will be Information Specialist. His duties will be as follows:

> Under the general supervision of the Chief of the Historical Section with wide latitude for the exercise of independent judgment and decision as Senior Information Specialist to carry out special assignments in the field; collect, compile and create photographic material to illustrate factual and interpretive news releases and other informational material upon all problems, progress and activities of the Resettlement Administration. To supervise a small group of assistants from time to time depending on the importance and size of the assignment, and other related tasks.

OUTLINE MEMORANDUM
FOR MR. STRYKER

Walker Evans; Southeastern States; trip by automobile; time: eight weeks from November 1, 1935.

Still photography, of general sociological nature.

First objective, Pittsburgh and vicinity, one week; photography, documentary in style, of industrial subjects, emphasis on housing and home life of working-class people. Graphic records of a complete, complex, pictorially rich modern industrial center.

Ohio Valley: rural architecture, including the historical, contemporary "Middletown" subjects; Cincinatti housing; notes on style of Victorian prosperous period. (Hills in this city offer revealing views for records of architecture, chiefly 19th century.)

Indiana, Kentucky, Illinois river towns, gather typical documents, main streets, etc., in passing. Ditto Mississippi river towns. Select one of these towns, such as Hannibal, Missouri, for more thorough treatment, if time allows.

Follow Mississippi, gather rural material in passing. Memphis, Natchez. Antebellum plantation architecture, flower of which is concentrated in Natchez. Highest development of American classic revival architecture. Mississippi Negroes between Natchez and New Orleans.

Louisiana: Plantation architecture. Belle Grove, 1858 (?), now in decay. The most sophisticated example of classic revival private dwelling in the country.

The other Louisiana plantations: historical records and notes of present use, present owners.

Teche County, Louisiana, the small rural French towns.

New Orleans: social decay, architecture, present city people, Negroes.

Birmingham, Alabama, industrial documentary pictures.

Cross Georgia and Alabama, rural subjects.

South Carolina, a cotton plantation.

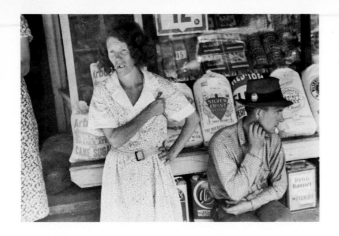

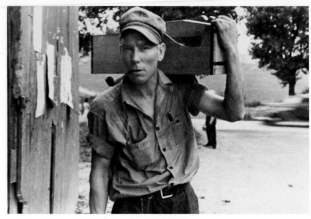

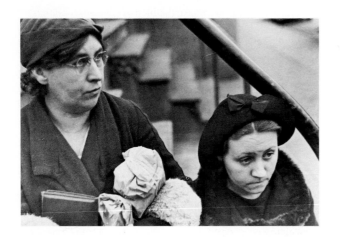

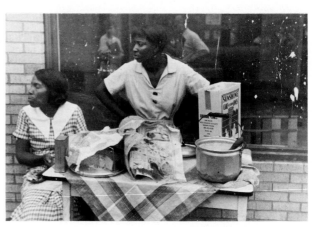

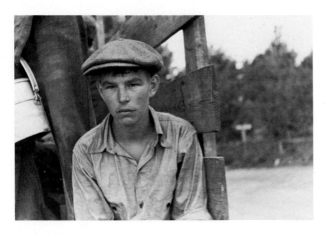

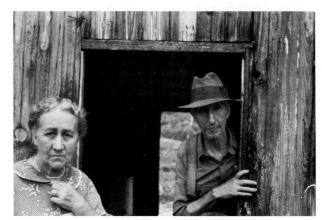

Pennsylvania and West Virginia, 1935. 35mm negatives

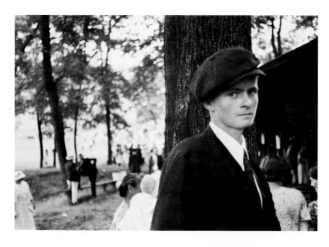

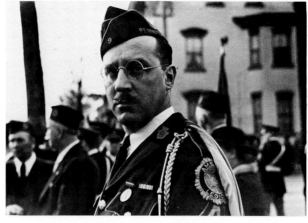

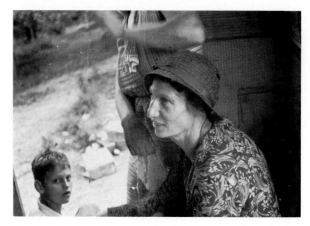

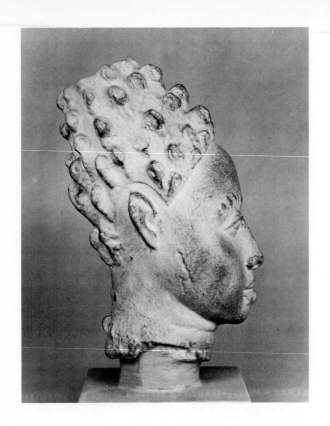
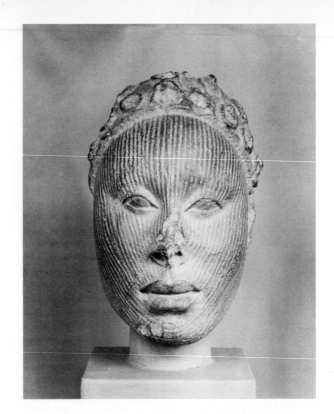
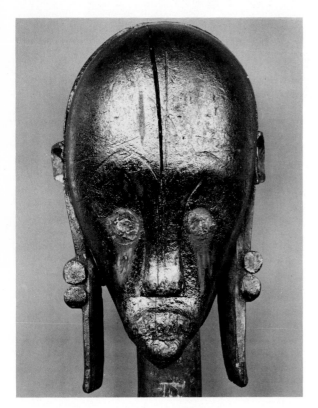

African Negro Art, 1935. 8 x 10 negatives

116

Exhibition of Photographs of African Negro Art
by Walker Evans

Assembled by the Museum of Modern Art, 11 West 53 Street, New York, this Exhibition of Photographs of African Negro Art represents the outstanding objects shown in the Exhibition of African Negro Art held at the Museum in March, April and May 1935.

Under a grant from the General Education Board, the Museum engaged Walker Evans to photograph the objects. A successful photographer of sculpture, Mr. Evans is perhaps more widely known for his documentary photographs of the recent Cuban revolt and for his photographic record of 19th Century American houses, of which the Museum has a collection.

News release, Museum of Modern Art, (Winter 1936)

"There were a number of developments on the African Sculpture front today. A Miss Ulrich from the Museum called up for a complete list of all negatives taken, all prints made, etc., so that there would be some basis on which to pay you extra. This can wait until the printing is done, said she; but the statement must be very complete and very itemized. . . . There's a very good chance (I got this information on condition I would not tell you) that the Museum will have a couple of hundred dollars extra for you when the job is complete — and if I remember right there's a certain debt of $200 which must be paid soon! The other financial worry of mine is that there's now $70.00 in the bookcase. Of that I must pay $20 for this week's spotting, $10 to Cheever, and $10 to the Colonel himself on Monday. I will also need Hypo, acid, and odds and ends, as well as more printing paper. When the job is complete the strong box will be empty! . . . For God's sake don't forget to print those negatives and send them along *this week!*"

Peter Sekaer to W.E., 11/19/35

" . . . the Edison Company has just cut off the light at 20 Bethune! Non payment of bill for 10-12 dollars. Am going up to see Mabrie [Mabry] this afternoon to try to get enough money from him to settle the bill. I don't like this errand particularly, but poor John [Cheever] can't sit over there in the dark; and, anyway, there are something like 50 more prints to be done (odds and ends which had to be done over)."

Sekaer to W.E., 1/2/36

"Expenses in connection with photographing African Negro Art:

Films	$149.50
Paper	269.20
Trays, Washer, Clips, Envelopes, Blotters, Chemicals, File, Holders, etc.	93.00
Two printing machines	42.50
Expense of 75 enlargements and contact prints for travelling show	68.00
Salary to P. Sekaer, 21 weeks	525.00
Salary to J. Cheever, 14½ weeks	290.00
Salary to E. Deis for spotting first 1000 prints	39.00
Salary to J. Russack for spotting 8000 prints	195.00
To overhead in Bethune street	354.00
Total (excluding anything for W. Evans)	$2016.20

"Better worded and more neatly typed I submitted the above to Mabrie. This was at his request. Whether anything will come of it or not is yet to be seen. . . . "

Sekaer to W.E., 1/9/36

Mr. Walker Evans [12/36-1/37]
Corroll Hotel
Vicksburg, Mississippi

Dear Walker:

We had a little consultation here yesterday regarding some of the work we should like to have you do the balance of the time which you will be out. This is the result of our efforts. Before going any further, however, let me give you this bit of information. Ernestine Evans is leaving in the next day or two and will plan to meet you in Birmingham and discuss with you in much more detail some of the things which we should like to have photographed. The plan which I am giving you is the broader layout. Of course, we concede your right to modify, since you are on the ground and may see good reason why you should go to one place instead of another; but in general I do think that it will give you the opportunity to photograph the type of things which we most want. You and Ernestine, however, can work this out between you. The general layout follows:

Tupelo — The project at Tupelo is being returned to local management. There is an insistent demand here for additional photography to be used for publicity purposes, so it is absolutely essential that you get in and take a set of pictures showing the present state of the buildings, and some additional local color, also people and activities. I would suggest that you make one or two Leica strips of this and mail it in to us for development as soon as you can get it. You will probably want to contact the local Manager, using your Government credentials. This is one of the emergency jobs that I hate to bother you with, but it must be done.

Birmingham — I would suggest that you spend several days around Birmingham. There is no need to go into detail as to what you will do here. I am sure that you will have a grand time here with your eye for industrial landscapes. Wire us as soon as you get there where we can reach you, or be on the lookout for a letter at General Delivery, so that Ernestine can find you when she arrives.

After finishing at Birmingham, we should like very much to have you go to Monticello, Putnam County, Georgia, to do some work at the Piedmont Plantations (one of our projects). I am informed that you will find some very excellent examples of plantation homes. Incidentally, most of them are in a sad state of decay. You will probably have an opportunity here to get some good erosion pictures.

Monticello, Jasper County, Georgia — This is also a Resettlement Project. Here again you will find some good examples of old plantation homes.

We would then like to have you take the jump to Waycross, Ware and Brantley Counties, Georgia. In this vicinity you will find the Coastal Flatwood Project. Mr. James A. Pearson is the Manager at this Project. Here you will find cut pine lands and turpentine workers. Get us some good 8 by 10 shots and also some good Leica shots of the turpentine workers.

The next move is to St. Mary in the extreme southeastern corner of Georgia. Here Ernestine will advise you in more detail.

Next, proceed into South Carolina by way of Savannah, Wattersboro, Orangeburg, into Columbia. My recollection is that you desired to stop at Julia Peterkin's place. This is, of course, on your route. At Columbia, please try to go out to Winnsboro (directly north) and try to get some pictures of the model town maintained by the United States Tire Company. You will find in this general area plenty of examples of bad mill towns. Get us some of those also.

From here, I am very anxious that you should go northwest in South Carolina to Anderson. Here you will find Clemson College. One of our southerners tells us that this is a very rich territory for the following things — old estates, decay, erosion, and bad mill towns. In general, may I suggest the following things:

Put quite a little effort in getting us good land pictures, showing the erosion, sub-marginal areas, cut-over land. These should be taken wherever possible, showing the

relationship of the land to the cultural decay. Cotton planting is probably now going on. Try to get us a few nice "sirupy" pictures of agricultural scenes and general landscape pictures for cover pages.

We are enclosing your advance and your salary. We are also shipping to you, under separate cover, one case of film. I am ordering a wide angle lens and if possible, will have Miss Evans deliver it to you. This will give you a chance to do some interior stuff while you are out on this particular trip. If possible, get us some interiors of the country stores.

I realize this is a nice big order, but remember you've got to deliver or else I am going to catch the devil. Take time off to develop your film occasionally and keep sending it through. The enlargement of which you spoke was admitted even by the laboratory as a bad copy. Incidentally, I am not mounting up file copies of your pictures until you arrive, since I want approved copies against which we can have the prints made.

The $100 advance is all that you can have for the next month, as that is all that is permitted at one time. We shall try to get you more later if you need it. Above all else be sure to keep sending your film in. Also keep me posted of your whereabouts every few days. I think perhaps it would be advisable to send me a night message every few days, saying what your address will be. This is not terribly expensive and yet makes it possible to reach you in case of necessity.

<div style="text-align:right">

Sincerely Yours,
Roy E. Stryker

</div>

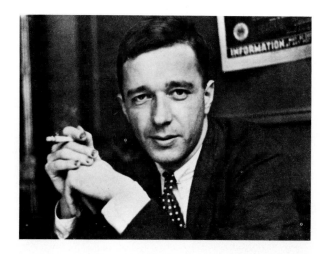

"After I finish developing your 4 x 5's I will send them along. And let me know if you would like some of those rolls of Leica film you took last year. That volume of work may help convince the gov't that you have been very, very busy!"

Sekaer to W.E., 1/2/36

*Walker Evans, New York City, 1937,
with fingernails stained by film-developer*

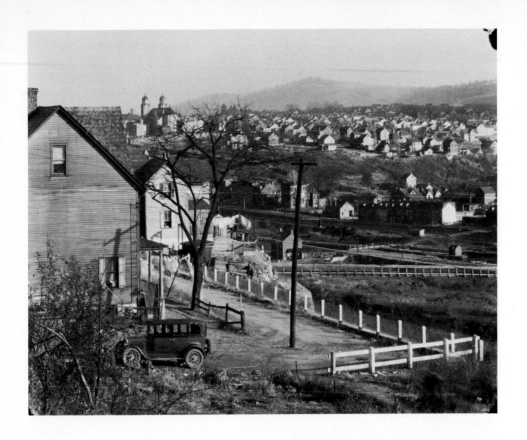

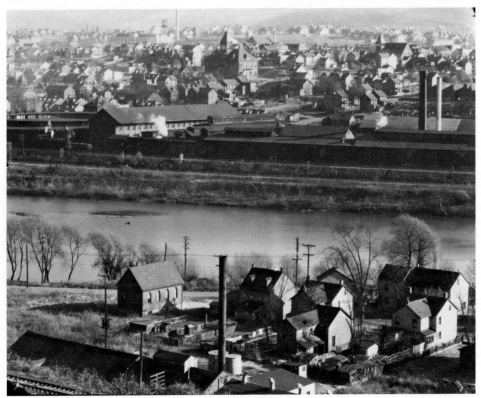

Phillipsburg, N.J. and Easton, Pa., 1936.
8 x 10 negatives

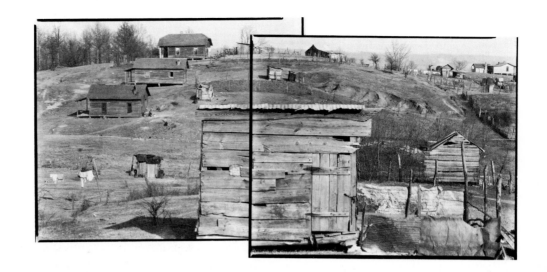

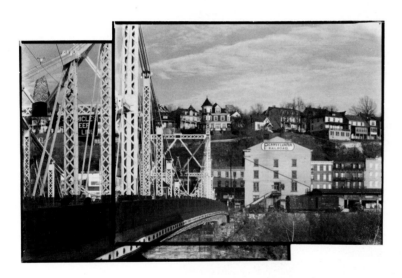

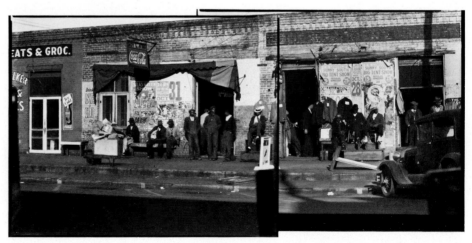

1935–1936. 8 x 10 negatives. Twinned variants
photographed from the same (or nearly the same) camera position

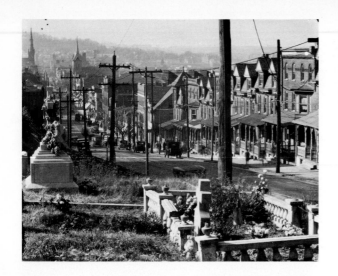 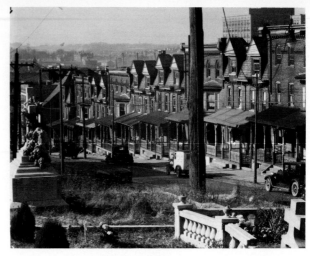

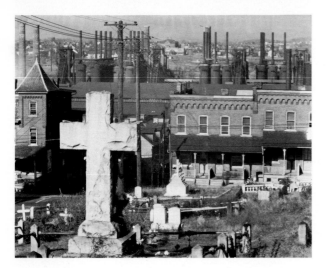

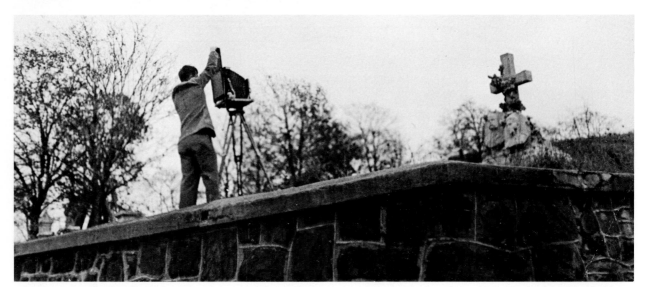

Bethlehem, 1936. 8 x 10 negatives, except snapshot above

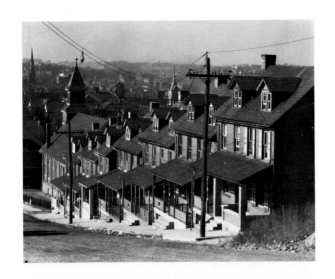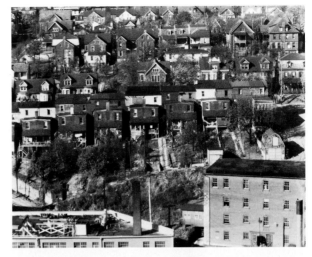

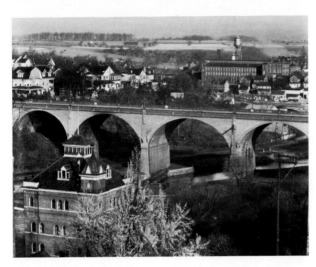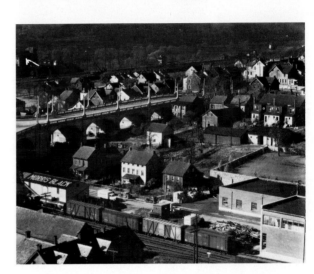

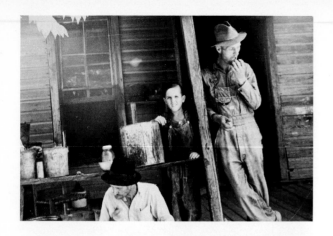
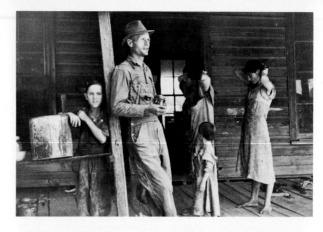
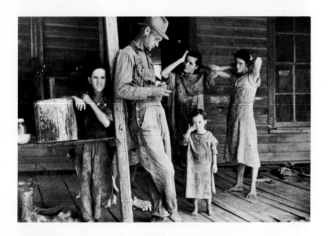
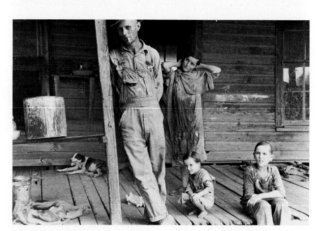
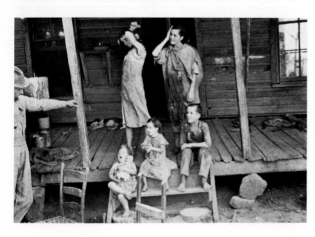
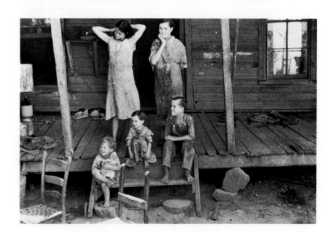

Alabama, 1936. 35mm negatives

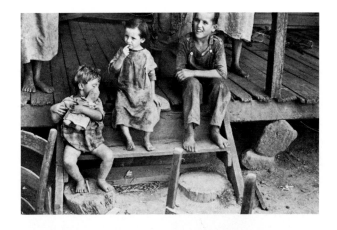 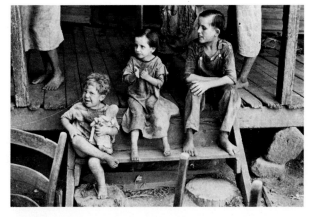

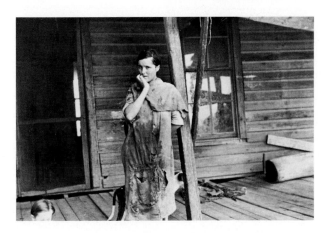

("These people. Did you find a lot of people who were hostile? You know, this northerner coming down to shoot pictures.")

Not then, no. Things were much more innocent then — people themselves, if you approached them correctly, were not what they are now. Oh, no. Those people would be red-necks now, but they weren't then.

("How did you approach them?")

Well, just by explaining exactly what we were doing and with some sympathy. With some respect. Sure. For one thing, we compensated these people. We bought them, in a way. That sounds more corrupt than it was meant to be. We went into their houses as paying guests, and we told them what we were doing, and we sort of paid them for that. Good money: there wasn't any money.

Boston interview

I'm often asked by students how a photographer gets over the fear and uneasiness in many people about facing a camera, and I just say that any sensitive man is bothered by a thing like that unless the motive is so strong and the belief in what he's doing is so strong it doesn't matter. The important thing is to do the picture. And I advise people who are bothered by this to cure it by saying to themselves, what I'm doing is harmless to these people really, and there's no malevolence in it and there's no deception in it, and it is done in a great tradition, examples of which are Daumier and Goya . . . Daumier's *Third Class Carriage* is a kind of snapshot of some actual people sitting in a railway carriage in France in eighteen-something.

Katz/Evans interview

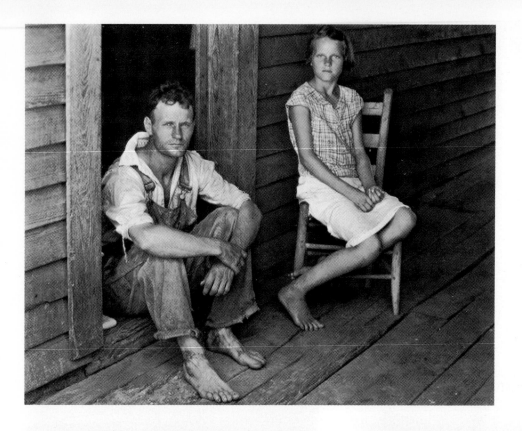

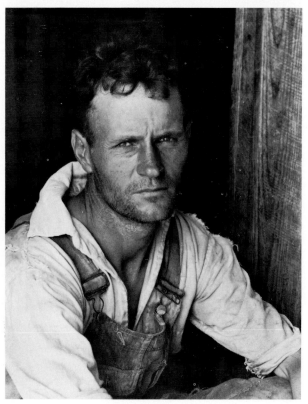

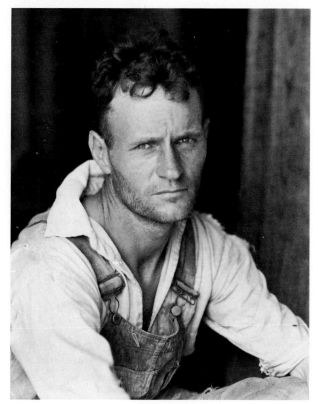

Alabama, 1936. 8 x 10 negatives except lower right,
facing page, which is a fragment cut from an 8 x 10 negative

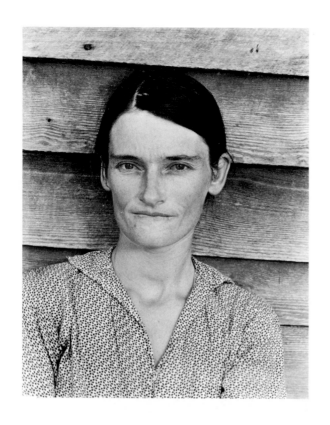

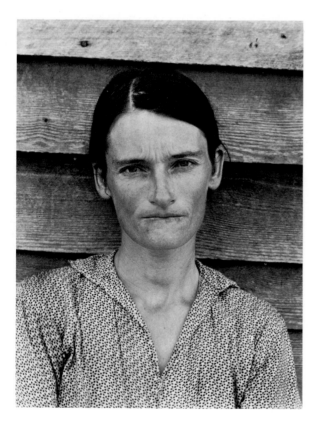

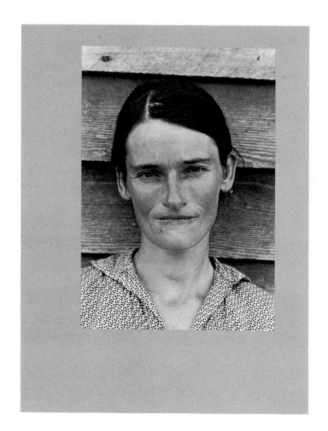

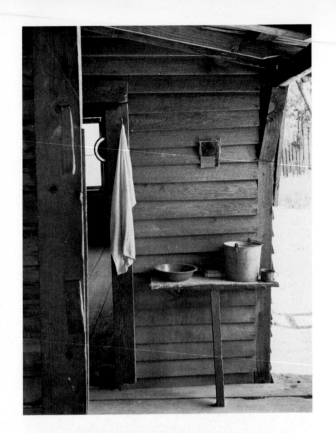

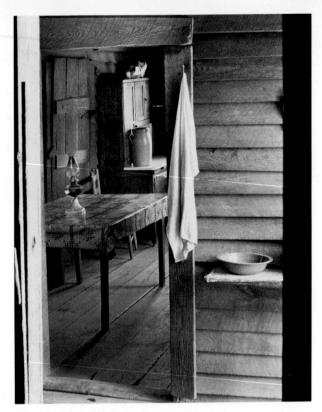

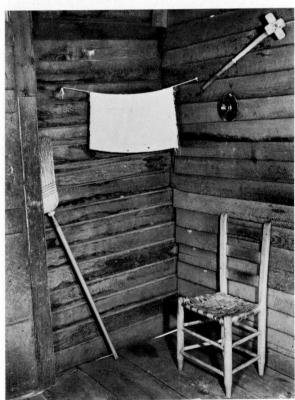

Alabama, 1936. 8 x 10 negatives

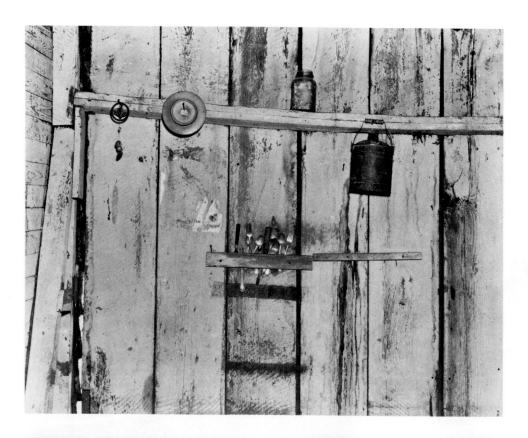

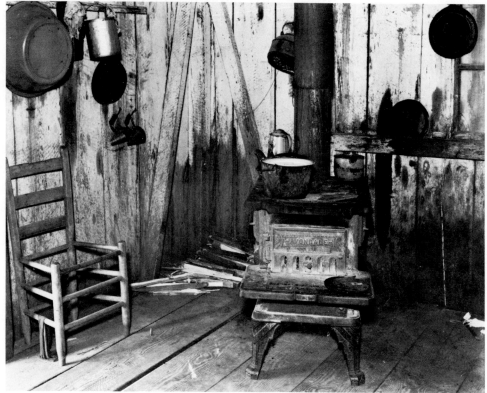

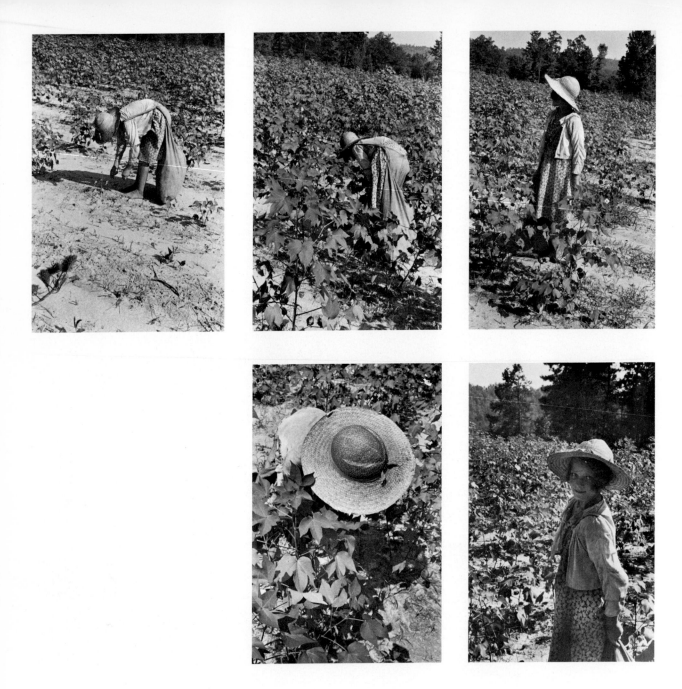

Alabama, 1936. 35mm negatives except 8 x 10 negative, facing page

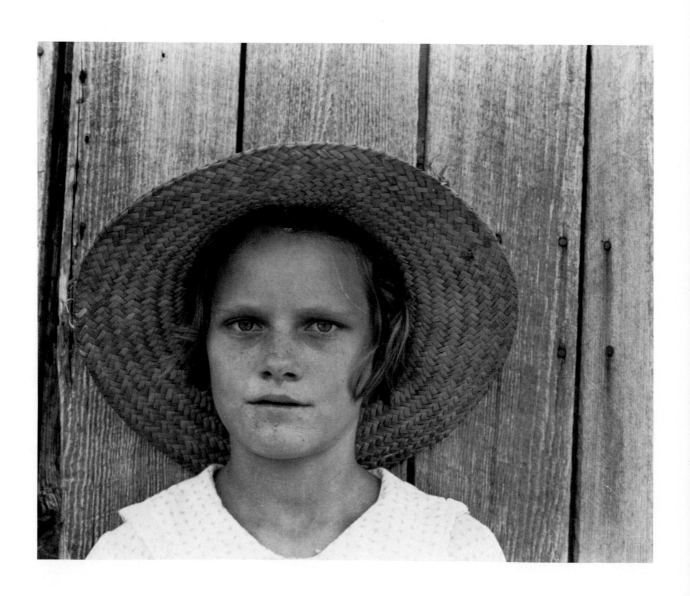

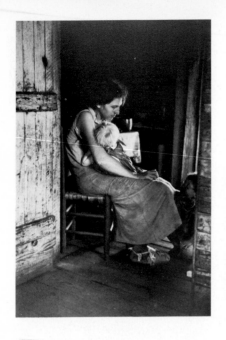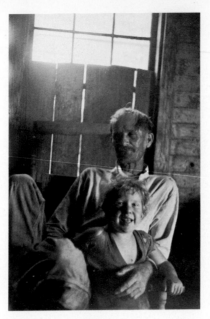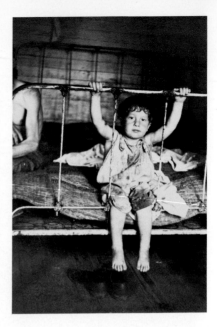

Alabama, 1936. 35 mm negatives, top this page;
lower photographs and facing page, 8 x 10 negatives

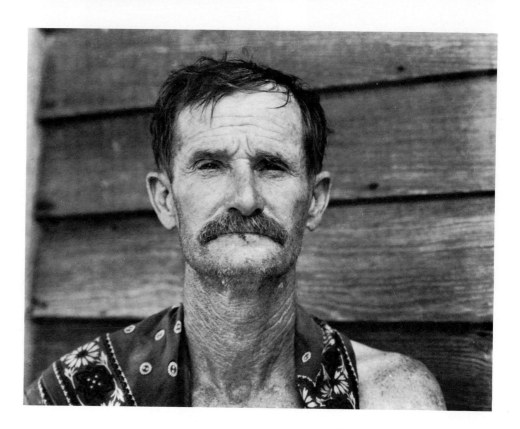

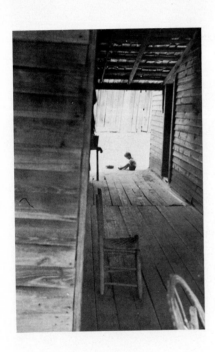 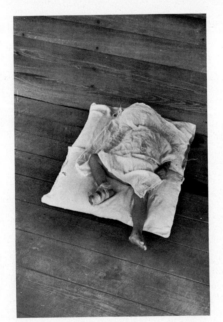

Alabama, 1936 . 35mm negatives

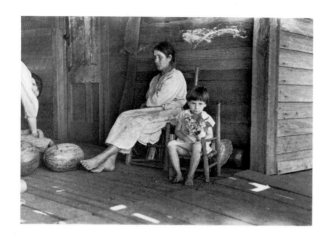

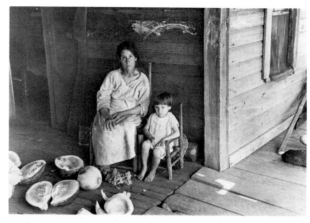

If most professional photography is dominated by the commercial stance or the artistic posture, Evans is in recoil from these. His work might even be said to have brought photographic style back around to the plain, relentless snapshot. In this sense the pictures in this book amount to a technical and a psychological adventure.

Evans's revision of publisher's proposed text for jacket of 1966 edition of Let Us Now Praise Famous Men

Alabama, 1936. 35mm negatives, facing page, 8 x 10 negative

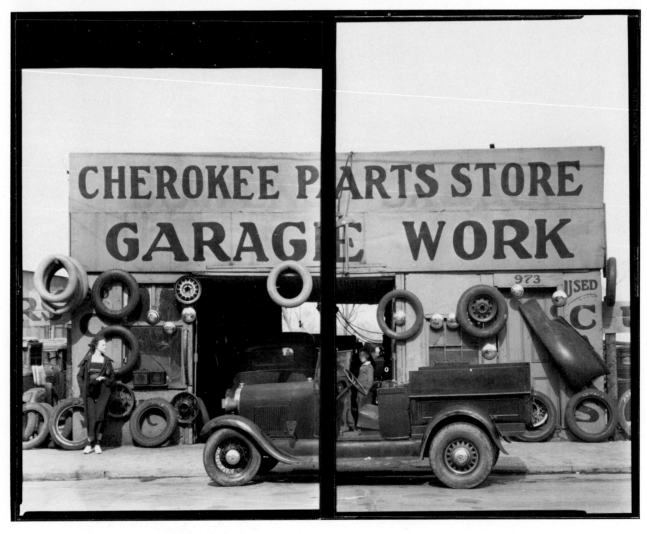

New York City, Georgia, Alabama, 1934–1936.
Fragments cut from 8 x 10 and smaller sheet film negatives

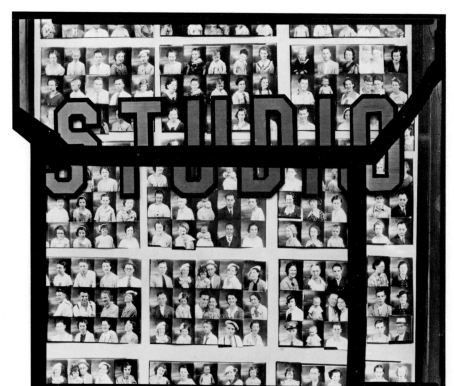

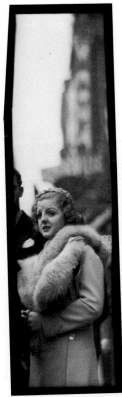

Stieglitz wouldn't cut a quarter-inch off a frame.
I would cut any inches off my frames in order
to get a better picture.

Katz/Evans interview

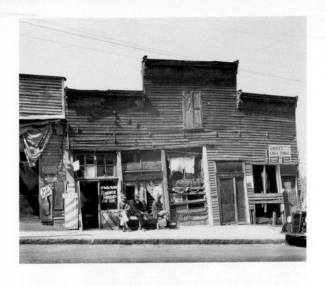

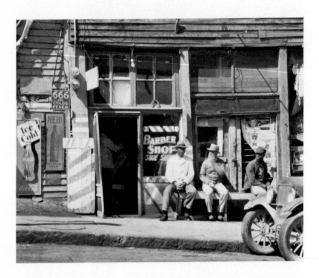

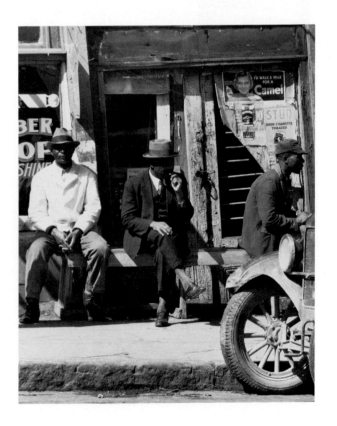

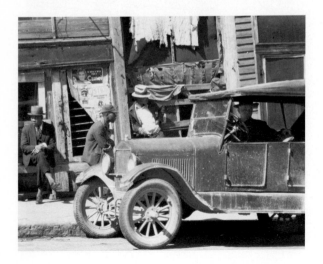

*Vicksburg, 1936. 8 x 10 negatives except lower right, this
page, which is a fragment cut from an 8 x 10 negative.*

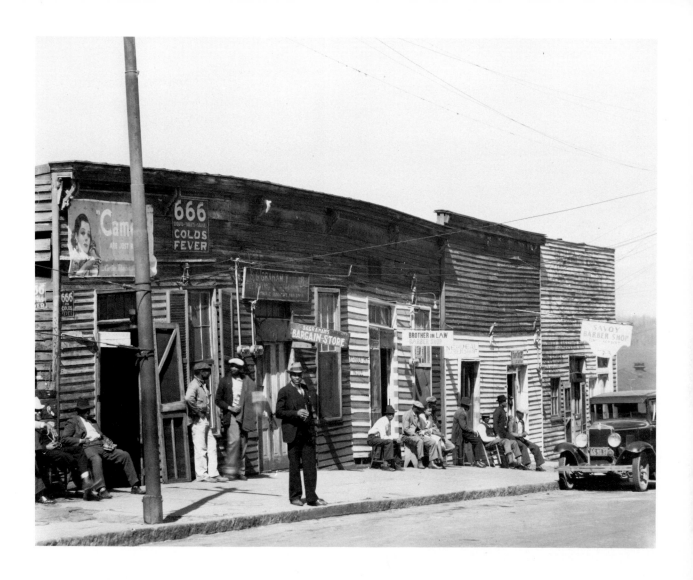

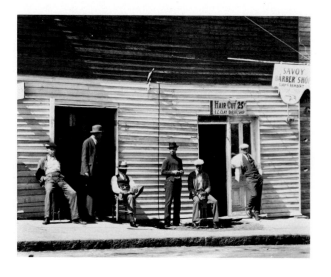

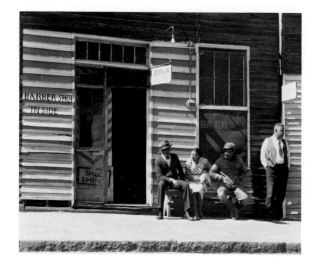

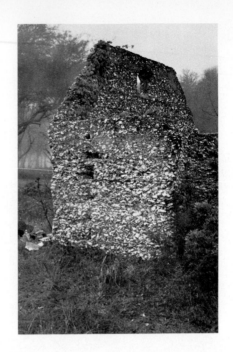

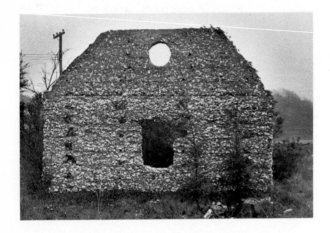

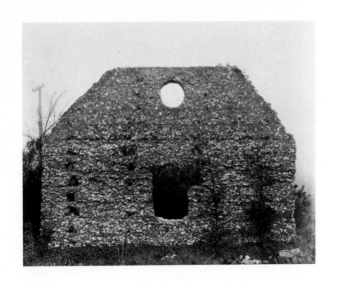

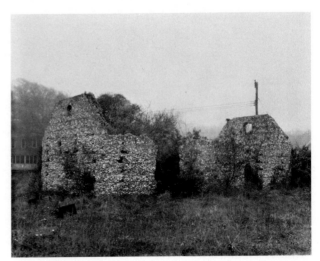

Georgia, 1936. 35 mm negatives, top two, this page;
8 x 10 negatives, bottom this page and facing page

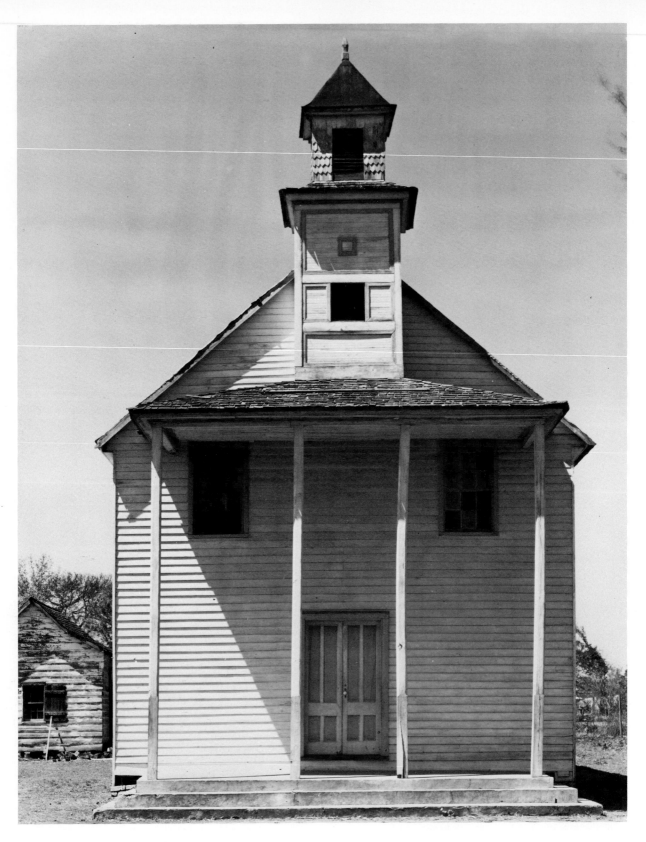

South Carolina, 1936 . 8 x 10 negatives, two focal lengths,
longer lens, this page

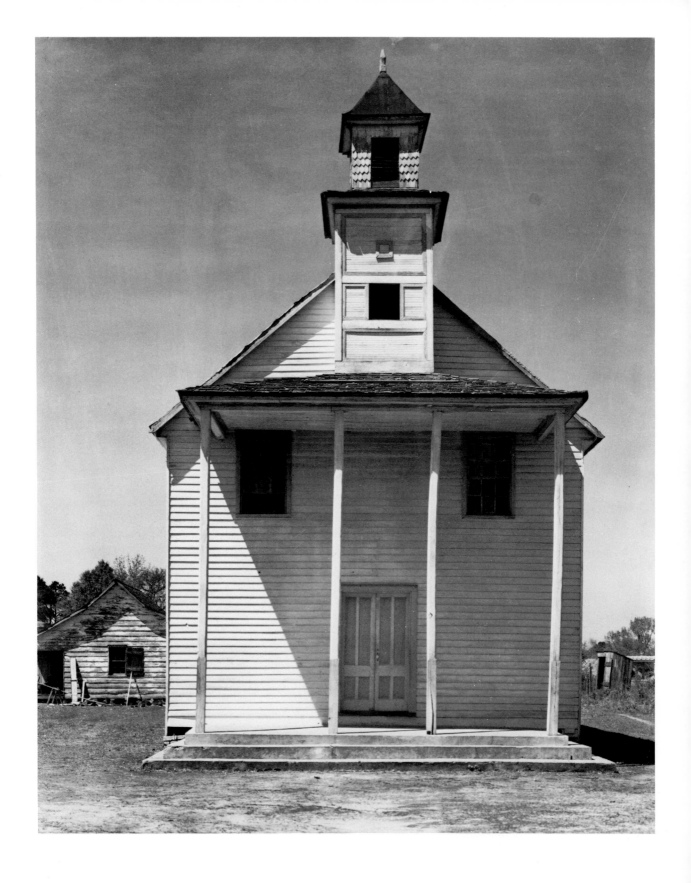

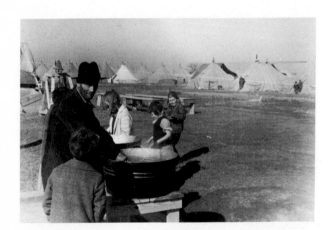
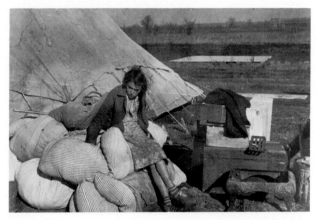
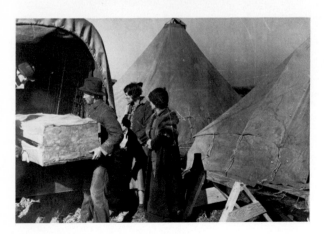

Arkansas, 1937. 35mm negatives

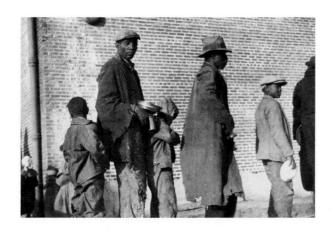

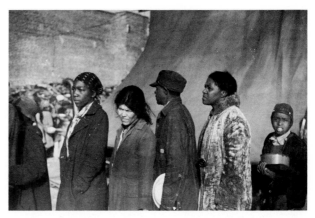

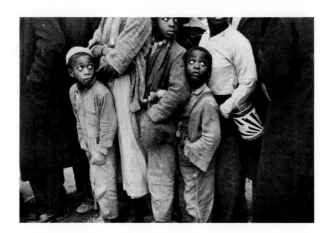

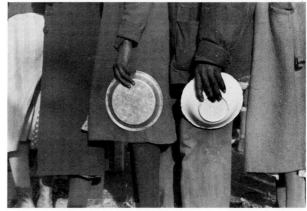

I am starting to motor back towards Washington but going slowly, working along the flooded river towns taking about ten days. . . . I had the flu but the flood was damned interesting, highwater refugees and all that.

To Leyda, 2/17/37, Memphis

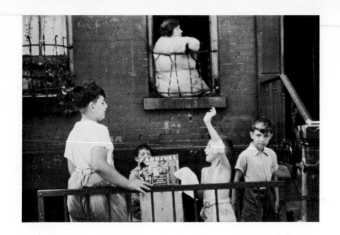 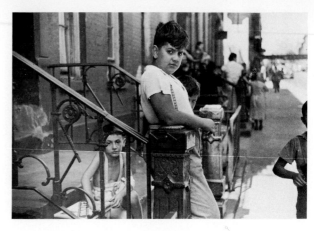

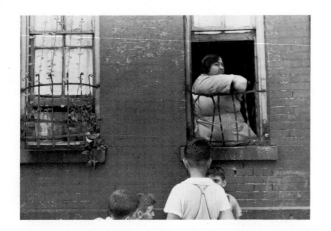 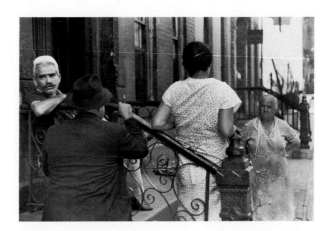

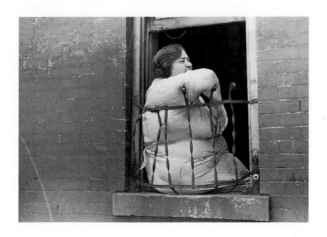 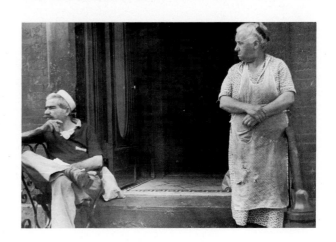

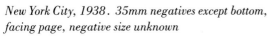

New York City, 1938. 35mm negatives except bottom,
facing page, negative size unknown

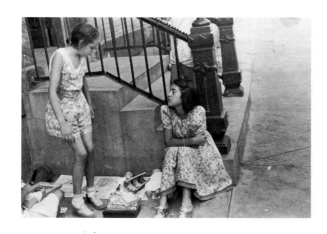

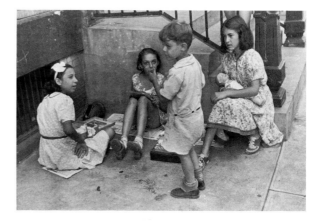

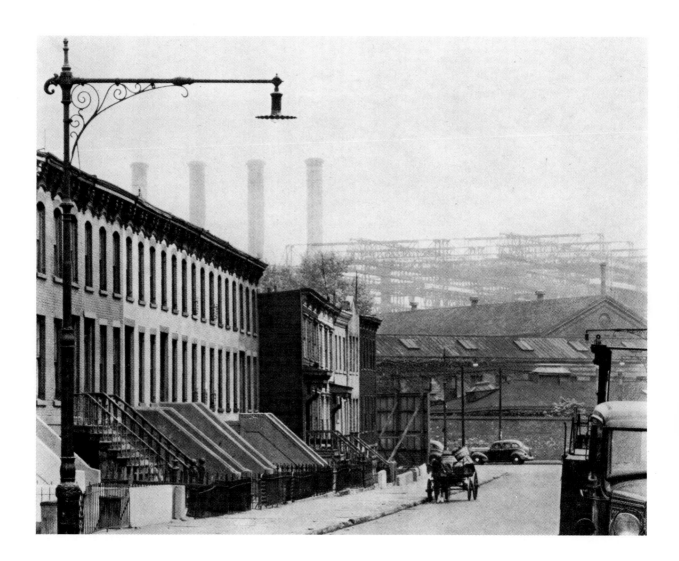

PLAN or ARRANGEMENT OF MUSEUM BOOK

TITLE	American Photographs
	Walker Evans
	Museum of Modern Art
JACKET	No reproduction. Two colors if possible. Words on back should run across, not along the length. Nothing on inside flaps; * perhaps a list of museum publications on back. Paper, color, type to be chosen in conference with J.B. [Joseph Blumenthal] Perhaps enlarged typewriter lettering, or the thin Roman of [? ? ? ?]
TITLE PAGE	Same as jacket, in black only
BINDING	Settled
ARRANGEMENT	Title page
	List of identifications
	Page: PART ONE
	Photos of part one, general, numbered
	Page: PART TWO
	Page: note by W.E., perhaps unsigned
	Photos of part two, people, numbered
	Blank page
	Kirstein piece, which must be given a title
	Blank page
	Colophon

*INSIDE FRONT FLAP might have:

This book contains a selection, made by the photographer, of pictures made during the past ten years. W.E. has been working more or less independently in photography. . . . [Whole sentence crossed out]

Perhaps: "with an essay by L.K." "interpretation"? "note"?

Bibliography gov't permission: plates no's so and so have been reproduced with the kind permission of Farm Sec.

Handwritten draft of plan for American Photographs.

NOTE

The aim of the following picture selection is to sketch an important, correct, but commonly corrupted use of the camera. A sentence from an essay on Mathew Brady by Mr. Charles Flato may illuminate the attitude behind this choice of photographs: "Human beings . . . are far more important than elucidating factors in history; by themselves they have a greatness aside from the impressive structure of history."

There are moments and moments in history, and we do not need military battles to provide the images of conflicts, or to reveal the movements and changes, or again, the conflicts which in passing become the body of the history of civilizations. But we do need more than the illustrations in the morning papers of our period. Pictorial journalism does in fact turn up records which will become valuable in themselves with time; but the journalism of the present is so corrupt that its products in the field of photography are only sparsely and accidentally of any value whatever; and only in time, when removed from their immediate contexts, will they serve the purpose under discussion. In example, photos of prominent people will be printed to advertise something, or just for themselves, or as in the case of "society" illustrations, merely to advocate the fitness of such-and-such a person's activities; but the accidental use to which these images may be put by future students and examiners of the period is far from the minds of the news photographers or of their employers. And then one thinks of the general run of the social mill: these anonymous people who come and go in the cities and who move on the land; it is on what they look like, now; what is in their faces and in the windows and the streets beside and around them; what they are wearing and what they are riding in, and how they are gesturing, that we need to concentrate, consciously, with the camera.

Author's Note (unpublished) for original edition of
American Photographs

For permission to reproduce certain designated photographs, acknowledgment is due the Farm Security Administration, Washington, D.C., and Harper and Brothers, New York. Acknowledgment is also due the editors of *The Hound and Horn* for permission to reprint several photographs which originally appeared in that magazine.

The responsibility for the selection of the pictures used in this book has rested with the author, and the choice has been determined by his opinion: therefore they are presented without sponsorship or connection with the policies, aesthetic or political, of any of the institutions, publications or government agencies for which some of the work has been done.

Author's Introductory Note to American Photographs,
*New York, Museum of Modern Art, 1938 (omitted in
1962 reissue)*

The objective picture of America in the 1930's made by Evans was neither journalistic nor political in technique and intention. It was reflective rather than tendentious and, in a certain way, disinterested. . . . Evans was, and is, interested in what any present time will look like as the past.

*Author's Introductory Note (unpublished), dated Nov. 29,
1961, for reissue of* American Photographs

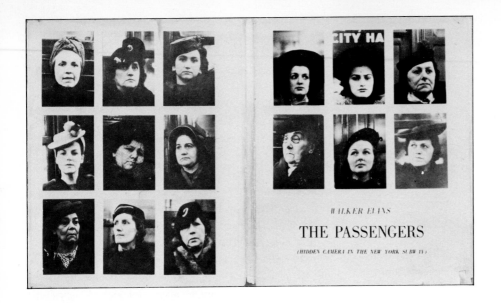

WALKER EVANS

THE PASSENGERS

(HIDDEN CAMERA IN THE NEW YORK SUBWAY)

The guard is down and the mask is off; even more than when in lone bedrooms (where there is a mirror), people's faces are in naked repose down in the subway.

To test and examine this special state, Walker Evans spent weeks underground, strapped to a Leica. His hunt there for true portraiture netted a sizable stock of remarkable prints, eight of which we reproduce.

Evans' most definitive book, *American Photographs*, appears this month in a new edition published by the Museum of Modern Art and Doubleday.

Evans's caption for photographs published in
Harper's Bazaar, *March 1962*

New York City, ca. 1959. Jacket mock-up, front and back, for a proposed book of subway portraits photographed in 1938 and 1941; facing page, double-page spreads from a dummy for proposed book of subway portraits

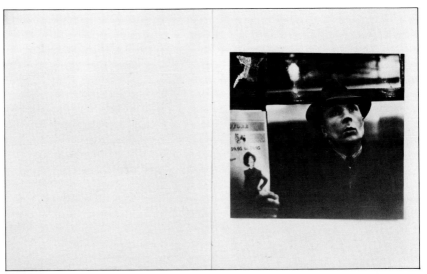

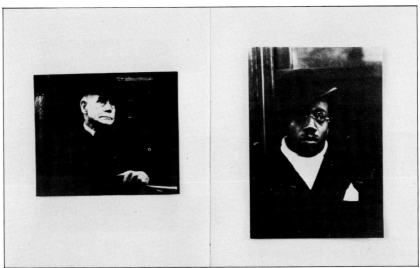

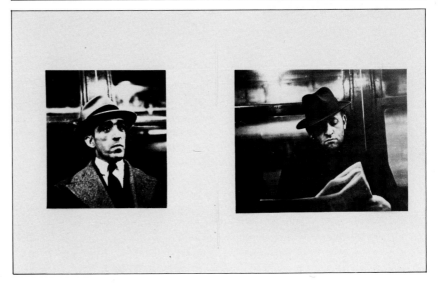

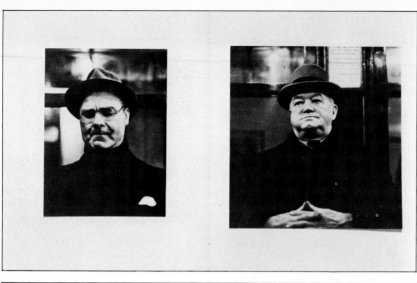

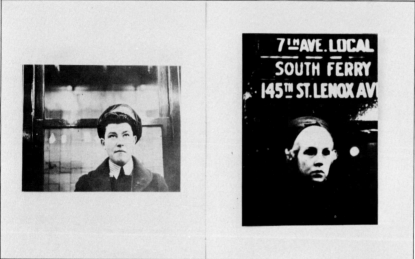

New York City, ca. 1959. Double-page spreads from a
dummy for proposed book of subway portraits

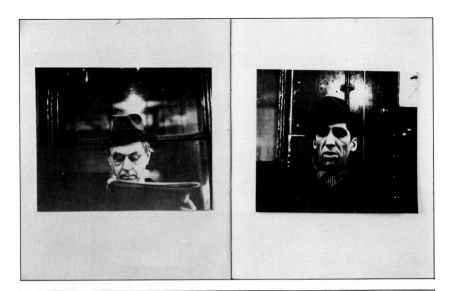

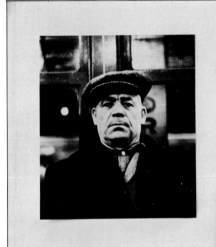

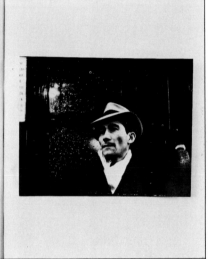

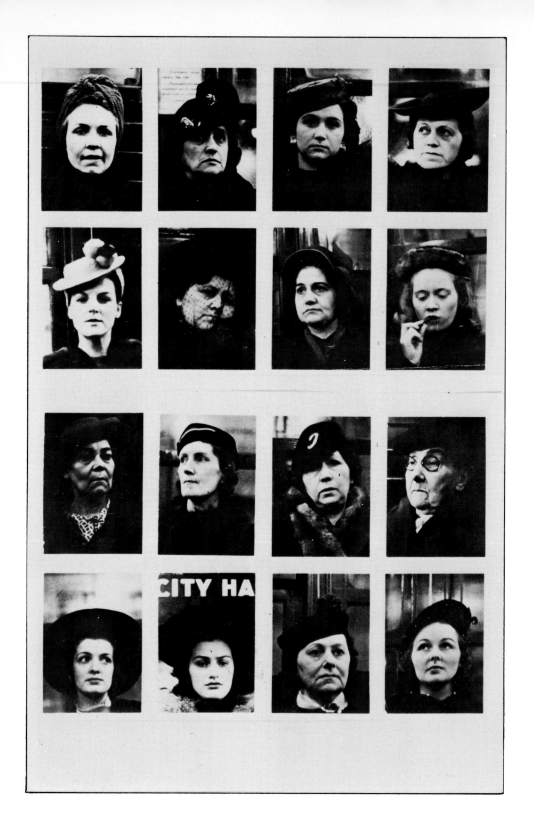

*New York City, ca. 1959. Page and spreads from a dummy
for proposed book of subway portraits*

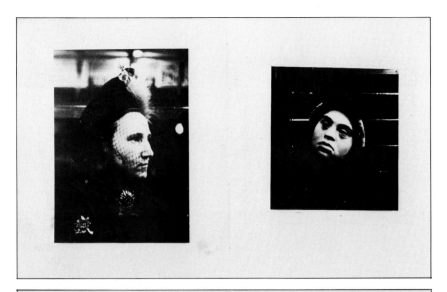

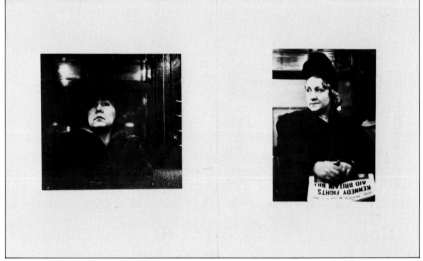

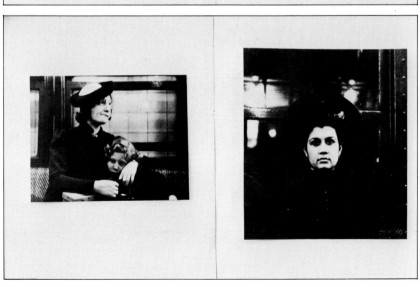

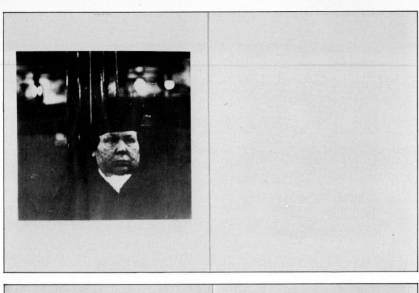

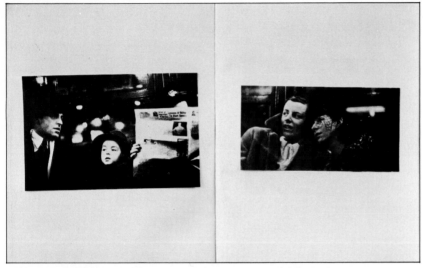

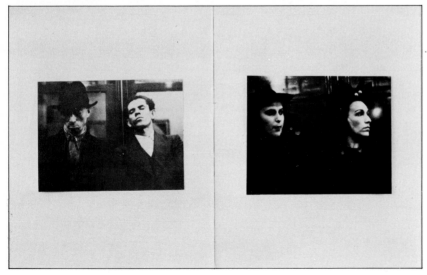

*New York City, ca. 1959. Double-page spreads from a
dummy for proposed book of subway portraits*

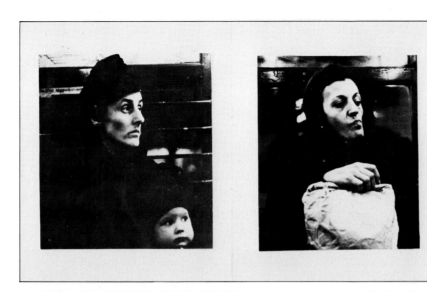

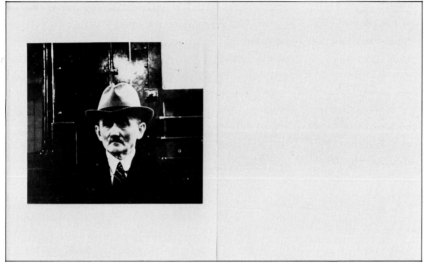

UNPOSED PHOTOGRAPHIC RECORDS OF PEOPLE

Theorists claim almost everything for the camera except the *negation* that it can be made not to think and not to translate its operator's emotion.

This collection is at least an impure chance-average lottery selection of its subjects — human beings in a certain established time and place. The locale was picked for practical reasons only, for rigidity of technical working conditions. Actually the ultimate purity of this method of photography — the record method — has not been achieved here, but it is present as an unfulfilled aim: I would like to be able to state flatly that sixty-two people came unconsciously into range before an impersonal fixed recording machine during a certain time period, and that *all* these individuals who came into the film frame were photographed, and photographed without any human selection for the moment of lens exposure. I do claim that this series of pictures is the nearest to such a pure record that the tools and supplies and the practical intelligence at my disposal could accomplish. Actually, of course, this is an edited, selected group of photographs, with the choices based on practical, never on aesthetic, or topical, grounds.

This is a fair run of the people in the city who actually do sit in this place, the subway bench; and the time is 1940, more or less.

Five draft texts (all unpublished) to accompany a volume of subway portraits. A selection of these photographs, made in 1938 and 1941, was published in 1966 by Houghton Mifflin, under the title Many Are Called, *with an introductory note written in 1940 by James Agee.*

THE UNPOSED PORTRAIT

The crashing non-euphoria of New York subway life may some day be recorded by a modern Dickens or Daumier. The setting is a sociological gold mine awaiting a major artist. Meanwhile, it can be the dream "location" for any portrait photographer weary of the studio and of the horrors of vanity. Down in this swaying sweatbox he finds a parade of unselfconscious captive sitters the selection of which is automatically destined by raw chance.

The portraits on these pages were caught by a hidden camera, in the hands of a penitent spy and an apologetic voyeur. But the rude and impudent invasion involved has been carefully softened and partially mitigated by a planned passage of time. These pictures were made twenty years ago, and deliberately preserved from publication.

As it happens, you don't see among them the face of a judge or a senator or a bank president. What you do see is at once sobering, startling, and obvious: these are the ladies and gentlemen of the jury. *1/7/62*

People Anonymous

PEOPLE IN THE SUBWAY

Unposed portraits recorded by Walker Evans

In America, people do not look at each other publicly much. The well bred consider it staring, and therefore bad form, and they just aren't curious. (An exception is the definitely rude going over one gets as a stranger in a small western town — sometimes southern — but that is another matter.)

I remember my first experience as a café sitter in Europe. *There* is staring that startles the American. I tried to analyze it and came out with the realization that the European interested is *really* interested in just ordinary people and makes a study of man with his eyes in public. What a pleasure and an art it was to study back, and a relief to me as a young more or less educated American, with still echoing in the mind his mother's "Don't stare!" (I still cannot point at *any*thing in public.) But I stare and stare at people, shamelessly. I got my license at the Deux Magots (dated 1926) where one escaped one's mother in several other senses, all good, too.

(In passing, consider the upright American *father's* horror at café sitting.)

Stare. It is the way to educate your eye, and more. Stare, pry, listen, eavesdrop. Die knowing something. You are not here long.

SUBWAY

You won't believe it, but there was a time, quite recent, when the New York subway was almost a peaceful, restful place. Who today is prepared to hear when I say that was the year 1941? Or when I say that lots of citizens actually had an affection for those rattling, roaring cars, the noise, the sense of speed, useful motion, the smell, the thousands of small human incidents, the inevitable familiar inventive blind man making his way down the rocking aisle. Looking back, one gets the feeling that, compared to now, the subway riders actually *liked* each other. . . .

SUBWAY

The choice of the subway as locale for these pictures was arrived at not simply because of any particular atmosphere or background having to do with the subway in itself — but because that is where the people of the city range themselves at all hours under the most constant conditions for the work in mind. The work does not care to be "Life in the Subway" and obviously does not "cover" that subject.

These people are everybody. These pictures have been selected and arranged, of course, but the total result of the line-up has claim to some kind of chance-average.

The gallery page is a lottery, that is, the selection that falls there is determined by no parti pris such as, say, "I hate women" or "women are dressed foolishly" or "———." It *is* an arrangement, of course, as is the rest of the book, but the forces determining it have to do only with such considerations as page composition, tone of picture, inferential interest of picture or face in itself.

Speculation from such a page of 16 women's faces and hats remains then an open matter, the loose privilege of the reader, and whoever chooses to decide from it that people are wonderful or that what America needs is a political revolution is at liberty to do so.

May 18, 1941 Sunday	1	Fairfield Ave. stores & tel. posts	9 AM	24 in	45	$1/25$	marked 17 on map.
	2	dump of Fairfield Ave	9:30 AM	15	22	$1/25$	18 on map
	3	dump of Fairfield Ave	9:30 AM	15	22	$1/10$	
	4	(off Albion St.) used car lot Fairfield Ave. & Anderson St.		15 in.	32	$1/10$	19 on map
		Mansard house West Ave & Prospect St.	11:30 AM				
	5				45	$1/5$	20 On map
	6				45	$1/2$	
	7	Park Ave & Lewis St. wood tower house	10:40 AM		45	$1/5$	21 map
	8	Half house State St.	11 AM		45	$1/5$	6 on map
	9	Half house State St.	11 AM		45	$1/2$	
		Blank Bros. Druggists RR St					
	10	Horizontal			45	$1/5$	
	11	Vert.	11:20 AM		45	$1/5$	11 on map
	12	Vert.			45	$1/2$	
		New Housing & Old Shell					
	13	Horizontal			45	$1/5$	
	14	Horizontal			45	$1/2$	map 22
	15	Vert.			45	$1/5$	
	16	Vert.			45	$1/2$	
		City Hall monument					
	17						
	18						
	19						
	20						8 on map
	21						
	22						
	23						
	24						
May 19 Monday		Housing 2nd shot: with wreckage		24 in	f64	$1/2$ sec	23 map

Tues A Tobacco Rd. poster & tenements city dump
May 20 B Savings sign at RR
1941 C Flag and houses
 D New housing across river

Independent St.
June 25
PEOPLE

NOTE

Roll of Rolleiflex exp. Wed. June 25
at 11 AM on Main St. Bridgeport:
shot at 3.5 to 4, 100 sec. shade,
even lighting, various distances,
some using whole glass, some magnifier,
none at eye level
meter reading was $^1/_{100}$, f4 for Supreme

— — — — — — — — — — — — — — — — — —

Part of a roll of Contax, Supreme shot in
Main St. of people, Bridgeport 12 noon
June 25. Varing distances 6 to 9 ft.
On first few frames, shutter seemed to
sound stuck on $^1/_{10}$ or $^1/_{25}$ though set
at $^1/_{125}$th.
Later OK in sound click.
Difficulty focusing
Look for depth and note if angle is
too great
Difficulty shooting face-on this close

high views 8 x 10
street traffic 8 x 10
factory views
boarding house interior
defense window hdw.
Merritt Pkwy shot
People at Pleasure beach
church house
more shop windows
Whelan counter
Reed's sitters
hot dog sign
Savers prosper sign, early morning sun
Furniture display. 2nd hand

Department store women Contax $^1/_{25}$th 1.5
Street people rolleiflex
Store front (Italian?)
25 on map Helen St & No. 1
laborers at 11:30 AM sitting out

*Bridgeport, 1941. Transcript of pages from Evans's field
notes. Initial numerals refer to identifying numbers on 8 x 10
film holders. Data at the right of each entry indicate
lens, aperture, exposure: i.e., 24 in = 24 inch element of
triple convertible lens; 45 = aperture; $^1/_{25}$ = exposure.*

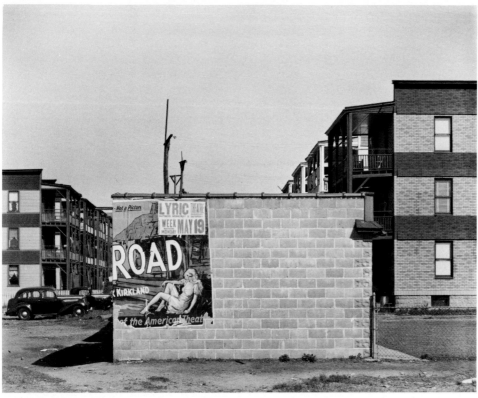

*Bridgeport, 1941. 8 x 10 negatives. Photographed for
"In Bridgeport's War Factories,"* Fortune, *September 1941*

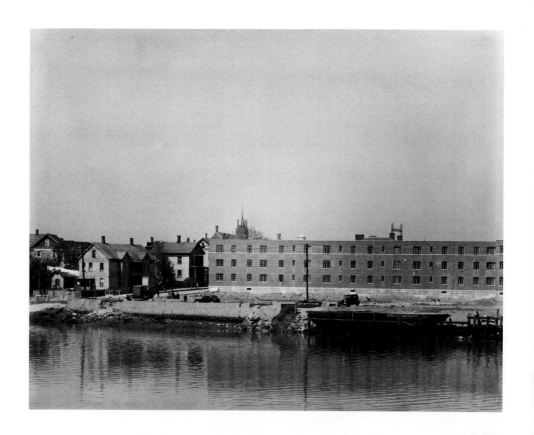

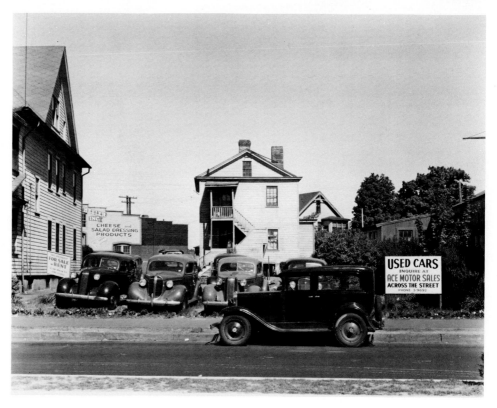

On an assignment, I would say to myself, You've got to do two things here. You've got to satisfy whoever is commissioning you — an editor — who then thinks he is doing something that will interest the public, and then you've got to satisfy yourself, too, which is an entirely different thing.

("Would it be too much to say that you didn't essentially do for Fortune what you wouldn't have done for yourself?")

That's just done by stubbornness, really, and also by the inner consciousness and conviction and knowledge that you, at any point, if conditions became intolerable, would

leave them. And that conveys itself, without any words, to the establishment you're working with. . . . I respected the people at Fortune who responded to my stubbornness, which was almost unconscious. They had the sense to know that they'd better leave me alone. I'd be better for them, even, if they left me alone. And I was. I deliberately took some ordinary assignments just to see if I could do them. They wanted a series of the younger heads of corporations in full-page color. A great challenge. It came out beautifully. Everybody was delighted.

Katz/Evans interview

Bridgeport, 1941. 35mm negatives, facing page; above 8 x 10

*Bridgeport, 1941. 35mm negatives (lower photograph this
page size unknown); facing page, 4 x 5 negative*

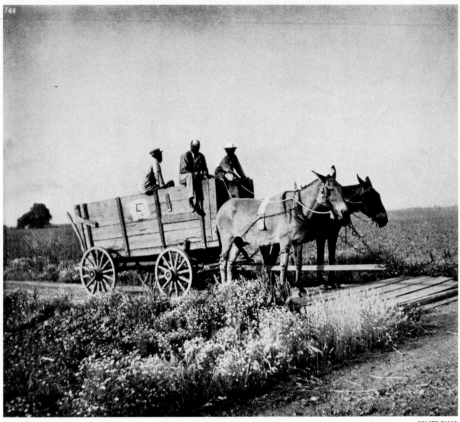

WALKER EVANS

FAULKNER'S
MISSISSIPPI

The geography of William Faulkner's world, of his ten novels,
his short stories, of his new novel, "Intruder in the Dust."...
Six pages of photographs by Walker Evans

William Faulkner has created, on the landscape of Mississippi, a violent legend. Roped into his twining series of ten novels, his many short stories, there is always the same masterly background, an effective pressure on his characters. Although he calls his vast county Yokanapatawpha, and his town Jefferson City, the descriptions fit only too well Ripley and Canton and Holly Springs and a dozen other Mississippi towns. The Faulkner landscape always has a ruined plantation, mules and a wagon and Negroes in a unit, a crossroads store, a jail, the courthouse in Courthouse Square, a graveyard, a poor white dogtrot cabin, a cupola'ed house on a street, Negro cabins with cotton growing to the door, and always, the tracks of the railroad. These are standard equipment in Faulkner's Mississippi.

On the roads of the Delta when the summer air is a long, slow quiver and the paintless cabins, the ecru land and the air melt together, it is quiet in the working daytime. There are always mules in the foreground: "Though the mules plod in a steady and unflagging hypnosis, the vehicle does not seem to progress. It seems to hang suspended in the middle distance forever and forever, so infinitesimal is its progress, like a shabby bead upon the mild red string of road." [*Light in August*]

VOGUE, OCTOBER 1, 1948

*Opening page of "Faulkner's Mississippi," Vogue, October 1, 1948;
facing page, environs of Oxford, Miss., 1948. 2¹⁄₄ x 2¹⁄₄*

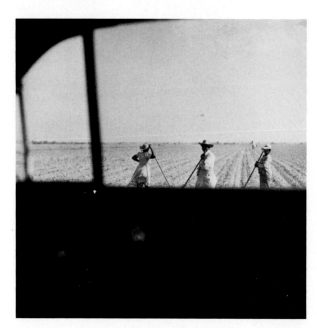

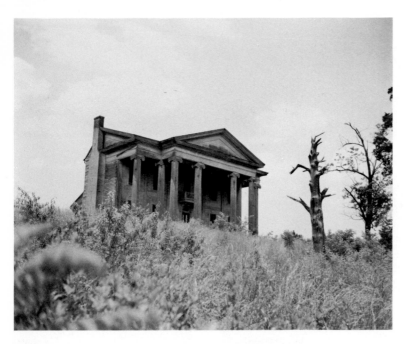

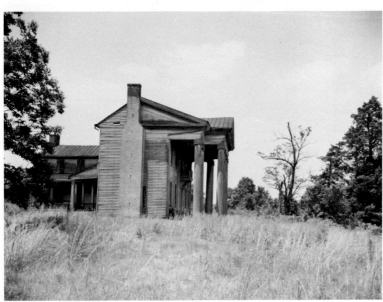

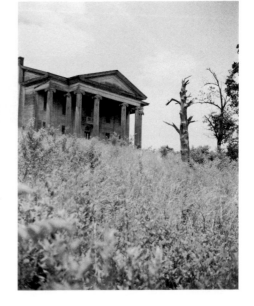

Mississippi, 1948. 4 x 5 negatives;
facing page, from "Faulkner's Mississippi"

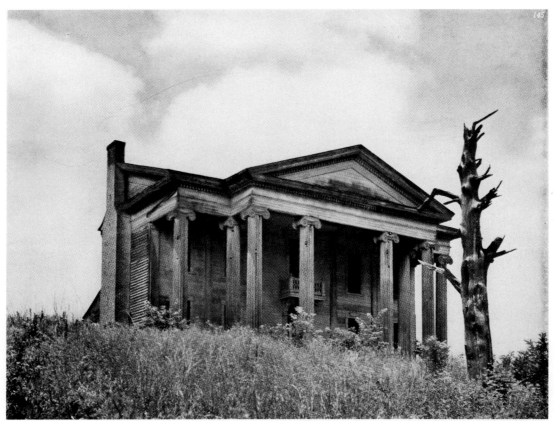

"RUIN RISING GAUNT"

Symbolically, historically, a plantation house is always important in Faulkner; sometimes gutted, sometimes burned, with only four chimneys standing, sometimes half-ruined, it raises its paintless face in *Intruder in the Dust*, in *The Hamlet*, in *Sanctuary*, in half a dozen more. It may look like the calm beauty of the photograph on this page—weathered mauve-pinked grey, which was once white, set in the beige glow of grasses: ". . . ruin rising gaunt and stark out of a grove of unpruned cedar trees. It was a landmark, known as the Old Frenchman place, built before the Civil War; a plantation house set in the middle of a tract of land; of cotton fields and gardens and lawns long since gone back to jungle, which the people of the neighborhood had been pulling down piecemeal for firewood for fifty years or digging with secret and sporadic optimism for the gold which the builder was reputed to have buried somewhere about the place when Grant came through the county . . ." [*Sanctuary*.]

VOGUE, OCTOBER 1, 1948

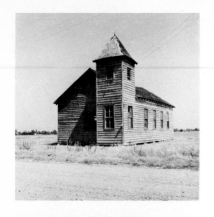 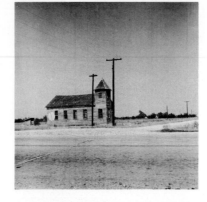 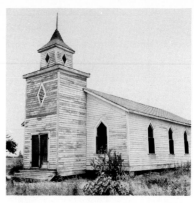

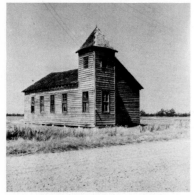 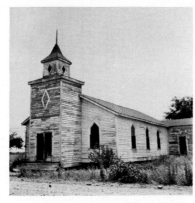 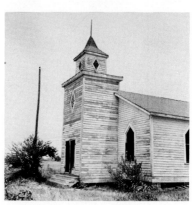

 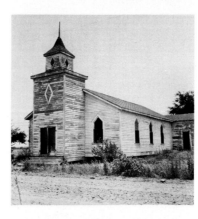 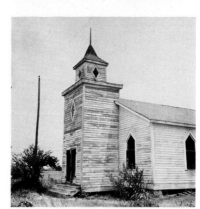

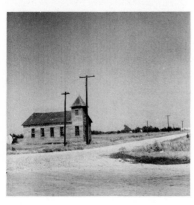 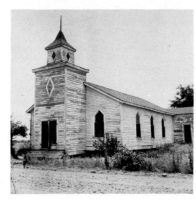 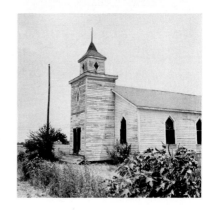

Mississippi, 1948. 2^1/4 x 2^1/4 negatives;
facing page, 4 x 5 negative

174

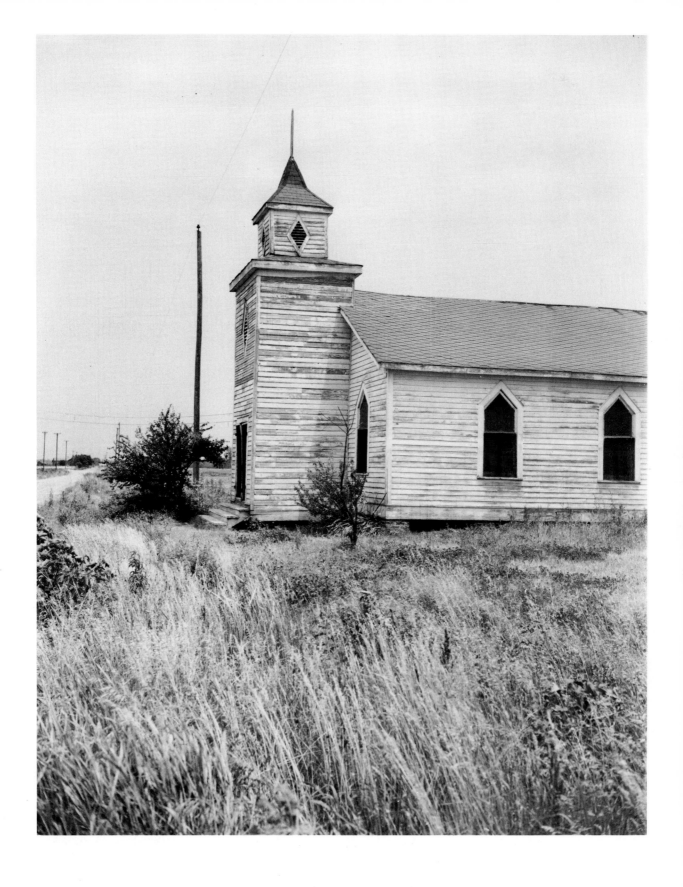

146

MILITARY CEMETERY

STORE IN TOWN

WALKER EVANS "CROSSTIES CUT OFF EVEN"

FAULKNER'S MISSISSIPPI *continued*

Although Faulkner's Mississippi centres around his imaginary Jefferson City, it bears a living likeness to a dozen towns in which the core is Courthouse Square, with its Confederate statue and its four sides of arcaded stores. Some of them are high-galleried, a dry, faded pink brick, some new and poison green. In towns where the hardware shops now have automatic dishwashers and the drugstores sell Chanel soap, there are still general stores which have "the old smells of cheese and salt meat and kerosene and harness, the ranked shelves of tobacco and overalls and bottled medicine and thread and plow-bolts, the barrels and kegs of flour and meal and molasses and nails, the wall pegs dependant with plow-collars and hames and trace-chains, and the desk and shelf above it on which rested the ledgers." [*The Bear.*] Some of those stores may have been passed by Grant's Army on its way to Vicksburg, where thousands of Union soldiers lie in the Military Cemetery, shaded by the South's magnolia trees, its black cypress.

VOGUE, OCTOBER 1, 1948

VOGUE, OCTOBER 1, 1948

All through Faulkner's Mississippi runs the thread of the railroad. In the Delta country, the riders can see the interminable frieze of women and children chopping cotton, a single mule in the distance, can see the sharecropper cabins that often seem to have just one enormous bed and a pink quilt. "There was a track and a station and once a day a mixed train fled shrieking through it. The train could be stopped with a red flag, but by ordinary it appeared out of the devastated hills with apparition-like suddenness and wailing like a banshee, athwart and past that little less-than-village like a forgotten bead from a broken string..." [*Light in August.*] Sometimes, as in *The Unvanquished*, there is "only a drowsing solitude of track which had sent no smoke and heard no bell in more than a year..."

Mississippi, 1948. "Faulkner's Mississippi"
4 x 5 negatives, facing page

176

THE MISSISSIPPI

CROSSROADS STORE

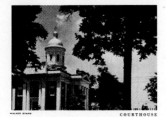

WALKER EVANS

COURTHOUSE

WASHWOMAN'S CABIN

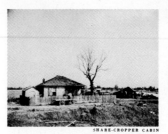

SHARE-CROPPER CABIN

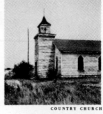

COUNTRY CHURCH

DOGTROT CABIN

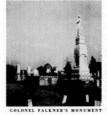

COLONEL FALKNER'S MONUMENT

SCROLLED, BALCONIED HOUSE

FAULKNER'S MISSISSIPPI *continued*

Faulkner's Mississippi is fed in one way or another by The River: "there was a high bright rosy glow quiet beyond the trees and shining on the river." [*The Unvanquished.*] By the bricked and white painted courthouse in the centre of its arcaded square. By the Negro washwomen whose cabins have slippery irons. By "the paintless Negro cabins where on Monday morning in the dust of the grassless treeless yards halfnaked children should have been crawling and scrabbling after broken cultivator wheels and wornout automobile tires and empty snuff-bottles and tin cans and in the back yards smoke-blackened iron pots should have been bubbling over wood fires beside the sagging fences of vegetable patches and chickenruns which by nightfall would be gaudy with drying overalls." [*Intruder in the Dust.*] By the Negro churches with tiger lilies and chokeberry in graveyard, "a weathered church lifted its crazy steeple like a painted church." [*The Sound and the Fury.*] By the crossroads store ["The Bear"]: "placarded over with advertisements for snuff and cures for chills and salves and potions manufactured and sold by white men to bleach the pigment and straighten the hair of Negroes that they might resemble the very race which for two hundred years had held them in bondage and from which for another hundred years not even a bloody civil war would have set them completely free."

VOGUE, OCTOBER 1, 1948

Faulkner's characters may live in "a paintless two-room cabin with an open hallway between." [*The Hamlet.*] In dogtrot houses, where sometimes there are a pump and a sewing machine and a beautiful wooden chair bought at the hardware store. Or they may live in a "big, squarish frame house that had once been white, decorated with cupolas and spires and scrolled balconies in the heavily lightsome style of the seventies." ["A Rose for Emily."] And they are buried, the ones who owned the scrolled balconied houses where their families may see "the graveyard on the knoll and the marble shaft at Uncle Dennison's grave." [*The Unvanquished.*] In such a handsome cemetery (*above*) lies William Faulkner's grandfather, the Colonel, who spelled his name without a *u*, and who was shot dead on the main street of Ripley, Mississippi.

VOGUE, OCTOBER 1, 1948

Mississippi, 1948. "Faulkner's Mississippi,"
2¹/₄ x 2¹/₄ negatives, facing page

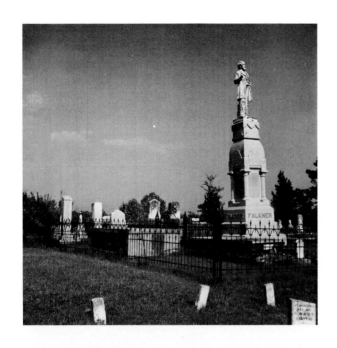

Dear Del: 7/23/48

I ask indulgence: official nonsense is beyond me. Instead, I'm writing a discursive letter which shall not be entirely playful if I can make a few points, and which I may refrain from signing with the name of Max Beerbohm. . . .

I can make a general criticism of the use of photography in Fortune. The magazine tries to do too much, thus diluting the photographer's concentration and penetration. Then after having ordered too much, it prints too many pictures, thus diluting the visual impact of the piece itself. All this comes from a habit of thinking of the visual part of Fortune journalism too much in terms of methods Time Inc. has worked out for the literary execution of its work. As it is, when I examine the writing-and-editorial performance of the magazine I conclude that this part of it is way ahead of the art performance. Pictures are so important and so telling a part of Fortune. The magazine has always offered readers a pretty luxurious visual treat. Quite apart from the many changes now contemplated, it needs some tightening here and there, chiefly in the matters of restraint and of a clearer establishment of photographic style. Restraint I spoke of in suggesting that we try to cover too much ground with photographs. As to style: do you think that there is a Fortune style of photograph? There *was* one, which served very well — though I never liked it. This was, in general, a romanticization of American industry. I never thought that that was looking at American industry at all, but such pictures could and did make people look at Fortune. They had one quality that I call essential to a picture, journalistic or other: they made you look, I repeat. And now, as I look through issues of the magazine, I see so often echoes of a dated manner. As an example, the color full-page made for the G.M. Diesel story:

This is not all bad. It is a big eyeful ($1.25). It is competent camera, but still, it is a kind of a cliché. I take this picture — uninvidiously, believe me — as an example of a weak and expected Fortune style which when used over and over slackens your readers' eyes. I'd say that was the part of doing enough pictures but not quite enough *with* pictures.

Here is another example, of something else — the sin of overcrowding. In the One-Newspaper Town story (August, 1947) everybody felt we had to show the newspaper plant and the newspaper-owned radio plant along with the chief executives of these plants, after we had produced and laid out the rest of the story's pictures pretty atmospherically, using the look of the town and its people — the background and the audience of the local press-and-radio. Well, we stuck these tag picture-notes almost postage-stamp size all together in a little knot that became, visually, quite illegible.

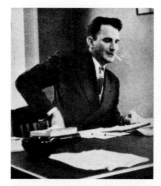

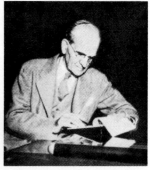

These four pictures could at least have been spotted in the text of that page, so that could be seen better.

Then there is an instance of a certain timidity (mea culpa) on the final page of the free, interpretive photograph spread on Chicago. In that portfolio the magazine was being as daring as I could wish, but we all let that over-stuffed-page habit keep us from ending off with the single strong bang of one symbolic picture.

Some of these illustrations of what I consider faults and downright errors you will have spotted. In fact we have

already discussed some. But I'd like anyway to underline them. And go on from there to point at a photograph I consider good. Here:

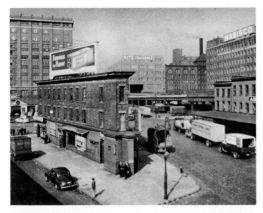

This picture is quiet and true. Since I am writing about photography, let me point out that this picture is a better part of the story at hand — National Biscuit Company — than a drawing or a painting would be. There is the profitable and well-run cracker factory in the sweaty part of town, there is a knot of men talking on the pavement about anything but crackers, amidst the irrelevant trucks. This is where Mal-o-Mars are cooked and this is where last week's newspaper meets the gutter too. And the Strand Hotel becomes Famous for Flavor. My point is, Fortune photographs should take a long look at a subject, get into it, and without shouting, tell a lot about it.

You may be sure that Fortune is looked at for its pictures and for the titles of its stories. That's what people *think* they have time for when they take it up. Later they read. But on this basis, can you afford to have a dull picture?

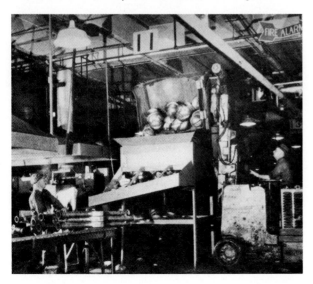

Can you afford to have any part of the magazine reminiscent of National Geographic or a smart trade journal parading the wonderful vice-presidents and the wonderful assembly belt of Zenith-Phoenix Punch Die and Bore? Well, it takes great care to avoid this — the kind of care you use to keep that atmosphere out of your writing.

Not only dullness is in question here. Let me hark back to the matter of visual-mindedness in editing. You need from writers a professional ability to produce readable copy. If you don't always get it — under this and that pressure — you re-write and re-arrange. You would never print a cluttered, confusing piece of prose. By the same token I'd like to see you throw out any photograph that does not properly invite the eye, even when it just anyhow contains an image of something you feel you need to have seen. You see why I said I thought Time Inc. editorial work ahead of its art work. (But I mean to confine the discussion to photography.) The Time literary *mind* is ahead of the Time visual mind. Since the former is necessarily in charge, the only way to improve matters is for the literary mind to alter its thinking about the visual. I've seen signs that something like this could be done without any broken lobes at all.

I am led by the above too close to the perilous question of taste not to fall into mention of it. You know the danger — as lief question a man's endowment with a sense of humor or his possession of a full set of real teeth, and enviable procreative powers. So — everybody has taste. I'm thinking of another aspect. Taste, let us admit, is a rather arrogant thing. If you have it, you have to use it rather arrogantly. But your arrogance may be so quiet and assured as to be unnoticeable: then, strange to say, people like it and fall in with you. Almost everybody likes a show of knowing taste — people learn something from it. Is there a greater pleasure?

Memorandum to Ralph Delahaye Paine, Jr., late summer 1948

TO: The Staff
FROM: R. D. Paine, Jr.

This is to confirm the appointment of Walker Evans to an assignment he has been working on unofficially for the past few months — namely, Special Photographic Editor. The real assignment is to develop a distinctive photography for the new Fortune.

Since this is the most intangible of assignments, it may be helpful to be very concrete about Walker's mode of operation:

1. He will take full responsibility for photographic illustration of selected stories. In these special cases, he will assign and direct the photographer, choose the pictures, and supervise the layout for final approval by the Art Director and the M.E.

2. On certain other stories designated by the Art Director, he will advise on the assignment and direction of photographers, and on selection of photographs for first layouts.

3. He will supervise the compilation of sources of what can be called "great pictures" — subjects peculiarly appropriate to Fortune. These pictures will probably be used most often in the Lead Story and in the Short Article section.

I bespeak the complete cooperation of both editorial and art department staffs in the important creative task that Walker has undertaken.

PHOTOGRAPHIC EQUIPMENT
OF WALKER EVANS

ITEM NO.	ARTICLE	AMOUNT INSURED
1.	One Speed Graphic #196211 with Zeiss F4.5 13.5 CM Lens #1980472 and Kalart Range Finder and Case	$ 132.50
2.	One Speed Gun (Kalart)	17.50
3.	One Contax 11 #C13823 with FI.5 Sonnar Lens #1661014 and Case	275.00
4.	One Turner Reich Anastigmat F7.5 Series 11 15" Convertible #150649 in Betax Shutter	125.00
5.	One Weston Master Meter #4925736 Model 715 and Case	20.00
6.	One De Vry Automatic Hand Movie Camera Serial #351 with Lens Wollensak Cine Velostigmat F3.5 (no serial number) and with Lens Dallmeyer 6 in. Telephoto F4.5 #118809 and Movie Tripod without Identification	150.00
7.	One Omega Enlarger Model D11 #34554	155.00
8.	One Kodak Projector Ektor F4.5 75mm #E01387	42.00
9.	One Kodak Projection Anastic-Mat F4.5 16mm	55.00
10.	One Bosch and Lomb – Zeiss Protar Lens Series 7 #359464	60.00
11.	One Sonar Lens 8.5cm #3208805	168.75
12.	One Tessar Lens 5cm F3.5 #3056147	18.75
13.	One Biogon Lens F2.8 #2078923	112.50
14.	One Contax 11 Camera #K55545 (without lens)	150.00
15.	One Automatic Rolleiflex Camera #1260498 and Xenotar Lens 2.8 #2946012	385.00
16.	One Automatic Rolleiflex Camera #1227146 with Zeiss Opton Lens #742606	250.00
17.	One Master Reflex #01778, with Primotar Lens 3.5 85mm #1143697	185.00
18.	One Kelar Lens 3.5 150mm #2061066	97.50
19.	One Leica 111C Camera #510611, Lens F.2 Summicron #1044191	333.00
	Total	$2732.50

EVANS'S PATENTED PORTFOLIO IDEAS

BEAUTY WITHOUT DESIGN
THE CLASSIC AMERICAN LANDSCAPE
THE MILL: HISTORICAL LOOK AT THE FIRST
 FEATURE OF THE NEW ENGLAND
 INDUSTRIAL LANDSCAPE
JUST WHAT DOES PALOMAR SEE?
THE BIG OUTDOOR SIGNBOARD BUSINESS
UNHAPPY MOTORING
THE BUSINESS OF BUSINESS INTERIORS
THE COMMERCIAL ARTISTS
SPONTANEOUS DISPLAY
HOLLY WHYTE'S OLD IRON FURNACES OF
 PENNSYLVANIA
THE INDUSTRIAL USES OF PHOTOGRAPHY
BUSINESS AMERICANA
THE HEAVY INDUSTRY CITY: PITTSBURGH
THE AWKWARD AGE OF ADVERTISING DISPLAY
THE PHOTO MAP OF THE U. S.
THE PICTURE AGENCY BUSINESS
THE FABRIC DESIGN BUSINESS (DIDN'T
 DEBORAH DO?)
A TOUR OF EUROPE FOR TRAVEL DREAMERS
THE DUDE RANCH AS A THING OF BEAUTY AND
 THE SEAT OF RENTED GOOD LIFE
THE BEAUTIFUL AND COSTLY GENTLEMAN'S FARM
 (THE BUSINESS MAN'S FOLLY)
PICTORIAL HISTORY OF KODACHROME
THE IMPERIAL CITY OF WASHINGTON
THE BUSINESS OF SHOPFRONT LIFTING
AN ANTHOLOGY OF WORK BY OFFICIAL COMPANY
 (FORD, ETC.) PHOTOGRAPHERS

Portfolio Suggestions

1. General stores still doing business. This would be business Americana, one of my specialties. I think there are enough for good 4 to 6 page black and white portfolio.

2. A set in color, and large size, of the R.R. company insignia on freight cars. These are loaded with association and nostalgia; most men have them by heart, if unconsciously, and have been noting them all their lives. Pick them out, enlarge them possibly full page in very true natural color and you have an unusual, eye-catching act. Naturalism is the essential style element in this picture idea. I go right to the cars and photograph the details in existing daylight, with all the cracks and the beautiful fadings left in. I'd love it, and could probably drool some prose to go with it.

3. An historical picture album of U.S. business and industry. Big order; a picture gathering and editing job. Old photographs that have become important documents. They exist, all right. Longtime fussy and probably exhausting work. Discuss if interested.

4. British Industries Fair open in May. Douglas Glass has the most remarkable set of portraits of British business leaders. I think they are sensational, in the best sense of the word. Maybe we could get them and rights to them from the London Sunday Times. I just saw this peg. This though is decidedly a portfolio, full pages, to do justice to excellent portraits by a real artist.

5. Ask me to explain an idea called "unsophisticated display," and to tell you how I might do this up into a portfolio. Beautiful stuff.

6, 7, 8. I got you interested already in the aesthetics of jet plane manufacture, Eastman color portfolio, and industrial ruins.

Securities Art

Three large engraving companies in New York turn out great lots of securities certificates. Very fancy eyefilling stuff. Tearjerking, funny, handsome. Portfolio of samples would be FORTUNEate. To be luxuriously knockout we might run actual engravings on banknote paper, give the readers a feel of this richness. (We once ran cigar-box art that way, on intaglio, years ago. It was the nuts.)

PRÉCIS OF CONVERSATION ABOUT WALKER EVANS PORTFOLIO AND FEATURE WORK

The following plans were acceptable to Hedley Donovan:

1. THE BEAUTIES OF THE COMMON TOOL. A dozen or so large, sensuous black-and-white picture studies of hand tools bought in ordinary hardware stores. Sensuous is the word. Extremely careful though simple studio photographs. The photographer will assume that a certain monkeywrench is a museum piece. The camera will drool over this and a countersink and a plumb bob. Abstract volupté. All will be strictly pure design: that is to say, no chiqued-up.

Raymond Loewy or Dreyfus commercial corruptions will be allowed in the show. (It is practical sense to do this indoor job this winter.)

2. U.S. INDUSTRIAL RUINS. This is Eric Hodgins' "Dark Satanic Mills" idea, about which he has written a well-remembered memorandum. Which may not need be paraphrased here. On hand is some little research. It was agreed that staff may be asked to make suggestions. This portfolio might be best in color.

3. THE UNCHANGEABLE TRADEMARK. Pictorial trademarks that are never changed because they have become commercial assets too valuable to drop. A layout display which will be careful not to resemble advertising, of the Uneeda boy; the White Rock angel nymph; Scott's Emulsion; 20 Mule Team Borax, and the like. This will depend on taste and ingenuity of layout.

4. PURE DISPLAY. How goods for sale are arrayed *naturally*, sometimes primitively, everywhere. The picture possibilities of this are high. Takes a good bit of looking around, takes photography, judgment, and leg-work.

5. A FOLDOUT PANORAMA of a midwest town business street around 1900, from the Library of Congress collection. There is a remarkable set of these, which I have seen. . . . Every rut and horsetail. I have a small copy of "Des Moines, Iowa, 1907." The cameraman was one F. J. Bandholz. This is Business History division of Americana. STREET EQUIPMENT. Was this or was this not acceptable? I have a more or less finished job on this on hand now, all color, it will be remembered.

Further; agreed to print photographs made by W.E. in London. To see.

CHICAGO

A camera exploration of the huge, energetic urban sprawl of the midlands

• • •

A portfolio by Walker Evans

The city so recently quitted by Sandburg and Dreiser, by Insull and Capone and Big Bill Thompson, did not subside with their departure. Even without such singers and prestidigitators Chicago, Illinois, is still one of the most arresting spots in the hemisphere. But when it sits for its portrait, it commonly bedazzles —

with stockyards, railroad stations, museums, and markets. Chicago often assumes you are in a hurry to view these, its prized and indeed remarkable postcard colossi. But, coaxed, it will reveal some far more characteristic items. On the following pages are a few Chicago sights that meet a leisured and untethered eye.

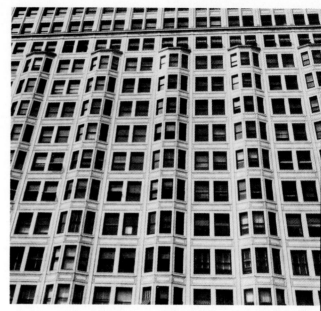

The skin-deep, perforated screen of the city—Michigan Avenue.

Pages from "Chicago, A Camera Exploration," Fortune,
February 1947

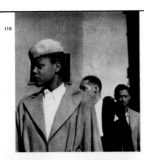

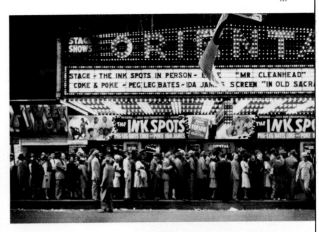

"Chicago is the only great city in the world to which all its citizens have come for the avowed object of making money." HENRY B. FULLER (1857-1929)

Evening in the Loop. Sunday in an alley.

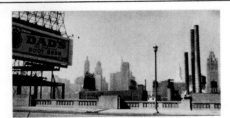

CHICAGO

Henry Adams saw in the place "the first expression of American thought as a unity . . ." D. H. Lawrence felt in it "a sort of palpitation I couldn't quite understand." Oscar Wilde drawled "Your city looks positively too dreary to me." Chicago revolted Kipling, and set Sandburg to composing one of the most stertorous stanzas in contemporary poetry.

Today no shivering men sleep under Michigan Avenue Bridge. Chicago makes no news with grand-scale and dangerous manipulators of finance. The front streets are reasonably clean, the back ones littered. You don't hear gunfire in theatre lobbies, though citizens resort to their fists rather promptly, and street-fight onlookers seldom ask in the police. Things are brisking along the way most Chicagoans think they should.

Yet, in common with most large American cities, Chicago is decaying in a sort of corporeal self-strangulation. And Chicago decays as it does everything else—spectacularly and speedily. A Prairie Avenue mansion is ripped down to save taxes, but its marble gateposts and vine-shrouded iron fence are left leaning into the future. A corner of the weedy clay island piled into Lake Michigan to make land for the Century of Progress Exposition of 1933 is now strewn with assorted relics of the big show: wan lampposts, rusted sewer pipes, huddles of serio-comic sculpture that seem to have spent thirteen embarrassed years imploring someone to hack them to pieces. The Progress men are gone. At your approach, at dusk, rats smartly abandon their little businesses. This teen-age Paestum is now in part a city dump.

Progress. Chicago has shouted it, believed in it, imitated it, and verily sweated it for several generations. But it has simply not had the time to brew for that mirage a definition or an evaluation. Perhaps the word money has served. Anyway, money is soldered to all the things Chicago has given the world: the mail-order catalogue, the sleeping car, mechanized gang warfare, the steel-frame skyscraper, the department store—not to mention the greatest heave of cultural aspiration since the fall of Rome.

Chicago in 1947 is perhaps more of a question mark than any big city in the country. It has spat up its most noisome gang leaders. It has diluted the stew of financial and civic corruption that was its fare during the twenties. It has weathered depression and come through war. Has the place grown up? Are definitions coming next? What of the energy it has so much of, that energy Henry Adams was so anxious to analyze? He sat aroused and dumfounded before the dynamos on view in the Electrical Building at the great Chicago World's Columbian Exposition of 1893. He was desperate for philosophical insight into the nature of the new mechanical energy. Had he come upon the stealthy uranium stockpile improvised under Stagg Stadium at the University of Chicago in 1942, would he have reached the end of his trail?

For Adams, Chicago was the point at which to penetrate the mysteries of natural and human force. Thus, in *The Education of Henry Adams,* he closes his brilliant Chicago chapter:

Chicago asked in 1893 for the first time the question whether the American people knew where they were driving. Adams answered, for one, that he did not know, but would try to find out. On reflecting sufficiently deeply . . . he decided that the American people probably knew no more than he did; but that they might still be driving or drifting unconsciously to some point in thought, as their solar system was said to be drifting toward some point in space; and that, possibly, if relations enough could be observed, this point might be fixed.

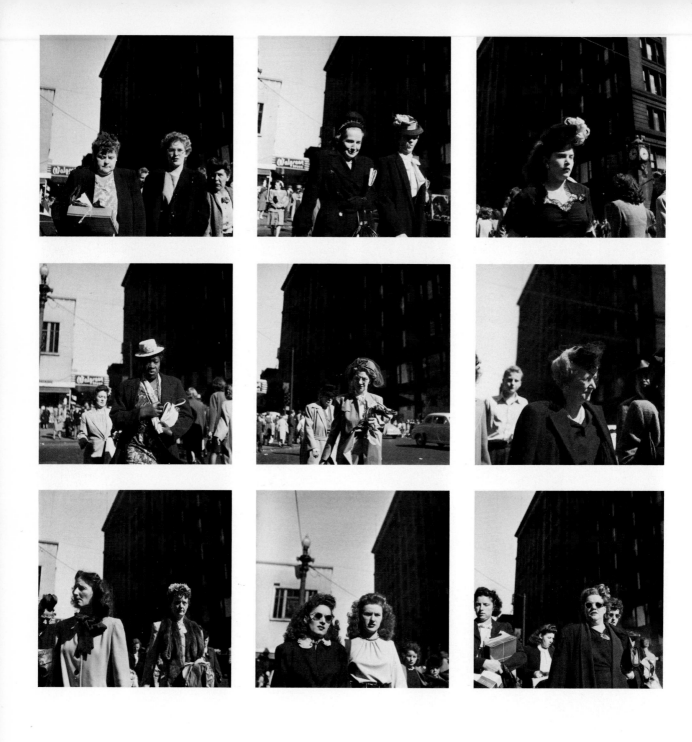

*Chicago, 1946. 2¹/₄ x 2¹/₄ negatives, facing page Evans's
enlargement from lower right negative, this page*

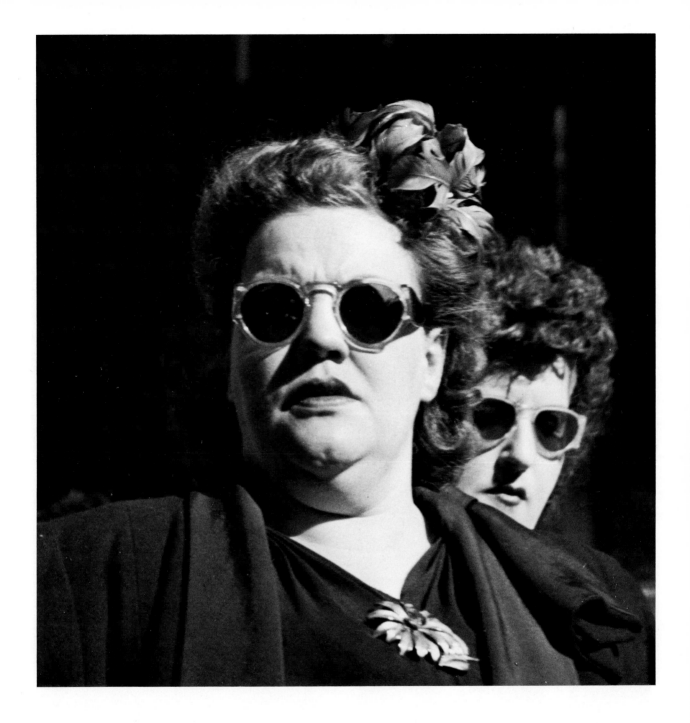

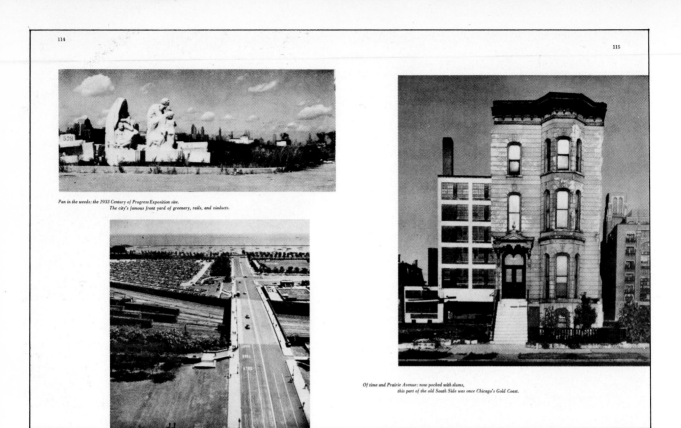

Pan in the weeds: the 1933 Century of Progress Exposition site.
The city's famous front yard of greenery, rails, and viaducts.

Of time and Prairie Avenue: now pocked with slums,
this part of the old South Side was once Chicago's Gold Coast.

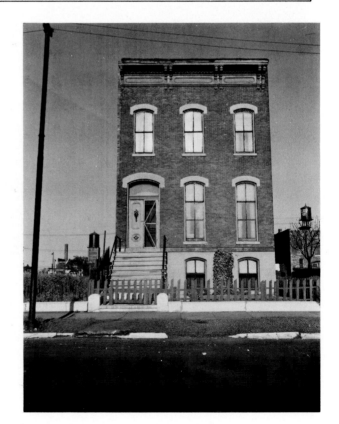

*Chicago, 1946. 4 x 5 negatives. Top, above, is a spread
from "Chicago, A Camera Exploration."*

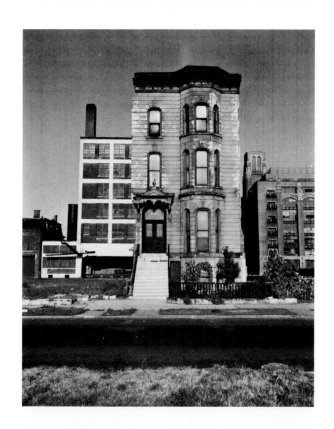 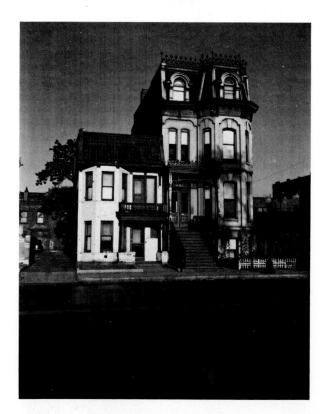

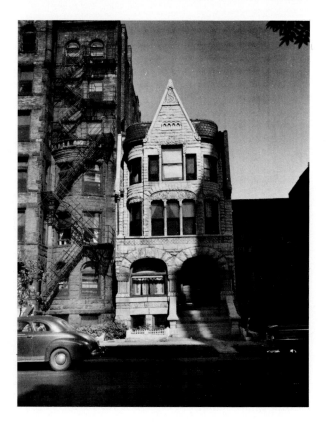 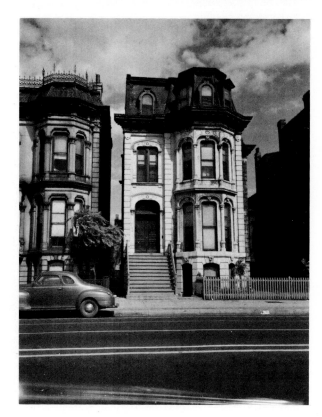

116

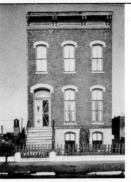

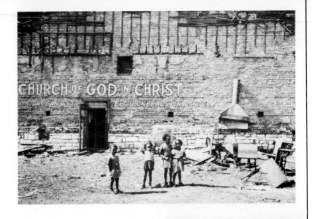

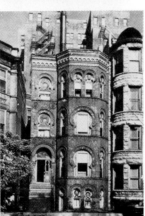

Mansions and mementos: the city's skin and bones in terms of historical echoes, opulent dreams, and plain Yankee statements.

Greater Chicago's 2,100 churches include one suburban Taj Mahal—the frosty, filigreed Bahai Temple, put up in 1920, on the north fringe of the city.

Chicago, 1946. 4 x 5 negatives. Top right on this page shows version used in Fortune; *cropping and perspective correction were done when the negative was printed*

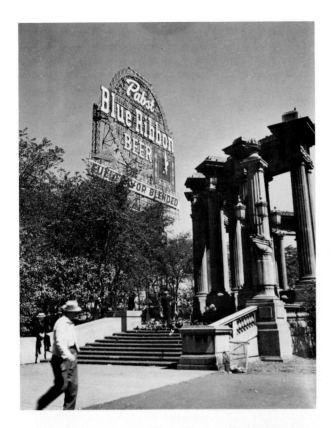

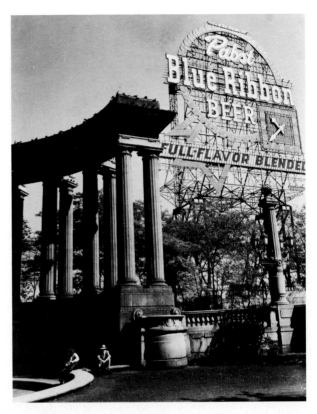

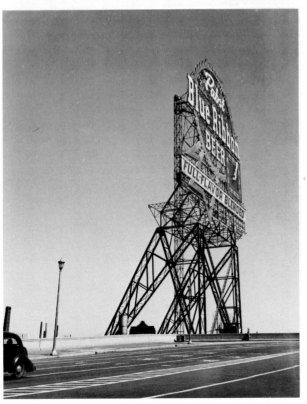

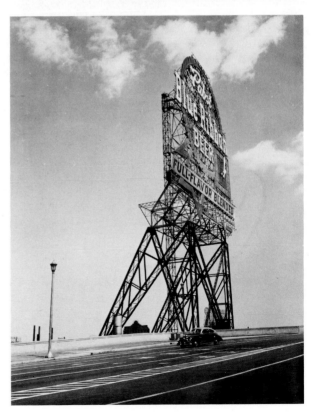

Paducah, Ky., 1947. 2¹/₄ x 2¹/₄ negatives. Photographed for "One Newspaper Town," Fortune, *August 1947*

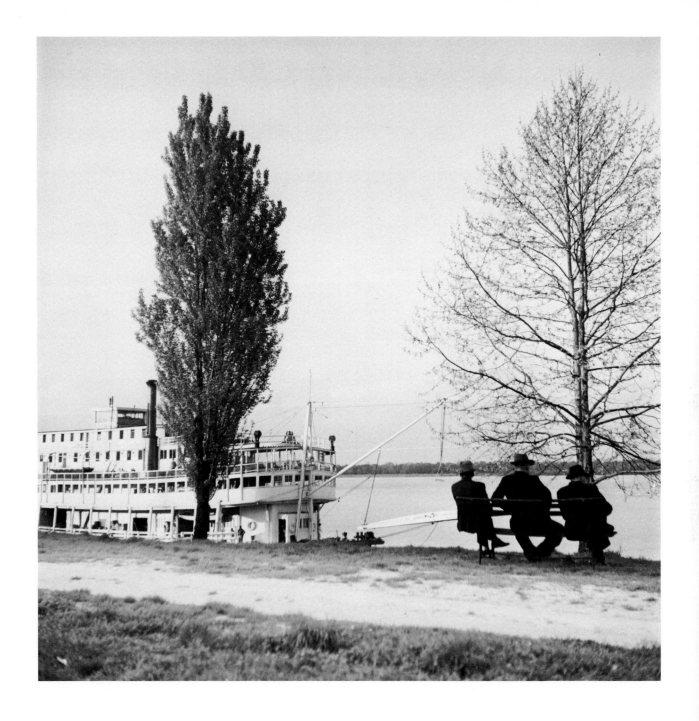

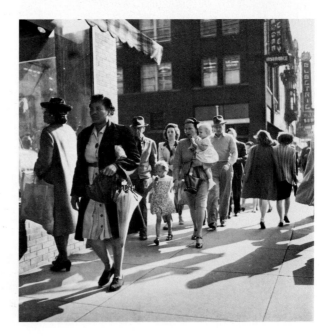

Paducah, 1947. 2¹/₄ x 2¹/₄ negatives

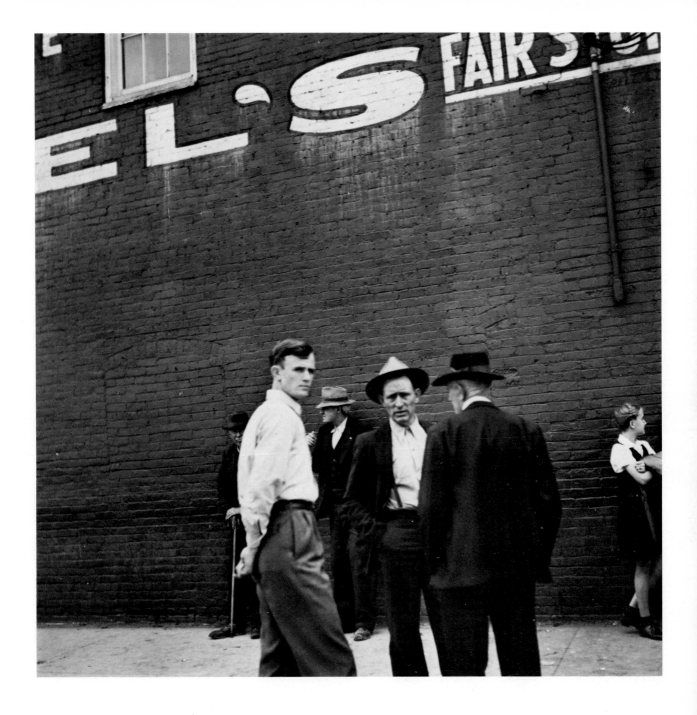

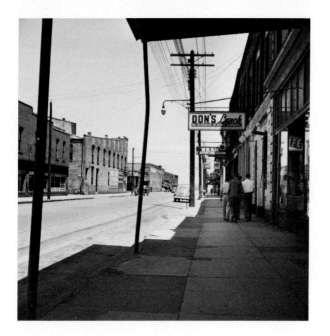

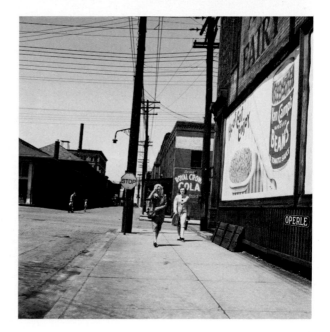

Paducah, 1947. 2¹/₄ x 2¹/₄ negatives

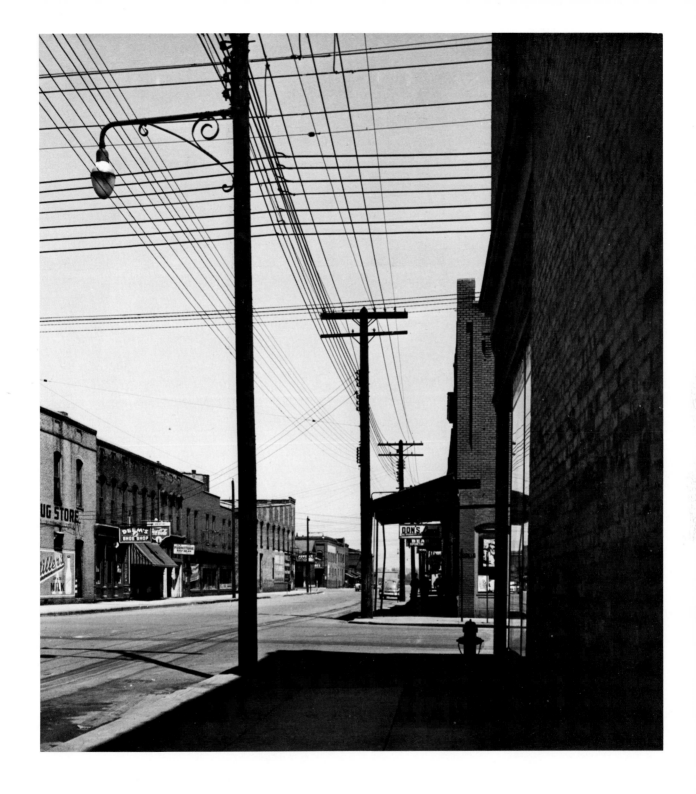

SUMMER NORTH OF BOSTON

"Sacrificing openly to the ivory idol—whose name is leisure."—Henry James

An American Portfolio by Walker Evans

THEY RISE on the ocean's rock edge. They perch on slopes of upcountry foothills. They stand on the shores of chilled inland lakes. They are New England's monuments to hot-weather leisure.

New Ocean House, Wentworth By-the-Sea, The Samoset, The Mount Washington . . . There are a dozen or so of these enormous, legendary resort hotels within the triangle made by Swampscott–Bar Harbor–Bretton Woods. Most of them were started before the turn of the century. All of them, enlarged and refurbished many times over, are still going strong.

August is their month. These are the weeks they welcome the battle for waterfront rooms and the small horrors of dinner-table misalliances. Now the tinkle of ice pitchers is louder, the whine of wicker heightened. The lending-library waiting list is longer for *Point of No Return*. Here once more is the fixed, reigning smile worn by the debutante from Sewickley, Winnetka, Cos Cob. And how to say good morning, safely, to the hotel bore? What to do with the forgotten damp bathing trunks just at train time? And there is that waitress who looks like Katharine Hepburn.

YOU COME upon their pilasters and their porte-cocheres sensing that this is America's version—in painted timber —of a Versailles or a Château Chambord; that here is a Blenheim risen in the Maine meadows. Catch one of these gay land arks in the late-day sunlight, under a fleeced sky: this is the nation's uttermost dream of secular grandeur, this clapboard castle, turreted, porticoed, balustraded, oriflammed.

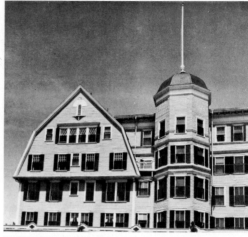

THE NEW OCEAN HOUSE, REBUILT 1901, SWAMPSCOTT, MASSACHUSETTS

New England, 1949. 4 x 5 negatives. Spreads from
"Summer North of Boston," Fortune, *August 1949*

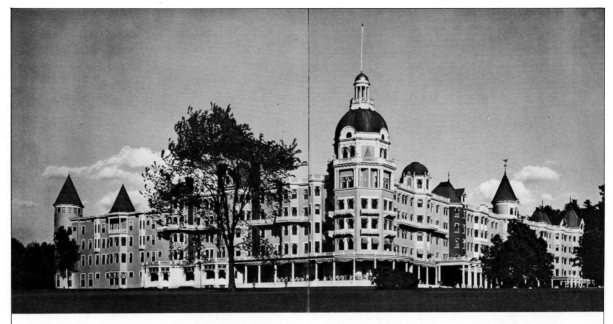

POLAND SPRING HOUSE was designed with the prodigality of a Wagner opera and the verve of a Sousa march. It is probably the most exuberant resort hotel building in the world. Certainly few others approach its architectural fanfare and crash of cymbals. The Grand Hotel, Mackinac Island, is larger, but . . . more quietly put together. In association of forms Poland Springs manages to bring you Carcassonne and Italian Baroque; Caesar Augustus, Pericles, and Chester A. Arthur all at once. Yet there

is an immense charm about the sight of it that fits the uses of a summer fortnight. Color: the mild yellow face; the pale green tower tops; the inexplicable, almost humorous single bay of natural brick; the rows of green-and-yellow striped awnings; and, topping all, a royal and saucy splash of gilt. Setting: a long, rising sweep of trimmed grass; backdrop of pine trees; lakes in valleys; New Hampshire mountains in the distance.

The hotel dates from 1876, with later additions. Today, in season, it is as shipshape as the *Queen Mary*. Surrounded by stables, a gazebo or two, greenhouses, links, courts, a chapel, and two satellite inns, it sits in its clearing like a feudal barony. The famous spring is kept under glass, hard by the Poland Water bottling works—a spanking little business founded in 1859. Land and plant were taken over in 1942 by Clark-Babbitt Industries, Inc., of Boston. But as for the 300-room Poland Spring House, its basic outward form has not been touched since 1903.

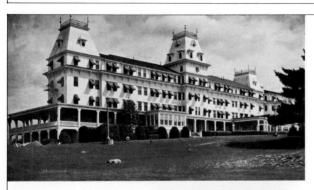

THE MANSARDED, bracketed, frame Wentworth By-the-Sea is a northeast coast landmark, put up in 1874. It stands in refinished white glory just outside of Portsmouth, New Hampshire. It is owned by Kansas-Texas hotel man James Barker Smith, who bought it in 1945. The Wentworth pays 20 per cent of New Castle, New Hampshire's, property taxes. It played its part in history, in 1905, by housing the delegates who drew up the Treaty of Portsmouth ending the Russo-Japanese War.

THE MOUNT WASHINGTON sails between waves of New Hampshire's White Mountains, at Bretton Woods. A stucco colossus launched in 1902, it is one of the world's more expensive summer-resort hotels. (The bill for one of its big suites, if paid for one year at its quoted daily rate, would come to some $55,000.) The Mount Washington also made history as the scene of the Bretton Woods International Monetary Conference of 1944.

HERE is one of the greatest expanses of white shingle on the east coast—shingle made lighthearted by a rousing arrangement of arches and bays. The Oceanside at Magnolia, Massachusetts, was built in 1879, with major additions and alterations up to 1911.

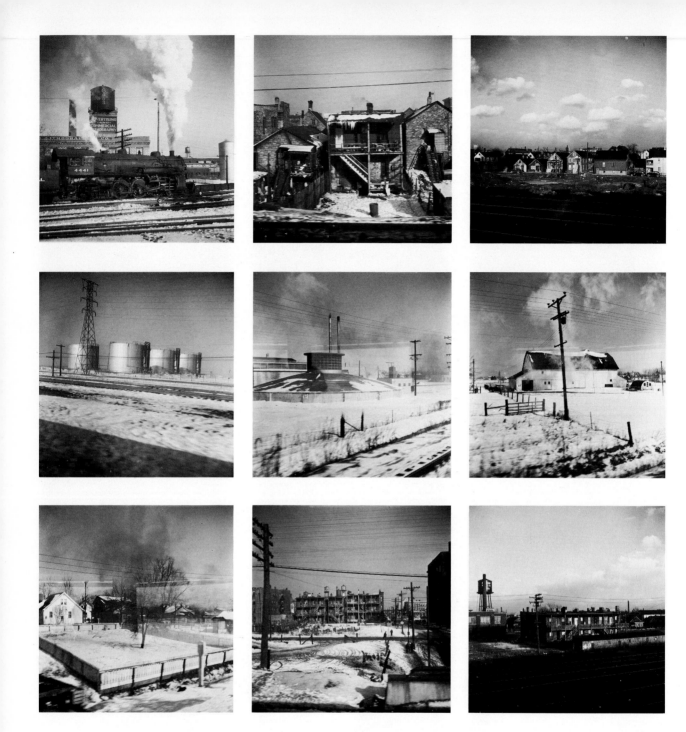

Through the train window, 1950. 2^1/$_4$ x 2^1/$_4$ negatives

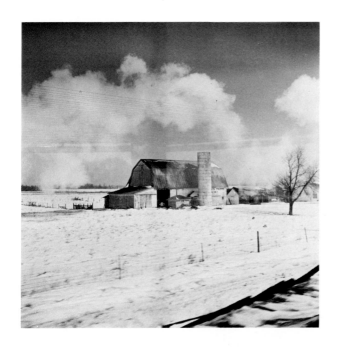

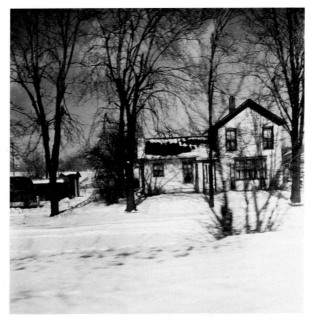

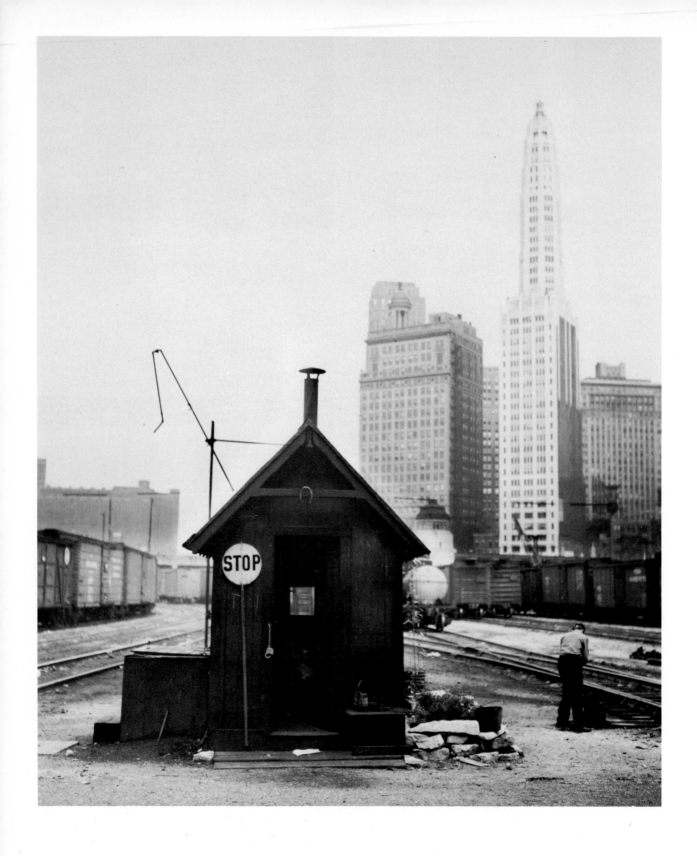

Chicago, 1951. 4 x 5 negatives. Photographed for
"Chicago River: The Creek that Made a City Grow,"
Fortune, *August 1951*

Washington, D.C., 1951. 2¹/₄ x 2¹/₄ negatives.
Photographed for "Imperial Washington," Fortune,
February 1952

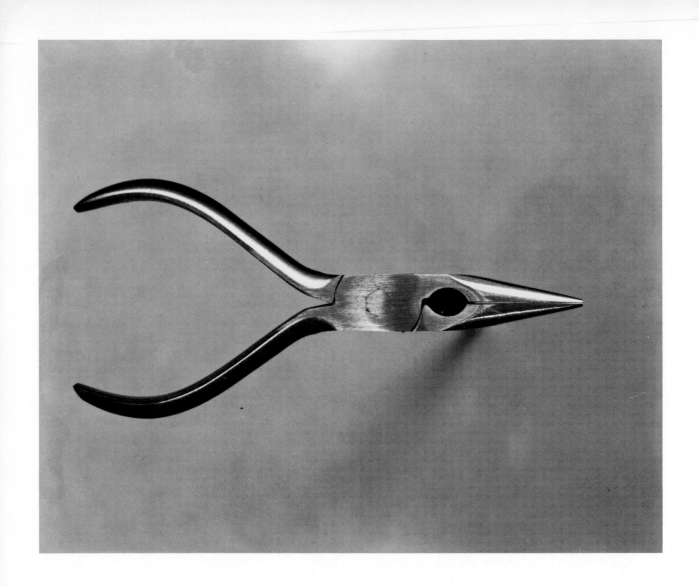

Time and again a man will stand before a hardware store window eyeing the tools arrayed behind the glass; his mouth will water; he will go in and hand over $2.65 for a perfectly beautiful special kind of polished wrench; and probably he will never, never use it for anything.

Penciled note

New York City, 1955. 8 x 10 negatives. Photographed for "Beauties of the Common Tool," Fortune, *July 1955. Top two, facing page, retouched at Evans's request*

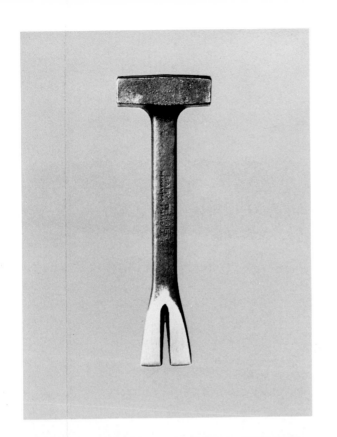

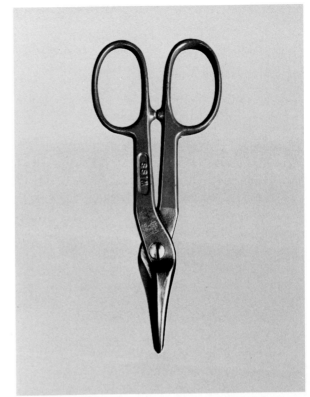

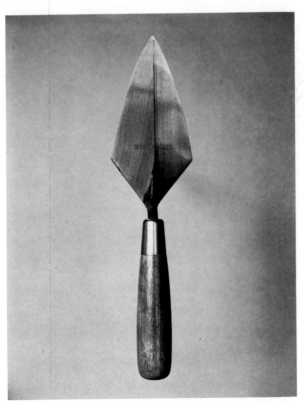

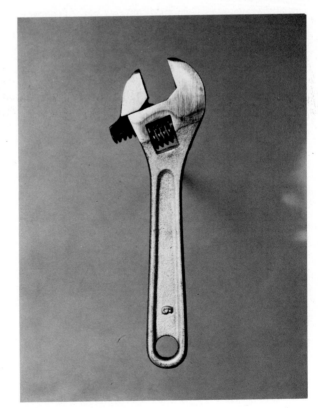

Messrs. Norton-Taylor, Banks, Allner, McQuade

From Walker Evans, a proposal

This morning I went out of curiosity through an
unguarded entrance into the great old main interior of the
Pennsylvania Station. Right now it is a spectacular theme
— I need not tell you why — but I wish to say that in the
light of our [Architectural] Forum inheritance there is an
immediate portfolio to be executed there, plus a story
related to railroad and real estate economics as well as
U.S. art history and architectural history down to and
through the contemporary (this because of Luckman's new
Madison Square Garden going to go up).

 I have already had a conversation with Walter
McQuade about this, and he is ready to discuss it with
you, and bring to the subject much more information than
I can supply. I bring you the visual impact, and am
prepared, willing, and able to execute work on it.

 But I must stress the immediacy of the proposed
action; the great main room (the Baths of Caracalla copy)
is being demolished right now. Photographically
speaking, the lighting is difficult, and in many places just
impossible, which precludes color work; but there are
enough black-and-white possibilities to make up a short
portfolio. I could do the work in two or three days; the
actual photography, that is. All I would need is solid,
correct credentials; entrée permission beyond question:
easy, I'm sure, to arrange. I could probably do this myself,
having once been in there officially, journalistically.

 2) Concerning NANTUCKET RESTORATION COLOR PORTFOLIO:
 All we need to complete this is shots of the interior of
the Walter Beinecke home there. I was refused permission
there when I did the other Beinecke Nantucket restoration
pictures in August. I believe we can now get in. It is only
one day's work. If house is open I could go any time, finish
and save our project. Beinecke family now sympathetic to
Fortune I'm told. Bud Lovelace knows W. Beinecke but he
not in today.

 Respectfully submitted [October 1963]

*New York, 1963. Pennsylvania Station,
enlarged section of 2¹/4 x 2¹/4 negative*

Pennsylvania Station, New York 1963.
2¹/₄ x 2¹/₄ negatives.

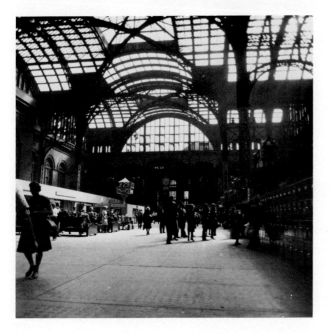

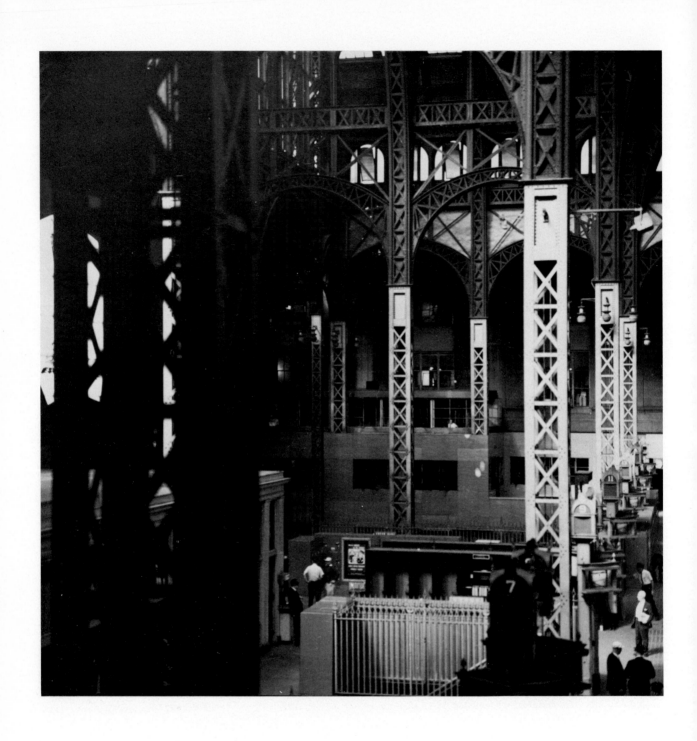

New York City, Pennsylvania Station, 1963.
2¹/₄ x 2¹/₄ negatives

When you say "documentary," you have to have a sophisticated ear to receive that word. It should be documentary style, because documentary is police photography of a scene and a murder. . . . That's a real document. You see art is really useless, and a document has use. And therefore art is never a document, but it can adopt that style. I do it. I'm called a documentary photographer. But that presupposes a quite subtle knowledge of this distinction.

Katz/Evans interview, Art in America, *April 1971*

Pennsylvania Station, 1963. 2¹/₄ x 2¹/₄ negatives

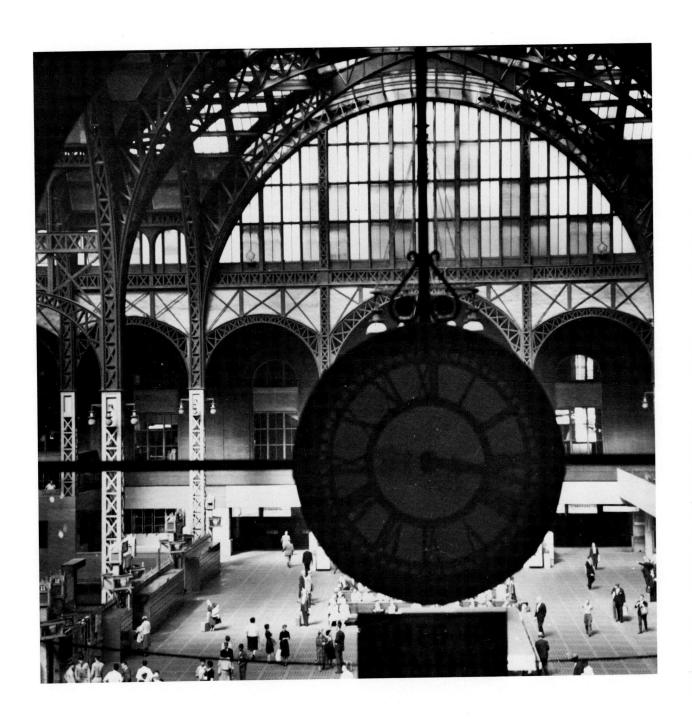

Debris, 1960s. 2¹/₄ x 2¹/₄ negative; facing page, 35mm

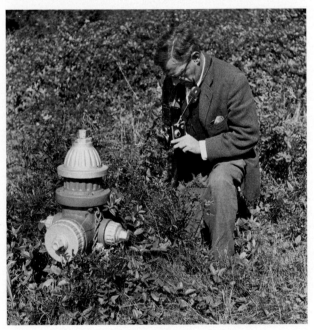

A garbage can, occasionally, to me at least, can be beautiful. That's because you're seeing. Some people are able to see that — see and feel it. I lean toward the enchantment, the visual power, of the aesthetically rejected object. . . .

Yale Alumni Magazine

Walker Evans at work, 1950s. 2¹/₄ x 2¹/₄ negatives
facing page, Evans's washbasin, 1975.
Photograph by John T. Hill

221

RANDOM NOTES & SUGGESTIONS
FOR PHOTOGRAPHERS

(I find that some, perhaps not all, photographers at Yale do not know certain facts, procedures, & processes in camera work and darkroom work. It will help them, and me, if they pick up the following information:)

1) Camera shutters usually are not geared for correct action in very cold weather. They can be "winterized" by The Professional Camera Repair Service, Mr. Forscher there, 37 W. 47 Street, NYC, 9th Floor.

2) The machine for print drying almost always leaves a slight surface impression on the print; it should not be used for perfect exhibition prints but the machine is OK for other, ordinary, purposes: file prints, reproduction prints, etc.

2A) Perfect surfaces will result if you simply hang 2 prints back-to-back, clipping four (corners) hooked clamps on string wire overnight. This also produces relatively flat prints, with curling only at edges. After you trim and crop, prints will be flat unless white margin was very narrow. Curl will extend in about one inch. Try to allow that much white blank or more, to trim.

3) The only correct spotting technique I know is the *Spotone* method, sold in most camera stores, with instruction sheet, which be sure to get. Smallest Nr. 0, soft hair brush should be used. Spontone penetrates any surface emulsion, is quickly removable, and is practically invisible on all surfaces if correctly applied. After it has performed its function of matching tones.

4) Camera shutter speed performance should be watched, periodically tested for accuracy or near accuracy. Shutters go off correction without your knowing it just like the timer in a car motor. Think of the camera as you would of your watch: no good if off very much. There is latitude of course in "black and white" film exposure, but color work, as you know, requires almost correct shutter timing. If you shoot at 1/50 sec. the map must really be 1/50 — and so for each dial setting.

I recommend use of cable release for all work where this is practicable: certainly for work done where conditions are more or less static, i.e., architecture, landscape.

I also recommend camera availability, I mean if possible carrying, even pocketing, a camera at the ready like a gun (meter too). Elaborate time-consuming preparation, followed by set, production-like photographic expeditions are all right, certainly, but today one may be armed for sudden sights. If you happen to own a 35mm. pocketable camera, carry it often.

For very cold weather, there is a golf glove made of very thin, sensitive leather which I find protective and workable. Damn sight better than bare hands at 10°. Rather expensive, though — something like $8 per pair. As you know, most regular gloves spoil your hand's working ability and sensitivity.

Work alone if you can. Girls are particularly distracting, and you want to concentrate; you *have* to. This is not anti-feminism; it is common sense. Companions you may be with, unless perfectly patient and slavish to your genius, are bored stiff with what you're doing. This will make itself felt and ruin your concentrated, sustained purpose.

Stay away from "camp" unless you are absolutely brilliant at it. Camp is arpeggio anyway. Half-camp is arpeggio that didn't come off.

Concern yourself not with the question whether the medium, photography, is art. The question is dated and absurd to begin with. *You* are art or not; whatever you produce is or isn't. And don't think about that either; just do, act.

[c. 1966]

Walker Evans at work, 1964. Photographs by John T. Hill

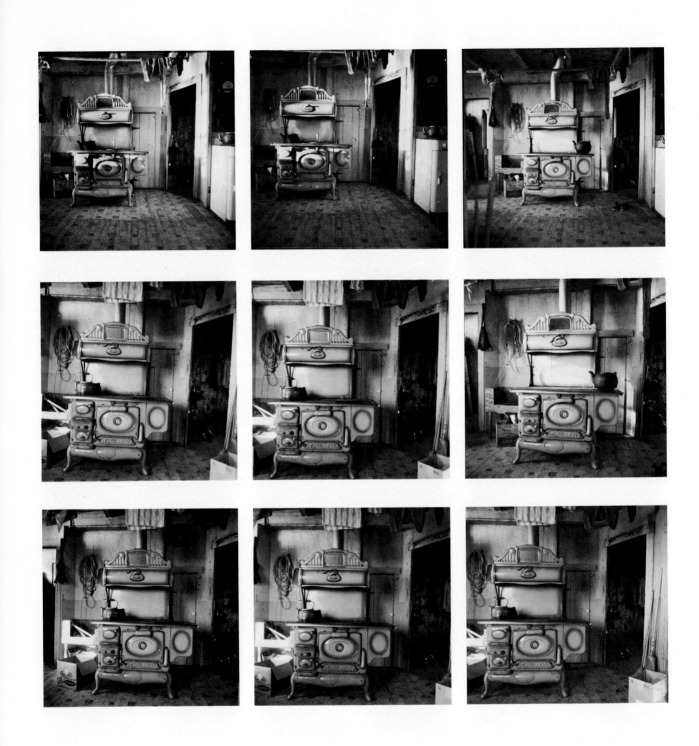

Nova Scotia, 1971 . 2¹/₄ x 2¹/₄ negatives

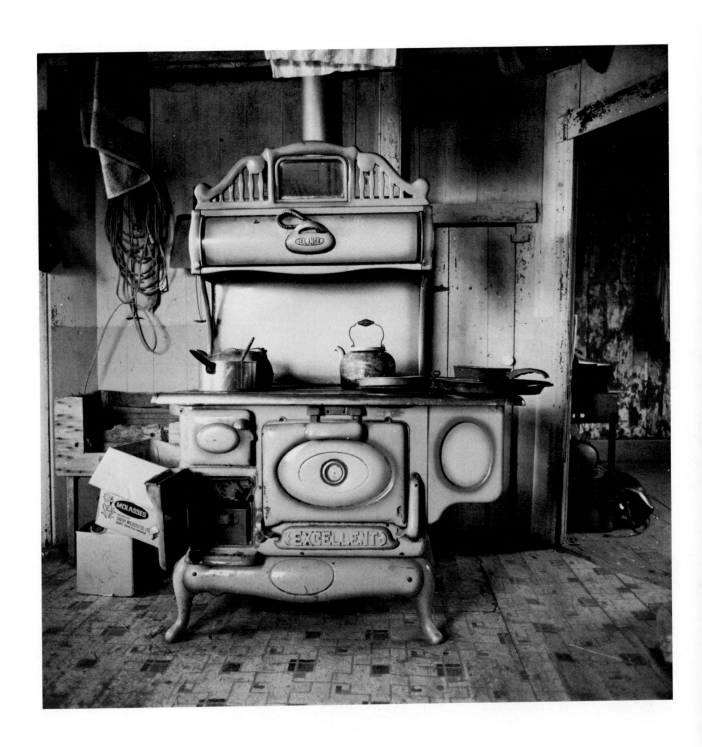

"He would wait each day for the right light on the stove
and then charge!"

June Leaf

LUCKIES TASTE BETTER

Connecticut, ca. 1972. Signs from Evans's collection,

The installation, here, of actual graphic "found objects" may need little or no interpretation via the written word. Assuredly, these objects may be felt — experienced — in this gallery, by anyone, just as the photographer felt them in the field, on location. The direct, instinctive, bemused sensuality of the eye is what is in play — here, there, now, then.

New Haven, Conn., 1972. Two walls from the exhibition at the Yale University Art Gallery, "Walker Evans: Forty Years." Nehi sign appears in Let Us Now Praise Famous Men. *Photograph by Jerry L. Thompson*

A distinct point, though, is made in the lifting of these objects from their original settings. The point is that this lifting is, in the raw, exactly what the photographer is doing with his machine, the camera, anyway, always. The photographer, the artist, "takes" a picture: symbolically he lifts an object or a combination of objects, and in so doing he makes a claim for that object or that composition, and a claim for his act of seeing in the first place. The claim is that he has rendered his object in some way transcendent, and that in each instance his vision has penetrating validity.

Wall label for exhibition of signs and photographs of signs, Yale Art Gallery, December 1971

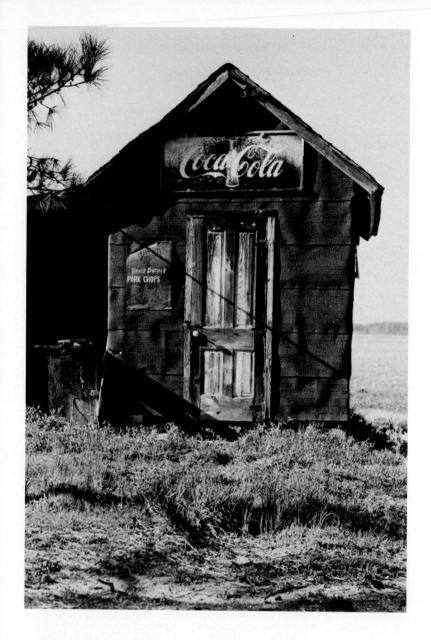

You've got to collect. Pieces of the anatomy of somebody's
living. . . . You contrive to ask around. Can you lead me
to any material like that? . . . You know how a collector
is. He gets excessively conscious of a certain object and
falls in love with it and then pursues it. . . . And it's
compulsive, and you can hardly stop.

Katz/Evans interview

Virginia, 1972. 2¹/₄ x 2¹/₄ negative
Facing page, same sign in Evans's living room,
photograph 1975, by John T. Hill

Brighton, England, 1973. 2¹/₄ x 2¹/₄ negatives

I'm in a stage right now that has to do with color and I'm interested in it. But I don't think that the doors open to falsehood through color are any greater than they are through the manipulation of prints in black and white. You can distort that, too. I happen to be a gray man; I'm not a black-and-white man. I think gray is truer. You find that in other fields. E. M. Forster's prose is gray and it's marvelous.

I've now taken up that little SX-70 camera for fun and become very interested in it. I'm feeling wildly with it. But a year ago I would have said that color is vulgar and

Connecticut, 1973–1974.
Polaroid SX-70 color prints

234

should never be tried under any circumstances.

("What are you trying to do with it?")

Oh, extend my vision and let that open up new stylistic paths that I haven't been down yet. That's one of the peculiar things about it that I unexpectly discovered. A practical photographer has an entirely new extension in that camera. You photograph things that you wouldn't think of photographing before. I don't even yet know why, but I find that I'm quite rejuvenated by it.

With that little camera your work is done the instant you push that button. But you must think what goes into that. You have to have a lot of experience and training and discipline behind you, although I now want to put one of those things in the hands of a chimpanzee and a child and see what happens. Well, not the chimpanzee — that's been done before. But I want to try that camera with children and see what they do with it. It's the first time, I think, that you can put a machine in an artist's hands and have him then rely entirely on his vision and his taste and his mind.

Yale Alumni Magazine

Connecticut, 1973–1974.
Polaroid SX-70 color prints

My thought is that the term "documentary" is inexact, vague, and even grammatically weak, as used to describe a style in photography which happens to be my style. Further, that what I believe is really good in the so-called documentary approach in photography is the addition of lyricism.

Further, that the lyric is usually produced unconsciously and even unintentionally and accidentally by the cameraman — with certain exceptions. Further, that when the photographer presses for the heightened documentary, he more often than not really misses it. . . .

The real thing that I'm talking about has purity and a certain severity, rigor, simplicity, directness, clarity, and it is without artistic pretension in a self-conscious sense of the word. That's the base of it — they're hard and firm. . . .

"Lyric Documentary," lecture at Yale, 3/11/64

("Do you think it's possible for the camera to lie?")
It certainly is. It almost always does.

("Is it all right for the camera to lie?")
No, I don't think it's all right for anything or anybody to lie. But it's beyond control. I just feel that honesty exists relatively in people here and there.

Yale Alumni Magazine

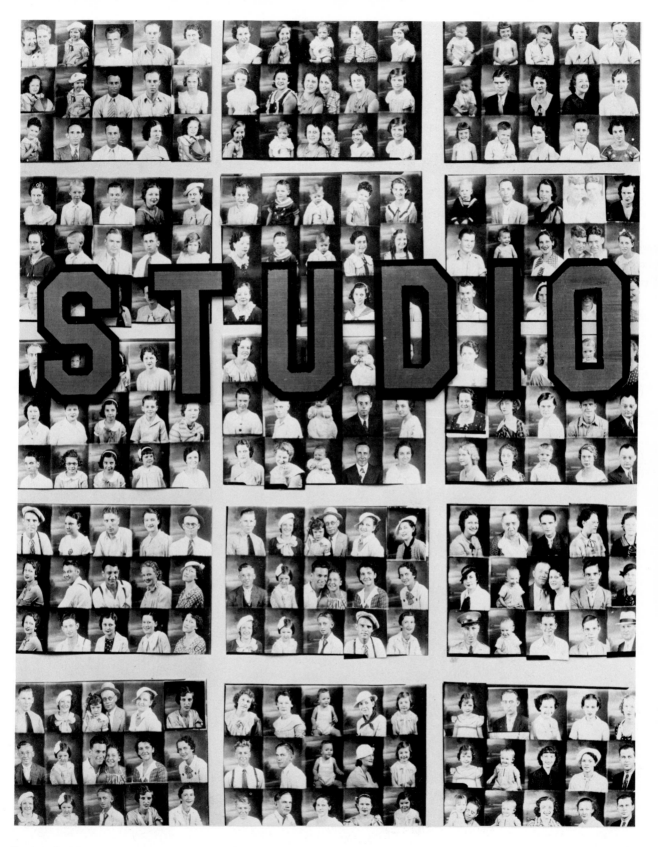

Savannah, 1935. 8 x 10 negative.

239